Women in San Juan, 1820–1868

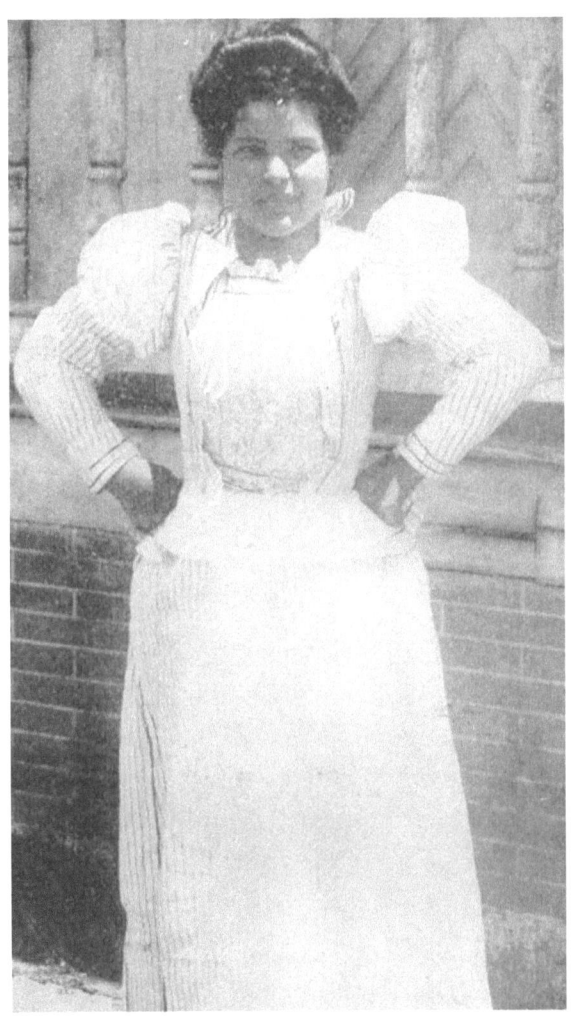

A Porto Rican Cigarette Girl

Market Women at San Juan

Women in San Juan, 1820–1868

Félix V. Matos Rodríguez

Markus Wiener Publishers
Princeton

Second Markus Wiener Publishers edition, 2022
Copyright © 1999 by the Board of Regents of the State of Florida

All rights reserved. No part of this book may be reproduced or transmitted in any form or by any means, whether electronic or mechanical—including photocopying or recording—or through any information storage or retrieval system, without permission of the copyright owners.

For information write to:
Markus Wiener Publishers
231 Nassau Street, Princeton, NJ 08542
www.markuswiener.com

Photos courtesy of the Center for Puerto Rican Studies, Hunter College, CUNY

Library of Congress Cataloging-in-Publication Data

Matos Rodríguez, Félix V., 1962–
Women in San Juan, 1820–1868.
Includes bibliographical references and index.
ISBN 978-1-55876-283-1 (pbk)
1. Women—Puerto Rico—San Juan—History.
2. Working class women—Puerto Rico—San Juan—Social conditions.
3. Women—Puerto Rico—San Juan—Economic conditions.
4. City and town life—Puerto Rico—San Juan—History. I. Title.
HQ1525.S26M38 2001
305.4'097295'1—dc21 2001033867

Markus Wiener Publishers books are printed in the United States of America on acid-free paper, and meet the guidelines for permanence and durability of the Committee on Production Guidelines for Book Longevity of the Council on Library Resources.

*To my parents, Marta and Félix, and to my grandparents,
Margarita, Marta, Vicente, and Victor*

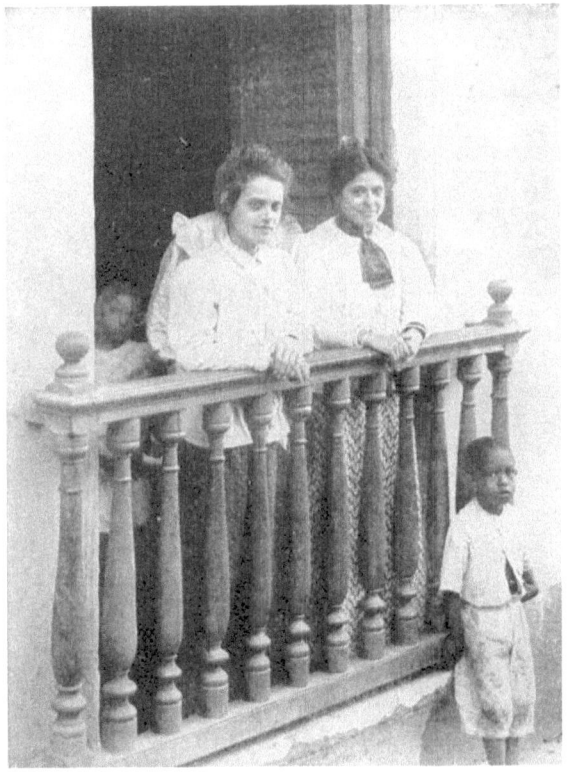

*Teacher and Young Lady Pupil
of the Girls' Seminary at San Juan*

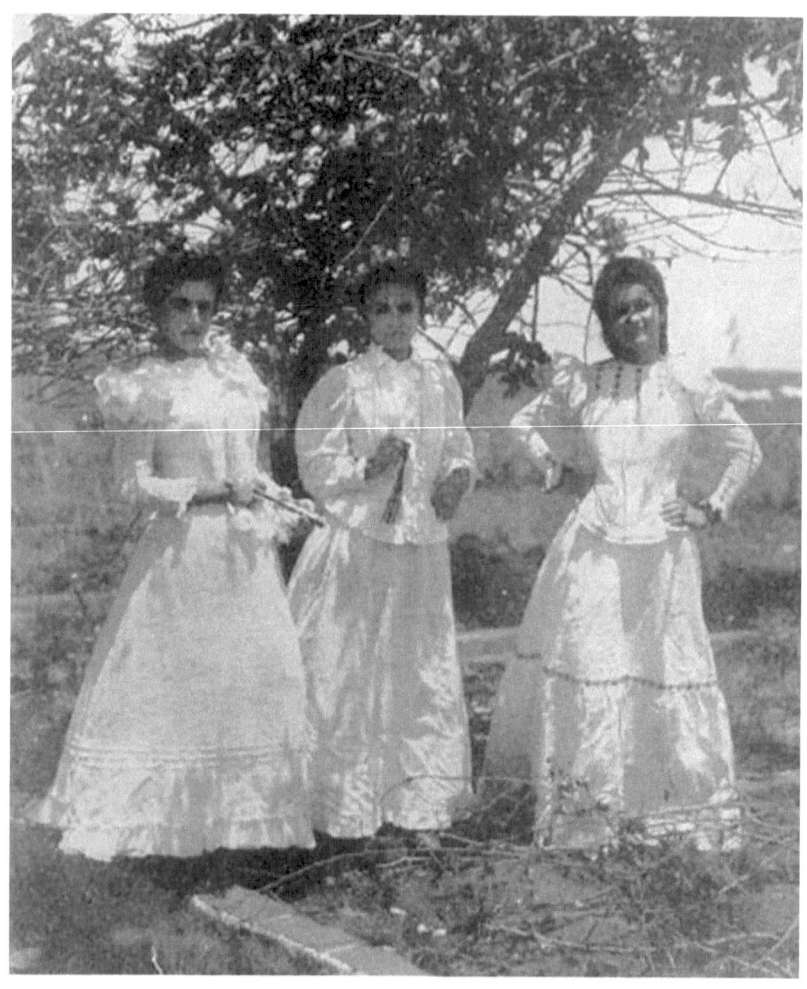

Group of Senoritas of Aristocratic Spanish Lineage

Contents

List of Tables viii

List of Maps viii

Acknowledgments ix

Abbreviations xii

Introduction 1

1. San Juan, Puerto Rico (1765–1868): An Overview 10

2. San Juan: Space, Population, and Urban Setting 36

3. Elite and Middle-Class Women in San Juan's Economic Life 59

4. Through the Back Door: Lower-Class Women in San Juan's Economic and Social Life 84

5. Venturing into the "Public": Women, Beneficence, and Education in Nineteenth-Century San Juan 101

Conclusion 125

Glossary 131

Notes 133

Bibliography 159

Index 177

Tables

1.1. Puerto Rico's Population: Eighteenth and Nineteenth Centuries 18
2.1. San Juan's Population 37
2.2. San Juan's Population by Sex 39
2.3. Population Totals for San Juan by Race 39
2.4. San Juan's Population by Sex: 1833 and 1846 44
2.5. San Juan's Population by Race: 1833 and 1846 46
2.6. Percentage of Slaves in San Juan's Population 47
2.7. Percentage of Slaves in San Juan's Population by Barrio: 1833 and 1846 48
2.8. Population of San Juan by National Origin and Sex: 1833 50
2.9. Population of San Juan by National Origin and Sex: 1846 51
2.10. Puerto Rican–Born Population in San Juan by Race and Sex: 1833 and 1846 57
3.1. House Ownership in San Juan by Sex and Marital Status: 1833 and 1846 69
3.2. San Juan's Room Renters by Sex and Barrio: 1833 and 1846 70
3.3. Women's Trades in San Juan by Barrio: 1846 78
3.4. Women's Trades by Legal Status and Barrio, San Juan: 1846 79
3.5. Female Domestics and Seamstresses in San Juan by Race and Barrio: 1846 80
3.6. House Ownership of San Juan's Female Domestics and Seamstresses: 1846 80

Maps

1.1. San Juan: The Walled City 13
1.2. San Juan and Its Hinterland 17

Acknowledgments

Among the many things that writing a book supposedly teaches you is to know who your real friends are. Books are a truly collaborative enterprise in both intellectual and social terms. I want to take this opportunity to express my gratitude in print to some very important people in my life.

Although most of my family members had—and continue to have—their doubts about the appropriateness of my becoming a historian, I sincerely believe that my upbringing left me with few other true career alternatives. My grandparents, after all, were and are seasoned *cuentistas* (storytellers); my *abuelos* were traveling salesmen of sorts; and one of my *abuelas* taught in Puerto Rico's public school system for thirty years. From my parents, who have always been avid readers, I inherited the passion for books and reading. They also taught me to be proud of Puerto Rico, to work hard, to share my talents with others, and to try to get to the bottom of things. I want to thank them for all they have done and continue to do for me.

I want to thank Liliana for the joy and energy she has brought to my life. Her encouragement, support, and good humor have allowed me to complete this project. To my brothers, Javi and Rafael, thank you so much for continuing not to take your brother seriously. You probably do not know it—and I will never admit it—but your generosity and encouragement have kept me going during very difficult times. Cece and Víctor Alexander Matos had always been supportive, with timely doses of reality. The Arabías, particularly Doña Lillian, also deserve praise for supporting and encouraging this "adopted" family member.

Two good friends and mentors have helped me to become a historian and have tried incessantly to help me succeed: Fernando Picó, who has a talent for getting me to do things I should never get involved with, and Pedro San Miguel, who was my high school teacher and became my big brother at Columbia University, have been constant sources of support and inspiration. I just hope that I can be to others the kind of friend and mentor that they have been to me.

Although many people have offered me much-needed support and encouragement throughout the different phases of this project, there are some whom I wish to acknowledge individually. Without the great emotional and intellectual support of Humberto García-Muñiz and Juan José Baldrich, this project might have never been completed. Emilio Kourí, *pana, hermano,* and fellow historian, has tolerated me since our high school days. For your patience and encouragement, thank you. Ruth Glasser, as a friend and colleague, has given new meaning to the phrase "above and beyond the call of duty."

This book evolved from a doctoral dissertation submitted at Columbia University. There, former Associate Dean Russell Berg gave the university bureaucracy a friendly and encouraging face. Professor Herbert Klein, my dissertation advisor, probably agonized over this project as much as I did. His support, wrath, and criticisms have made me a more mature person and a better historian. I also want to thank the members of the defense committee—Deborah Levenson-Estrada, Gabriel Haslip-Viera, Elizabeth Blackmar, and Phillip Silver—for their helpful comments and insights.

A special word of thanks also goes to Marysa Navarro, who encouraged me, read numerous drafts, and provided many suggestions on how to improve this study. I want to thank Silvia Arrom, Patrick Manning, Teresita Martínez Vergne, Jay Kinsbruner, and Eileen Findlay for reading versions of this manuscript and offering solid feedback. Eileen's particular generosity, faith, and vision need to be highlighted here. Lynn Stephen, Amílcar Barreto, Kristen Harper, and Sarah Shoenfeld also read individual chapters and provided me with valuable insights.

My friends and colleagues at the Social Science Research Council and Northeastern University have endured the writing and reviewing process with me over the past few years. I want to let you know how much I have appreciated your patience and your support. I want to thank, in particular, my colleagues in the History Department and the *familia* from the Latin American Student Organization (LASO).

Among the many friends who have helped along the way are Luis Silva, Rosi Fernández, Jorge and Glori Diaz de Villegas, Sammy Céspedes, Teruca Subirá, Ricky Rodríguez, Edgardo Ramos, Alvaro and Carolina Silva, José and Debbie Sánchez, Alfredo Cubiñá, Ana Mejía, Chris and Diego Dietche, Carlos Batlle, Emilio Juncosa, Sean Santini, Nina Gerassi, Ana M. Bérmudez, Juan J. and Ana Belén Bérmudez, Víctor Rodríguez, Maria Emma Mannarelli, Luis Duany, Sonia Pérez, Jorge Duany, Carlos Cianchini, Michael Maldonado, César Salgado, Ivan Bauzá, Angel Oquendo, Patricia Rivera, Israel Ruiz, Ana Cecilia Rosado, Benigno Trigo, Sherri Baver, Iris López, Laura Nater, Mabel Rodríguez, Willie Font, Lolita Luque, Carmen A. Pérez, Ignacio Olazagasti,

Mari Quiñones, Margarita Mergal, Guillermo Baralt, Betzaida Natal, Estelle Vilar, Aida San Miguel, Rafael Cabrera, Carlos Rodríguez, Jaime and Susan Fortuño, Roberto and Licette Fonseca, Chenti and Mayra Feliciano, Lourdes Rivera, Robert Winn, Hugo Rodríguez-Vechinni, Juan Carlos Quintero, Ivette Rodríguez, Kaveh Khosnood, Salma Moody, Peter Noble, Orlando Torres, Charles Beirne, Bonnie Gossels, James Oles, Francisco Scarano, Luis Martínez-Fernández, Jeremy Aldeman, Sheila Smith, Ingrid Vargas, Luis Figueroa, Virginia Sánchez Korroll, Jacabed Rodríguez, Jaime Castañeda, Emilio Pantojas, Olga Jiménez Wagenheim, Luz del Alba Acevedo, Lisandro Pérez, José Cruz, Celina Romany, Ricardo and Dora Mendes, Andrés Meléndez, José Flores, Víctor and Odile Pérez, Jorge Arteta, Clay McShane, William Rodríguez, Luis Falcón, William Fowler Jr., Brodie Fisher, Nelly Cruz, Linda Delgado, María Estorino, Joan Krizack, Altagracia Ortiz, Wilfredo Ramos, Jessica Colón, and many others I omit at my own peril.

One of the many great things about finishing this book is that I will be able to return to the Archivo General in San Juan with new projects and requests for my friends there. The *ganga* at the Archivo has made researching a pleasant experience. To José Flores, Hilda Chicón, Milagros Pepín, Neftalí Quintana, Sonia Calero, Gustavo Santiago, Ramonita Vega, Carmelo Viruet, Luis de la Rosa, and Carmen Alicia Dávila, my greatest gratitude and appreciation. Although she is no longer at the Archivo Histórico Diocesano, I want to thank Marta Villaizán for directing my work in that archive. Her guidance and long-distance support have been truly invaluable throughout this whole process.

A word of thanks also to Meredith Morris-Babb, who nurtured this project at the University Press of Florida, and to her helpful staff. Thanks also to Marjorie Kaye for the two maps produced for this book. Finally, I want to acknowledge the crucial financial support of the Dorothy B. Compton Foundation, American Historical Association, and Northeastern University's Provost Office Fund for Minority Faculty Research.

Abbreviations

AGPR	Archivo General de Puerto Rico
AHD	Archivo Histórico Diocesano
AHN	Archivo Histórico Nacional
C	Caja
CP	Fondo Colecciones Particulares
E	Expediente
f	folio
FGEPR	Fondo Gobernadores Españoles
FMSJ	Fondo Municipal San Juan
FOP	Fondo Obras Públicas
FPN	Fondo Protocolos Notariales
L	Legajo
P	Pieza/Parte
S	Serie
Se	Sección
v	vuelto

Introduction

> It is not the voice that commands the story: it is the ear.
> Italo Calvino, *Invisible Cities*

Bernarda Baez, a black woman, was the widow of San Juan's cathedral church bell ringer, José Méxias. Between 1834 and 1840, Baez rang the cathedral's bells, replacing her sick and incapacitated husband. After her husband died in 1840, Baez asked the Cathedral Chapter to allow her to keep officially the job of bell ringer.[1] She argued that, after all, she had been performing the job for the last couple of years. Baez also asked church officials to remember that she had several children to take care of.[2] To avoid any potential controversies, Baez proposed naming a male friend, a *persona de confianza*, to appear in the record books as the official bell ringer. The Cathedral Chapter approved Baez's petition. Unfortunately for Baez, the fraudulent scheme became a public scandal in 1846, just prior to the arrival of the newly appointed bishop, Francisco de la Puente. The scandal forced both ecclesiastical and political authorities to take action. Baez was forced to resign as bell ringer and was asked to move her family out from the cathedral's grounds.

Baez's story is exemplary of important aspects of mid–nineteenth century urban life in San Juan. First, the anecdote illustrates both the rigidity and fluidity of gender, class, and racial hierarchies in the city. The ruckus caused in the Cathedral Chapter reflected the concern that colonial officials and the elite had in making San Juan a symbol of Spanish modernity, morality, order, progress, and respectability for the rest of the island. The idea of a woman, particularly a black woman, performing such a public, visible job in the colony's most important house of worship was inconceivable to many in the city. Second, Baez's experience shows how porous class, gender, and racial hierarchies could be in San Juan, right under the direct scrutiny of military, political, and ecclesiastical authorities. Baez's story also shows how, even in circumstances of gender and racial subordination, women found ways to circumvent the system in order to improve the quality of their lives or just to survive. Finally, this story suggests that women could and did occupy positions often at odds with the dominant gender structures of the time in San Juan.

The main concern of this book is to see how women in mid-nineteenth century San Juan participated, were affected by, and took advantage of the attempts to create a modern, respectable, and progressive city. The concerted efforts by elite members and colonial authorities to achieve these goals targeted *sanjuaneras* in different ways. Both the local male elite and the Spanish colonial officials hoped and pushed for more participation of elite, "respectable" women in education, family rearing, beneficence, and moral regeneration. In this way, women participated in tasks traditionally associated with their socially prescribed roles as nurturers and mothers. Women were expected to contribute under the watchful eye of husbands, fathers, priests, and government and military officials and to help regenerate society from within the narrow boundaries prescribed by men. Lower class, "disreputable" women were to continue in their roles of producers, as workers, and reproducers, as mothers of future workers. Interestingly, the prescribed roles of poor and colored women were partially determined and managed not only by men but also by elite women.

Since the second decade of the nineteenth century, both Spanish colonial officials and San Juan's elite had designed and attempted to implement various projects to move the city into the modernity and progress experienced by other American and European cities.[3] Those grand schemes peaked in San Juan between the 1830s and the 1860s, coinciding with a gradual deterioration of the sugar export bonanza that had fueled flourishing economic activity in the city. In fact, the economic difficulties San Juan faced made the need for reform and change all the more vital. Spain could not afford to have the capital city of one of her last colonial possessions in disarray, and neither could the local elite, for their economic and social interests were also at stake. San Juan's economic difficulties prevented the state from gaining the fiscal resources needed to carry out the majority of its progressive plans, thus allowing the church and certain sectors of the elite to pursue their independent projects. Elite women were among the ones to benefit from this independence, as they became active partners in many of the beneficence institutions created after the 1840s. The fissures caused by the fiscal and social crisis in the colony created alternate spaces for some groups, particularly elite women, even when they were being used by the state and the local male elite as one of the cornerstones of their modernizing and liberal hegemonic project.[4]

Obviously, things did not work out according to the enlightened blueprints of elite members, priests, and government officials. To begin with, there were tensions in the relationship between these groups which would become evident as the nineteenth century advanced.[5] Furthermore, the economic and urban changes that San Juan was slowly experiencing weakened

patriarchal structures and allowed for some unanticipated spaces of autonomy for women, particularly for elite and professional women. Finally, the Catholic Church also rearticulated loyalties and strategies in an attempt to gain some of the political and economic power it had prior to the 1820s. The Church also wanted to contain the secularization efforts of the Spanish government and some sectors of the local elite.

Women were not just passive bystanders observing the changes occurring in midcentury San Juan. As I will show in the pages ahead, they fought with ingenuity and tenacity to limit the impact upon their lives of the economic changes affecting the city. Elite and upper-level women tried to fend off attacks from creditors who attempted to seize their businesses or, in the case of widows, the fortunes of their deceased husbands. Other "landladies" tried to evict nonpaying tenants, tried to build more rooms into existing structures, or took troublesome tenants to court. Lower-class women engaged in petty trade, street selling, or moonlighting as domestic workers to earn additional income. They took lovers to court to guarantee promised financial security for themselves and, in some cases, for their children. Female slaves pushed their masters for more freedom either to rent themselves to others or to secure a few hours of the day to pursue their own interests.

Poor and colored women fought against being kept in their place, notwithstanding the best efforts of the colonial authorities. Against the repeated reprimands of town council officials, women sold foodstuffs and services up and down the unpaved streets of San Juan. Domestics and peddlers were loud and noisy as they performed their tasks, often in the company of their children and other women.[6] Laundresses protested and threatened to strike when essential items for their work, such as water cisterns, were not made accessible to them. The more city officials pushed women and people of color outside San Juan's walls, the more creative these women got in finding ways to circumvent or ignore official regulations. Furthermore, in their newly formed, extramural barrios, poor and colored women created survival, familial, and solidarity strategies, which stood better chances of succeeding given the added distance from the centers of colonial, military, and ecclesiastical power.[7]

That space and that distance—created by relocating poor and colored people, the majority of whom were women—had been a crucial aspect of the state's modernizing agenda since the early nineteenth century. The influx of immigrants and slaves and the political turmoil caused by the Haitian Revolution and the independence wars in South America alarmed Spanish colonial officials and most sectors of the city's elite. They engaged in a project that drove "suspicious" and potentially rebellious sectors of the population outside the city's walls and built new government, military, and commercial

structures in the neighborhoods where the relocated people had lived.[8] Improving and modernizing the city's architectural infrastructure coincided with eliminating those people and places that the elite and the government considered dangerous, ugly, and disreputable.

One space where the modernizing hegemonic project of the upper classes and the colonial state met with the daily life of both elite and poor women in San Juan was beneficence institutions. Although the notion of beneficence was part of the liberalizing and secularizing strategies of the Spanish state in the early nineteenth century, the proliferation of such establishments in San Juan began at midcentury.[9] As research on beneficence and charitable crusades has shown for other parts of the United States and Latin America, the creation of hospices, hospitals, schools, and other similar institutions was usually connected to attempts by local elites at consolidating or protecting power and privilege.[10] Beneficence in the Caribbean and Latin America served as a control mechanism aimed at policing and controlling poor and colored people. In the case of San Juan, beneficence was tied to the elite's attempt to secure reliable domestic workers once slavery was abolished and to reshape the racial, gender, and class hierarchies that slavery had guaranteed in the past. Elite women played a key role in securing a vital source of labor to support their ongoing, class-based privilege and leisure. They also moved onto a more public stage as managers and employed more formally some of the skills many had quietly developed as owners, co-owners, and partners in businesses and real estate.

In the case of beneficence, I am interested in exploring the roles played by elite and lower-class women and by the colonial state and the church in shaping the nature of such establishments. Although the data are skewed in favor of documenting the work and role of elite women, beneficence is an arena where one can see the conflicting realities of *sanjuaneras* and the effects of modernizing institutions on women of different racial and socioeconomic backgrounds. Other studies in San Juan, particularly that of Teresita Martínez Vergne, have emphasized the structural dynamics of power relations in the regulation and articulation of space in the major public beneficence establishment in San Juan, the Casa de Beneficencia.[11] Although I also looked at the development and functioning of the Casa, I decided to concentrate on the emergence of private and semiprivate institutions, such as the Asilo San Ildefonso. These institutions show the alternate alliances and arrangements that elite women groups were willing to forge with the church and the Spanish government in order to pursue their interests. From the vantage point of elite *sanjuaneras*, the state failed in running beneficence institutions. The state also failed in providing adequate transitional labor mechanisms for domestic labor prior to the abolition of slavery. If the Casa de Beneficencia exemplified

liberal ideology in San Juan during the first half of the nineteenth century, the Asilo San Ildefonso (and the many similar institutions formed after the 1850s) was paradigmatic of the convergence of beneficence and modernization in the city during the second half of the century.

Another important reason for examining beneficence institutions such as the Asilo San Ildefonso is that they provide the first recorded examples of women's organizations in Puerto Rico.[12] As such, they are of obvious historical importance to those interested in the origins, development, and growth of women's and feminist organizations on the island.[13] Through beneficence, elite women in San Juan and elsewhere in Puerto Rico opened a public space in management and the supervision of others, even if these others were only women and children. Through beneficence institutions and through quotidian life practices, poor and colored women learned the limits and difficulties of the "sisterhood" offered by elite women.

My research on San Juan documents the roots of the class- and race-based differences in Puerto Rico's turn-of-the-century feminist movements. Several authors have already commented on the differences between working-class and bourgeois feminisms in Puerto Rico's urban centers between the 1870s and the 1940s and about the feminists' inability to let class and race distinctions override gender affinities.[14] This book will demonstrate how in San Juan, for example, solidarity and mobilization, such as the laundresses' strikes and protests that occurred in the city, were part of poor women's experiences prior to the development of capitalism and of working-class or feminist movements. Furthermore, the data from San Juan will show that many poor and colored women faced family life and sexuality differently from their elite sisters. Plebeian women headed their households, had common-law marriages, and had different experiences based on their gender, race, and class positioning. These differences inevitably influenced the divergent postures that bourgeois and working-class feminists took in the late nineteenth and early twentieth centuries regarding issues related to family life, motherhood, and sexual morality.

Women in Latin America and the Caribbean were the targets of many crusades and campaigns during this period. Elites, national governments, the Catholic Church, and various social groups tried, on different occasions, to manipulate authority, consolidate power, and prepare for the future with policies and rhetorical strategies that often targeted different sectors of the female population.[15] In the case of Mexico, Jean Franco and Silvia Arrom have documented how, during the post-independence era, some of the advances that upper-class women had made earlier were nullified, at least on the educational, cultural, and political fronts.[16] "The bleak wind of nationalism," as Franco calls it, also swept through most of Latin America in the

nineteenth and early twentieth centuries. Although the discourse that tied nation building and modernization usually limited the spaces for social and economic mobility of most women regardless of class or race, it also helped to erode some of the basis for patriarchal authority.[17] As is usually the case in these complex scenarios, the intended and unintended results for women of the policies and strategies advocated by male politicians, patriarchs, and priests were a combination of increased control, surveillance, and restrictions, with possibilities for autonomy and independence in some realms.

The efforts and campaigns mentioned above, regardless of national particularities, were always intricate endeavors because they often called for an enlarged role for women in society but always under the restraint, guidance, and control of male figures in the family, the government, or the church. Recent research in nineteenth-century Cuba, for example, has shown how upper-class women were targeted in an educational campaign to fight the racial fears of the Cuban elites and the Spanish colonial government.[18] The Cuban campaign was not without tensions, as many feared that educating elite women as a sign of the civilized nature of Cuban society risked altering the gender hierarchy on which that high level of "civilization" rested. In another example, Sandra McGee Deutsch has documented how the turn-of-the-century Catholic Church in Argentina tried to use women to fight secularization trends.[19] The Argentine case is probably representative of most of Latin America, where the Catholic Church regrouped in the second half of the nineteenth century after decades of post-independence civil wars and inter-elite conflicts.

Historical research about how gender-structured campaigns have been used to construct communities and identities in Puerto Rico is just starting. For the nineteenth century, Eileen Findlay's work on the city of Ponce is the only one to date using gender analysis to show how controlling women's sexuality served to articulate and construct national identity and colonial hegemony.[20] In Ponce, the state, the labor movement, bourgeois and working-class feminists, and elite-dominated political parties all attempted to manipulate sexual norms and practices to advance and legitimize their hegemonic projects. At a time of dramatic flux in Puerto Rico's history—the end of Spanish, and the beginning of U.S., colonialism—the perceived challenge of a "sexual threat" provided a common enemy against which different groups could create their communities.

Apart from adding to the growing corpus of work on gender construction and women's history in nineteenth-century Latin America, the case of Puerto Rico provides an interesting variant to the works that have accentuated modern nation building in the region. The case of San Juan provides an example of the modernizing project of an elite and a colonial government, since Puerto

Rico remained a Spanish colony throughout this period. In this context, it is interesting to see how colonialism affected the elements of this process which are comparable to the Latin American experience. San Juan was a place where secular authorities and institutions attempted to develop without the context of independent nationhood.[21]

The "eagerness of modernity" (as Silvia Alvarez Curbelo has called it) and colonial status in Puerto Rico provide testimony to the contradictory and complex nature of political and cultural life in the Americas in the nineteenth century. Literary critic Carlos J. Alonso has argued that the program of modernity sponsored by local cultural and political elites was fundamentally ambiguous because "at the precise moment that Spanish American intellectuals asserted their specificity or made a claim for cultural distinctness, they did so by using a rhetoric that inevitably reinforced the cultural myths of metropolitan superiority."[22] The case of Puerto Rico shows how the state's rhetoric of modernity was used to solidify the colonial relationship. Spain, and Spanish supporters in Puerto Rico, wanted to demonstrate that all the benefits of modernity—economic, cultural, and social—could come to the island because of and through its colonial link. The Spanish government also defined modernization as the further integration of the island into the world market of agricultural staples. Liberal elite members, on the other hand, wanted either political autonomy or independence and saw the connection to Spain as a sign of burdensome backwardness.[23] If the programs and the rhetorical strategies of the most conservative advocates of modernity seem to have prevailed in San Juan between 1820 and 1868, it was not because of a lack of competing and contradictory visions.

The connection between colonialism, modernity, and patriarchy was important in San Juan between 1820 and 1868. Gender scholars have shown how, in times of crisis or flux, gender hierarchies are aggressively protected.[24] The threat of political revolution and of racial rebellion had lurked behind the shadows of the Spanish colonial state in Puerto Rico since the early part of the nineteenth century. Consequently, the state was particularly vigilant in watching for any challenges to order and safety. If the government could not guarantee that women would abide by their socially prescribed roles, how could one expect it to defend Spanish colonialism and slavery? It should not be surprising, then, that one of the earliest casualties of anti-independence persecution in San Juan was a woman, María de las Mercedes Barbudo,[25] who was exiled to Cuba in 1824 for her seditious communications with pro-independence supporters inside and outside Puerto Rico. As this book will show, men and women in San Juan did not experience colonialism in the same way.

The vision of a modern San Juan and the particular gendered dynamics

inscribed in that vision were products of the early nineteenth century. As Silvia Arrom has shown for Mexico, the roots of such early attempts can be traced to Bourbon reforms aimed at making the Spanish colonial empire more efficient and profitable.[26] Subsequent governments, social classes, and churches in Puerto Rico have attempted to promote their own versions of a safe, progressive, respectable, and orderly city in the late nineteenth century, after the U.S. invasion of 1898 and following the 1930s and the Depression.[27] Inevitably, in all such projects women were to play an important, if always subordinate, role even when some women were included in designing the modernizing vision.[28] My work on midcentury San Juan serves as a reminder that these ever-changing visions and the gendered structures that sustained them have historical roots that preceded the turn of the twentieth century, the era on which most of the historical literature has concentrated.

This book also speaks to the ongoing need, in Caribbean and Latin American history, to continue research on women's lives and on the way that gender relations have been historically constructed. In the last two decades, some important research has already been published.[29] In the particular case of Puerto Rico, even though there has been increasing interest among historians in women's and gender history, we still lack comprehensive studies of the pre-twentieth-century period.[30] My research about San Juan should help to contextualize future research regarding women and gender in Puerto Rico in subsequent eras. This book will also help Latin American and Caribbean scholars to incorporate the experiences of Puerto Rican women into their regional research.

For a region that is as heavily urbanized as the Caribbean is today, there is a dearth of historical research on the evolution of large urban centers. My research on San Juan attempts to revive interest in urban social history in Puerto Rico and the Caribbean. In Puerto Rico's particular case, the historiography produced since the 1970s has been biased toward rural, agricultural, and plantation histories.[31] While it might be true that most historians of the nineteenth century were right to concentrate their analyses in rural areas because this was where a vast majority of Puerto Ricans had lived up until the early twentieth century, it is also true that Puerto Rico today is a predominantly urban society with pressing urban problems in need of the insight that good historical analysis can provide. Thus, I focus my research on San Juan in order to foster the development of a nineteenth-century, urban, social history literature in Puerto Rico which will complement the existing predominantly nineteenth-century rural historiography and the current twentieth-century urban literature.[32] In order to understand cities like San Juan today, we need to understand their past.

This book is organized thematically and chronologically. The first chapter provides a brief overview of the main sociohistorical and economic aspects of San Juan's history. It also provides a sense of how San Juan evolved as a city, from the late eighteenth century up until the mid–nineteenth century. The modernizing projects of the Spanish colonial authorities, the local elites, and the Catholic Church are also analyzed in this chapter. The second chapter illustrates how San Juan's demography changed as a result of Spanish migratory and urban renewal policies. In the century from 1750 to 1850, it transformed from a city with a majority of women and people of color to one with a majority of men and whites. Spanish demographic and urban policies were destined to shape the population in accord with their vision of what a progressive, safe, and respectable city should be like. In the third chapter, I examine the different roles that elite women played in San Juan's economy and how they faced the economic difficulties that the city experienced between 1830 and 1870. Chapter four documents the lives of poor and lower-class women in the city during the same period and shows how poor women were targeted for certain campaigns, such as the anticoncubinage crusade, and how they responded to the reformist and invasive intrusions of the Spanish state under the banners of reform, modernity, and enlightenment. In the fifth chapter, I discuss a point of convergence for both elite and lower-class women, exploring how beneficence institutions had been historically oriented toward women in San Juan and how elite women moved to establish and control beneficence establishments to secure their class and race privileges over their less fortunate sisters. The conclusion provides some observations on the situation of women in San Juan on the eve of 1868, a date usually associated in the Spanish Caribbean as a watershed of political, economic, and social changes in the region.[33]

1

San Juan, Puerto Rico (1765–1868)
An Overview

In 1853 the members of San Juan's town council received a letter from Governor Fernando de Norzagaray detailing his plans for new construction in the city. In that letter the governor, after inviting *cabildo* members to endorse his plans to build a new market in one of the most impoverished parts of the city, challenged them to have their town council's tenure remembered as "the period of the aggrandizement of culture and good taste" in the city's history.[1] In that same letter Governor Norzagaray revealed his plans to build a sewage system and a new jail and to proceed with prior plans to pave the city streets. Although he was not the first governor to propose grandiose plans for the colony's capital city, Norzagaray's letter reflected the contemporary concern and interest in making the city a symbol of Spanish modernity, morality, safety, order, progress, and respectability for the rest of the island.

The city of San Juan and its residents were coping with the changes experienced throughout the late eighteenth and early nineteenth centuries. Physically, the walls surrounding the city made expansion and new construction difficult and expensive. Demographically, the city's population increased during that period, placing further strains on San Juan's limited housing stock and forcing the development of working-class, nonwhite, extramural neighborhoods outside the city walls. The period from 1867 to 1868 was named by *sanjuaneros/as* the "period of the yuca"—yucca being a bitter tuber consumed by the local population—because of the financial difficulties faced by city residents.[2] In fact, San Juan's economy had been fairly stagnant since the 1840s. By the end of the 1860s, then, the residents of San Juan were living in a moment of transcendental flux in the city's history.

This chapter provides an introduction to the way San Juan became the city it was by the 1860s, exploring the spatial development of the city since

the late eighteenth century. Along with the city's urban growth in the early nineteenth century came the visions and plans that the Spanish government, the Catholic Church, and the city's elite had for San Juan. The second part of the chapter discusses and analyzes the evolution of those visions between 1820 and 1862.

Spatial Development in San Juan, 1765–1862

The city of San Juan was founded in 1521 after residents of the original capital of the colony—Caparra—became dissatisfied with its location. San Juan was built on the western side of a small barrier island lying between the island of Puerto Rico and the sea.[3] One of the main attributes of the new location was its excellent and easily defensible harbor. The city, however, was small in size: 682 meters long and 430 meters wide.[4] It occupied only about a third of the barrier island.

The physical space around which the city of San Juan developed in the nineteenth century was already well established by the end of the eighteenth century. The fortified walls and most of the military fortifications constructed to guard against foreign attacks had been completed by 1782.[5] Although these walls protected the *sanjuaneros/as* well during the British siege of 1797, they also caused a definite problem for San Juan's urban growth: "In fact, with the building of the walls, city territory was delineated, providing for a clear differentiation of the inside/outside spaces. However, San Juan during this period was not more than a 'shell,' a framework, for a city that was not built until the XIXth century."[6] Even when military regulations continued to play a decisive role in the city's urban development, the changing economic and political realities facing the colony gave other considerations leverage in challenging the military's influence. The tearing down of part of the wall that surrounded the city in 1897 was a late victory for the forces that, during the last third of the century, had been demanding a transformation of—or an end to—Spanish colonialism on the island.[7]

As the nineteenth century commenced, San Juan still had some open spaces within its walls. Even with these open spaces, the fundamental texture of the city had been essentially defined by the end of the eighteenth century. As a matter of fact, the city's basic grid-line format had been firmly established since the sixteenth century.[8] By the beginning of the nineteenth century, many of the key buildings around which San Juan's daily life revolved had been in place for centuries: the cathedral; the Captain General–Governor's residence (the Palacio de Santa Catalina or Fortaleza); the Dominican, Carmelite, and Franciscan convents; the Town Hall; the plazas; and the military fortress of El Morro. Changing needs and orientations led to the construction of new

buildings, or to the remodeling of old ones, throughout the nineteenth century.

As opposed to the buildings and fortifications that had been part of the city's life in previous centuries, other areas in San Juan were in the process of defining their role within the urban structure. At the beginning of the nineteenth century, for example, all of the city's four intramural quarters (or *barrios*, as they were called) had clusters of wooden houses and poor huts (*bohíos*) within them. As the century advanced, the *arrabales*, as the clusters were known, disappeared since more space was needed to build housing both for the city's growing population and for the civil and bureaucratic infrastructure developing in San Juan.[9] Some of the *arrabales* became independent barrios in the second half of the nineteenth century.

The city was segmented into four quarters by using Luna and Cruz Streets as dividing lines (map 1.1). Luna Street marked the north-south boundary, while Cruz Street marked the east-west one.[10] At the beginning of the nineteenth century, the city's four intramural barrios were: Santo Domingo, located on the northwestern side of the city, surrounding the Dominican convent and the small plaza by the convent's side; San Juan,[11] or Fortaleza, located on the southwestern side of the city and including the cathedral, the Carmelite convent, the Plaza de Armas, and the Captain General–Governor's residence; Santa Bárbara (named after the hermitage located there), which comprised the northeastern side of the city and included the new market and a gunpowder arsenal; and San Francisco, located on the southeastern part of the city and named after the Franciscan church and convent located at the barrio's center. Later in the century, a fifth intramural barrio, Ballajá, was created. This barrio was originally part of the Santo Domingo barrio and comprised the area located between the Dominican convent, the Military Hospital, and the grounds of the El Morro fortress. All of these buildings were compressed into the small area created by the city walls. This intramural area consisted only of 62 acres in total area.[12]

San Juan was a small city by New World, and even Caribbean, standards. Havana's intramural sector, for example, measured nearly 350 acres.[13] At the onset of the nineteenth century, the cities of Kingston, Bridgetown, and Port au Prince were bigger in size and population than San Juan.[14] Yet none of these cities had the legacy, as San Juan did, of being merely a military garrison for nearly three centuries. Even if San Juan was small by Caribbean urban standards, there was not another town or city in Puerto Rico at the beginning of the nineteenth century which could rival it.[15] San Juan was clearly a distinct urban area in Puerto Rico in terms of its extension, population, structure, and hegemony.

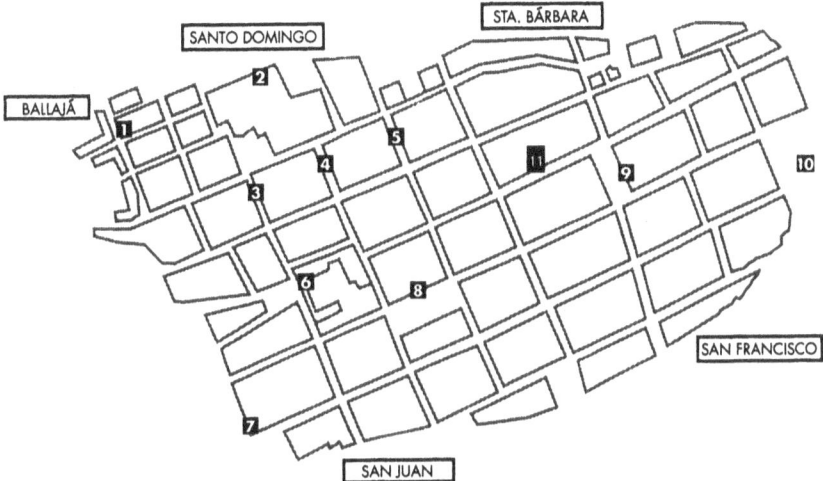

1. Asilo de Beneficencia 2. Dominican Convent 3. Calle del Cristo 4. Calle San José
5. Calle de la Cruz 6. Cathedral 7. Governor's residence 8. Cabildo 9. San Francisco Church
10. Municipal theater 11. Calle de la Luna

1.1. San Juan: The Walled City.

Many of San Juan's barrios had *arrabales* at the beginning of the nineteenth century. These *arrabales* were most predominant in the Santa Bárbara and Santo Domingo barrios. The latecomer Ballajá barrio was initially a huge *arrabal* within the Santo Domingo barrio.[16] Yet, as the century advanced, more houses were constructed of masonry. Chronicler Iñigo Abbad's late-eighteenth-century description of wealthy and predominantly peninsular people living in two-story houses, and *criollos* living in one-story houses, exemplified more house ownership patterns than actual house occupancy.[17] If it was true that wealthier Spaniards—and some *criollos*—owned most two-story buildings, it would not be accurate to generalize about the other tenants, visitors, boarders, or occupants of the rooms in those buildings. During the nineteenth century it was not unusual in San Juan to find families of different ethnic and racial backgrounds living in the same building.

Many of the masonry houses built in nineteenth-century San Juan followed the neoclassical features that were typical of the architectural style of most of the city's colonial buildings.[18] Careful proportionality, abundant straight lines, and laconic decorations characterized many of San Juan's houses. The architectural style took advantage of the city's sloped topography, since the city's northern side is more elevated than the southern side. The city's architects also had to balance their concerns with protecting houses against tropical phenomena,

like hurricanes, and observing the many military regulations governing construction in the city.

The majority of the city's best and most important stores were located in the Fortaleza and San Francisco barrios. These barrios had easier access to the harbor and the docks, which were located in the southern part of the city. All the gates (*puertas*) connecting San Juan with the outside world were also located inside these two barrios. The Puertas de San Juan and de San Justo led to the bay and the docks, while the Puerta de Santiago, or de Tierra (literally "gate to the land"), was the city's only land entrance. Before the new marketplace was built in the Santa Bárbara barrio in 1853, the open plazas within the Fortaleza and San Francisco barrios housed temporary markets, further increasing these barrios' claims to being the city's commercial centers.

The barrios of Santa Bárbara and Santo Domingo lacked the commercial activity of the other two barrios. Yet, the slaughterhouse was located within Santa Bárbara.[19] Many street vendors and *revendones* (resellers) operated in these barrios, taking advantage of the distance from the main market. In these two barrios, for example, women were quite active as *revendonas* and also as sellers of *mondongo*, a local stew made with tripe, which was a very popular dish especially among people of color in the city. In fact, one of the streets that runs through both Santa Bárbara and Santo Domingo—San Sebastían Street—was often referred to as the *calle del mondongo*.[20] In these two barrios also resided many of the city's artisans. Carpenters, painters, shoemakers, bricklayers, blacksmiths, and others were initially attracted to these two barrios by the construction projects and later by the permanent presence of military installations. Both the El Morro and San Cristóbal fortresses were located in the northern part of the city within the barrios of Santo Domingo and Santa Bárbara.

Another important aspect of San Juan's urban development was the city's lack of access to steady supplies of potable water. No rivers crossed the city, and as part of an island the city was totally surrounded by salt water. Many *sanjuaneros* collected water in cisterns, which some of the masonry houses had. Each of the military fortifications and many of the Spanish institutional buildings also had huge cisterns, which were made available to the public in cases of severe droughts or emergencies.[21] A big fountain was located on the isle's easternmost side, well outside the fortified walls. The fountain was next to the San Antonio bridge, which connected the isle of San Juan to the rest of the bigger island, Puerto Rico. From this fountain drinking water was transported into the city in casks.[22] Women also did their wash near the fountain.

There were several other smaller wells in the city, such as the one in the

Plazuela de las Monjas (the small plaza located in front of the cathedral and next to the Carmelite convent) and the one near the San Justo Gate. Wells were also found in the extramural barrio of Puerta de Tierra and on the tiny island of Miraflores, next to San Juan. Water was also brought into the city in small boats, which crossed the harbor with potable water collected from the nearby rivers in Palo Seco, Cataño, Caparra, Isla Grande, and Cangrejos. People also purchased drinking water near the city gates or waited until a water carrier brought it in a barrel to their houses.[23]

As the nineteenth century progressed, the few open spaces still available in the city for gardening and keeping domesticated animals disappeared. This situation increased the city's already high dependence on outside food and cooking supplies. Wood for cooking was brought from Cangrejos or from some of the tiny inlets around Miraflores and Isla Grande. Meat was imported from all parts of the island, as military authorities forced upon all municipalities a quota of cattle to supply the city's needs. Cattle were also needed to meet the demands of the military garrisons and the visiting fleets.[24] This meat supply system was extremely controversial and unpopular and was abolished in the early nineteenth century. However, San Juan continued to import meat and vegetables from the rest of the island throughout the century. Other vital supplies—including oil, wheat flour for bread, candles, and olives—were imported for the most part from Spain.

During the late eighteenth and early nineteenth centuries a dedicated, if not always successful, attempt was made at modernizing the city's infrastructure. San Juan, for instance, began plans to pave its streets in 1789, but the project continued to make only limited progress during the period under study. In the last two decades of the nineteenth century, the *cabildo* was still granting contracts to finish the pavement project.[25] Transportation within the city was difficult and inefficient. Not only were most of the city's streets unpaved, but they were narrow and unsafe. The traveler Edward Bliss Emerson noted, with surprise, the lack of carriages and carts in the city.[26] Land communication and transportation were limited by the physical constraints imposed by the Puerta de Santiago and the San Antonio bridge. To prevent the island's producers from having to cross the city—from the Santiago to the San Justo gate—in order to take their goods to the docks, a small road was constructed in 1860 which bordered the outside of the wall and connected the extramural barrios of Puerta de Tierra and La Marina.[27] The Carretera Central, which linked San Juan with the rest of the island, was started in 1852, and the section between San Juan and Caguas was completed in 1857.[28] All of the road improvements did not end the busy traffic through the San Juan bay, as many small boats from the surrounding municipalities brought

their products to the city for sale. A steamship company began to service the route between Cataño and San Juan in 1853.[29]

General Features of San Juan's Economy, 1782–1860

For most of San Juan's pre-nineteenth-century history, the city had been little more than a strong military outpost guarding the entrance to the Spanish empire in the Americas. The city served as the military headquarters of an island which did not figure prominently in the Spanish crown's economic grand design until the late eighteenth century. Up until the nineteenth century, the city consisted of a few houses scattered around the well-established Spanish urban grid system and military fortifications, plus the necessary—if unimpressive—church and government buildings. The city's Spartan atmosphere, particularly if compared to other Spanish urban settlements in the Americas, was evident to most visitors. The city streets were muddy and uneven; houses were plain in architecture and decor.[30] Military architecture and concerns dominated the urban contours of San Juan up until the nineteenth century.

San Juan and its hinterland figured prominently in Puerto Rico's late-eighteenth-century expansion in sugar production for the world market. The port of San Juan was easily accessible, by road and sea, to the fertile valleys of the neighboring municipalities of Loíza, Trujillo, Guaynabo, Bayamón, Cangrejos, Río Piedras, Toa Alta, and Toa Baja (map 1.2). Land became available in these areas as a result of the government's struggle against the cattle ranchers—*hato* owners—which had dominated the regional economy.[31] Once the *hatos* were dismantled, investors from San Juan were ready to exploit the agricultural resources of the city's hinterland.

The initial group of sugar cane *hacendados* in San Juan was a mixture of foreigners and of Spanish government, military, and church officials. These people had access to the capital needed to start a sugar cane venture. A particularly important group was composed of several Irish immigrants who came to the Island either as army officers or as crown officials. *Haciendas* with owners' names such as O'Daly, Kiernan, Power, Quinlan, and Fitzpatrick were common in the area between Loíza, Río Piedras, and Guaynabo.[32] Other influential *sanjuaneros* acquiring sugar lands in the city's hinterland were Captain José T. Zeballos, Lt. Colonel Ignacio Mascaró, Colonel Isidoro Linares, and Licenciado Nicolás Alonso de Andrade.[33] No doubt the ecclesiastical and governmental connections this group possessed gave them easier access to the resources and credit needed to operate sugar haciendas.

Not only did San Juan's economy benefit from the profits of the early expansion of the sugar trade, but the city also became an important distribu-

An Overview 17

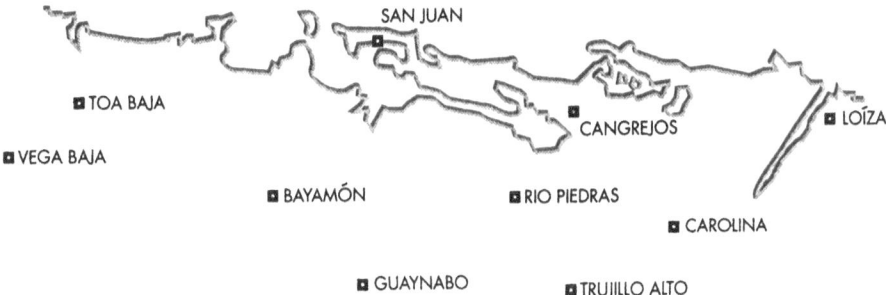

1.2. San Juan and Its Hinterland.

tion center for slaves. Although a considerable number of freed blacks, peasants, and former convicts lived within the city's hinterland, more labor was needed to operate the sugar haciendas, which needed the disciplined, controlled, and steady labor that could be guaranteed only by slavery. As a result, the number of slaves entering San Juan increased dramatically from the late eighteenth century onward.[34] Later in the nineteenth century, when sugar production moved to the south and west, the flow of slaves followed the expansion of the new sugar haciendas.

San Juan's merchants controlled a significant volume of Puerto Rico's slave imports, at least until the late 1830s.[35] Even as the northeastern region fell behind Ponce, Guayama, and Mayaguez in terms of sugar production, San Juan remained an important location in the slave import market. The commercial contacts established since the late eighteenth century, as well as the continued importance of San Juan's port, had made it possible for city merchants to remain active in the slave trade, even when sugar production moved to other areas in Puerto Rico. Around midcentury, San Juan began exporting slaves not only to the other municipalities in the island but also to places like Cuba, where sugar *hacendados* were willing to pay top prices for them.

During the eighteenth and nineteenth centuries, San Juan's economy was further stimulated by the military's efforts to finish the protective wall around the city and upgrade the city's existing military installations. During the eighteenth century, the fear of an invasion by competing European powers had led Spain to invest considerable financial resources in securing the military invulnerability of San Juan. Most of the money employed in the city's military construction came from New Spain's silver supplies. The construction boom attracted laborers and artisans to the city, although a considerable amount of the construction work was done by penal labor transported from Spain.[36] Even when the island experienced demographic growth in the eigh-

teenth century, Spanish officials wanted to secure additional laborers for military construction (table 1.1). The increased presence of laborers, artisans, prisoners, and military personnel in the city translated into more economic opportunity for women. The expansion in economic activity, with its related demographic growth, increased the demand for domestic services, such as cooking, washing, cleaning, and sewing.

Although there are no specific data about the eighteenth-century experiences of *sanjuaneras* involved in domestic work, the census data indicate the growing presence of women—particularly women of color—in the city. A majority of the city's population during the late eighteenth century were women. Considering that the expanding economic opportunities available to women were limited to certain occupations, it is safe to assume that many of the women in the city (particularly women of color) were involved in some kind of domestic work. The city provided an economic outlet for women who could easily find employment in the difficult chores of the domestic economy. The same significant movement of women to central urban areas, attracted by the expansion in domestic employment, has been documented in other Latin American cities in the nineteenth century, such as Buenos Aires and Mexico City.[37]

Table 1.1. Puerto Rico's Population: Eighteenth and Nineteenth Centuries (Selected Years)

Year	Population
1765	44,883
1783	87,994
1797	138,758
1800	155,426
1802	163,192
1815	220,892
1820	230,622
1827	302,672
1832	330,051
1846	447,914
1854	492,452
1860	583,308
1872	617,328

Source: Dietz, *Economic History of Puerto Rico*, table 1.6, 31.

The movement of goods and people between San Juan and its hinterland was an important part of the city's life during the eighteenth and nineteenth centuries. The city's hinterland provided many of the products consumed by San Juan's residents. San Juan had very little actual agricultural production, cattle raising, fishing, or manufacturing; its dependence on the world outside its walls for food and supplies had been one of the city's characteristics since the seventeenth century.[38] Although the focus of this study is on life within the city walls, one cannot fully understand the economic and social dynamics affecting San Juan without examining, at least briefly, the city's relationship with its hinterland.

San Juan's hinterland produced many of the foodstuffs consumed in the city. The *estancias* in Loíza, Trujillo, Río Piedras, Guaynabo, Bayamón, Toa Baja, Toa Alta, Palo Seco, Cataño, and Cangrejos all produced goods for the residents behind the city's walls (see map 1.2). Iñigo Abbad mentions that free people of color cultivated yams, yucca, beans, and rice in Cangrejos and Hato Rey to sell in San Juan's market.[39] Many of the residents in the extramural barrio of Puerta de Tierra, for example, were *labradores* or *jornaleros* (agricultural laborers).[40] Women were active in carrying and selling many of the goods produced in the extramural barrios into the city's streets and markets. Sometimes *revendones* from the city ventured into the hinterland or into the extramural barrios in order to purchase foodstuffs and then sold them at a lower price than retailers. As I will show later in this chapter, this practice was condemned by San Juan's merchants and by the city council throughout the century. The areas of Puerta de Tierra, Cangrejos, and La Marina also had communities of fishermen who practiced their trade in San Juan's bay and in its nearby rivers and mangroves.[41] The fish corrals established in these areas paid a license fee to San Juan's town council, which also sponsored a fish market in the La Marina barrio.[42]

Charcoal and wood, too, were brought from the extramural barrios into San Juan. Most of those supplying charcoal to the city were poor people of color. Claiming to have these people's interests at heart, the town council rejected a petition by Don Juan Berenguer to open a charcoal depot in the city.[43] The town council argued that the depot would have left jobless many of those who carried charcoal into the city. But the *cabildo*'s real fear was decreasing the toll revenues derived from the Martin Peña Bridge, which most charcoal suppliers crossed to bring their goods into the city from Cangrejos and Río Piedras. La Carbonera was a tiny island, right next to Puerta de Tierra's shoreline, where vegetable charcoal was prepared and sent into the city to supply San Juan's fuel and cooking needs.[44]

The *estancias* provided supplies for the large slave population that worked

on the sugar plantations surrounding San Juan. Many of the owners of these *estancias* and sugar plantations lived in the city. Edward B. Emerson spent quite a number of days visiting the city's hinterland and the sugar estates of foreign planters like Sidney Mason, Mr. Hoop, Mr. Grant, Mr. McCormick, Mr. Watlington, and Mr. Storer.[45] Many of these planters resided in the city. It was not uncommon, for example, for members of the town council to excuse themselves from meetings because they were out of the city visiting their haciendas.[46] A midcentury survey of the holdings of some of the most important merchants in San Juan showed that they owned many sugar estates around the city's hinterland.[47] Among the *sociedades mercantiles* in San Juan which owned sugar haciendas were Latimer y Cia., Sobrinos de Ezquiaga, José María Caracena, B. Borrás y Hnos., and Barreras y Castillo. Clearly, the city's wealth and commerce depended heavily on the fortunes of its agricultural hinterland.

After benefiting from an early jump start in the local race for control of sugar exports, San Juan, by the third decade of the nineteenth century, had ceded its primacy as the most dynamic center of the island's economy to the coastal municipalities of Guayama, Ponce, and Mayaguez. Puerto Rican sugar producers experienced their best economic years during the 1830s and 1840s.[48] Yet, although other municipalities experienced accelerated economic growth after 1820, San Juan's economy did not grow at the same pace. The competition from other ports caused San Juan to lose its supremacy as the island's top export center. Nevertheless, the city remained Puerto Rico's leading import center.

San Juan both benefited and suffered from the nineteenth-century economic cycles that Puerto Rico's export-oriented agriculture experienced. The city's economic life was also influenced by the changes in the Spanish and U.S. economies, especially those of the New England and New York regions. During the 1820s, for example, fiscal problems in Spain affected San Juan's resident colonial and military bureaucracies. The emerging trend of depreciating agricultural prices (particularly for sugar), which started around 1835, continued to haunt Puerto Rican producers until the late 1860s.[49] The intermittent boom and bust cycles associated with agricultural export production affected the merchants in San Juan, particularly in the period between 1840 and 1870. These were not easy decades for *sanjuaneros(as)*.

Particularly difficult for San Juan's residents was the period between 1840 and 1868. The 1840s was a rough decade for most Puerto Rican *hacendados* and merchants. Throughout this decade, severe droughts affected agricultural output, a shortage (and concomitant price increase) of slave labor provoked panic, and sugar prices experienced record lows. The effects of these agricultural problems were immediately felt in urban areas. The topics of

vagrancy, petty crime, and inadequate water supplies often occupied the discussions of San Juan's *cabildo*. Between the late 1840s and the 1850s, municipal employees started to demand salary increases to fight the escalating cost of living. Teachers asked for salary increases in 1846; the city architect and doctors asked for and got raises in 1856.[50] During the 1850s San Juan's economy was crippled by more droughts, a recession, and the cholera epidemic. The 1860s did not prove to be a better decade, as the colony's structural economic problems continued. As a result of an international financial crisis, 1867 and 1868 proved to be catastrophic for the city, with further devastation caused by a strong hurricane and by a series of earthquakes and tremors.[51] By the end of the decade, the city's economy was in serious need of rebuilding.

The general economic malaise that San Juan suffered between the 1840s and the 1870s had repercussions on the city's real estate. The difficulties in collecting rent were an indication not only of the tight housing market but also of the overall decline experienced by the city's economy during the period. The governor, the town council, and other colonial authorities received complaints from landlords about the difficulties in collecting rent and, in cases of renter delinquency, evicting tenants. Local property owners and members of the city elite knew that new rental laws had been enacted in Spain in 1842. Landlords in San Juan were desperate for new regulations that would allow them to be tough on delinquent renters, to facilitate eviction and collection, and to be able to further subdivide their units in order to maximize profits.[52] The Spanish authorities saw in these petitions an opportunity to drive from the city many of its poor and colored people, who would not be able to afford the high rents the new regulations would create. The government offered to transfer poor people to Puerta de Tierra and Cangrejos. In these extramural barrios, the poor and colored would still be close enough to the city to provide cheap labor but far enough not to create any trouble.

In 1860 the Spanish government in San Juan finally agreed to apply Madrid's housing and rental laws to the city.[53] San Juan's landlords had gained a small victory in their quest for altering the urban texture of the city, but they still faced an uphill battle against military and colonial bureaucrats opposed to any major urban changes in San Juan. Writing in 1880, playwright Alejandro Tapia y Rivera echoed the frustration of city residents regarding the lack of flexibility of military authorities to eliminate part of the city walls to allow commercial and real estate expansion.[54]

The difficulty in collecting rent payments must have increased as the century advanced, especially after midcentury. The capital crunch that affected the island's economy was also heavily felt in San Juan. Lack of currency made payment difficult, and *obligaciones*—an agreement to pay at a later date—

became more common. Sometimes these *obligaciones* would be passed, instead of cash, from one creditor to another. The lack of currency and the economic crisis also gave special meaning to conciliation and verbal trials related to rent payment and evictions. Promises of future payment and the creation of payment schedules began to emerge as acceptable, if painful, solutions to cash-starved landlords and landladies.

Notwithstanding all the ills that plagued San Juan's economy in the period between 1820 and 1870, the city did manage to maintain a sizeable level of economic activity.[55] San Juan's economic life was dominated during that period by commerce (particularly reexporting goods from Costa Firme to Spain), construction, real estate, and the feeding and housing of the state and military bureaucracies. All these activities, plus the continuous efforts by the Spanish authorities to centralize political and economic power in San Juan, kept the city's economy afloat during most of the mid– and late nineteenth century.

Class and Social Structure in Nineteenth-Century San Juan

Very little is known about San Juan's nineteenth-century class and social structure. Part of the difficulty comes from the lack of detailed studies about the city's nineteenth-century economy. More than one author has argued that it is impossible to know, at this stage, anything certain about San Juan's class and social structure.[56] Others have gathered information on post-1860s trends and hypothesized about antecedent structures.[57] I have provided here a preliminary outline of San Juan's class and social structure between 1800 and 1860. This outline emerges from my research on the city's economic life combined with the findings of the Latin American urban literature and of studies of Puerto Rican urban centers like Ponce and Arecibo.[58]

There was clearly an upper class in San Juan through most of the nineteenth century. Merchants and sugar planters occupied the highest economic strata in the city's socioeconomic structure.[59] High-ranking members of the colonial and ecclesiastical government were also part of the upper class and usually were owners or co-owners of haciendas and warehouses. Most of the members of San Juan's upper class were white. Spaniards held almost all of the key military, civilian, and religious positions in the city; they were also dominant among the merchant group. Creoles and other immigrants from St. Thomas, the United States, and France made up the rest of the planter and merchant class.[60]

The city then had a small middle strata of storekeepers (*pulperos* and *bodegueros*), shop owners and retailers (bakers, tailors, and pastry-makers),

master artisans, professionals (lawyers, scribes, civil servants, doctors, and teachers), and lower-level bureaucrats and military personnel. This middle stratum, which was traditionally very small in most Latin American colonial cities, was particularly small in nineteenth-century San Juan due to the city's size and relative lack of economic development. The city's middle sectors, as well as the lower strata, were all divided by a hierarchy of occupational status and ethnic and racial classifications.[61] Professionals and mid-level merchants, for example, had a higher standing than artisans.

Martínez Vergne has suggested that an urban bourgeoisie arose throughout the mid–nineteenth century. This bourgeoisie had attained its economic and social power through education and was less dependent on commerce, agriculture, inheritances, marital alliances, or family ties for its livelihood.[62] Professionals were among the most important members of this group; they had to negotiate economic power with the older commercial and agricultural elite. This group grew in importance and prestige in San Juan during the last third of the nineteenth century.

Finally, San Juan's lower class was composed of apprentices, domestics, street peddlers (*quincalleros* and *revendones*), food retailers (*fonderos* and *mondogueras*), unskilled laborers, *jornaleros,* and slaves. Apprentices and younger artisans probably were at the top of this lower class. The precariousness of economic life in nineteenth-century San Juan also made the divisions among the lower class rather fluid. Yesterday's street vendor could become today's *jornalera* or tomorrow's domestic. Slaves were obviously at the bottom of the socioeconomic status scale. Still, the nature of the urban economy provided slaves with opportunities for self-purchase, renting oneself to other masters, and autonomy seldom experienced by slaves on the plantations. As with the upper classes, race, ethnicity, and *condición* all played a crucial role in determining one's position among the lower tiers of San Juan's class and social structure.

Building the Modern, Safe, and Respectable City, 1800–1860

The Spanish government and San Juan's elite had launched a modest but decisive modernization drive in the early nineteenth century. The goals of this drive were to bring the city of San Juan to the level of architectural beauty, hygiene, culture, economic efficiency, morality, material progress, and safety experienced in many other American and European urban centers.[63] One missing element in the vision of modernity shared by the Spanish government, the Catholic Church, and some sectors of the local elite was political participation. As the century advanced, alternate visions of modernity—in

politics, religion, economics, and cultural life—were proposed by competing sectors of the local elite and the emerging middle professional class. Yet, the political and anti-colonial elements of alternative liberal aspirations were avoided in Puerto Rico, for the most part, until the very end of the nineteenth century.

The desire for modernization and progress was only exacerbated by the financial bonanza caused by the development of sugar cane cultivation and sugar manufacturing on the island during the first three decades of the century. San Juan was the first urban center to reap the early benefits of Puerto Rico's nineteenth-century bonanza. The need for order and safety was also tied to the modernizing agenda and was connected to the need to maintain a reliable and docile labor force on the plantations. In San Juan, order was required to guarantee the work of the domestics and artisans who were the backbone of the urban economy. Most of these workers were slaves or free people of color.

With the fall of sugar prices and increased competition in the late 1830s, the island's, and San Juan's, economy received a major jolt. The economic depression experienced in San Juan from the late 1830s until the 1870s had important and contradictory consequences for those who had progressive dreams for modernizing the city. First, the capacity of the Spanish government to deliver services, construct new buildings, and sponsor other projects promised or considered vital for developing the city was hampered by financial constraints. Second, the financial difficulties, themselves, accentuated the need for reform and change in the Spanish colonial system. This, I believe, only made more desperate the uneven attempts by Spanish officials and elite members to consolidate the projects and the systems they believed a modern, progressive, nineteenth-century capital city should have. Furthermore, by midcentury the local Catholic Church, after decades of financial difficulties and ultraconservative leadership, initiated the recovery of some of the ground lost in the first half of the century.[64] The church proposed another vision for the city and for the colony, one that also relied on notions of order, hierarchy, morality, and respectability but which ran counter to the secular drive of the local elite and of the Spanish colonial government. The church focused its attention on family life and marriage and looked for women's support in its efforts.

I want to trace some of the modernizing ideas, language, and rhetoric employed by colonial officials, ecclesiastical leaders, and elite members in San Juan beginning in the 1830s. My main source will be the minutes from the town council meetings where the local elite and Spanish colonial officials converged to advocate and implement their vision of what San Juan should be like in the future. I will also analyze the church's perception of what a

modern San Juan should be like by looking at the *Boletín Eclesiástico*, which became the church's propaganda mechanism in the late 1850s, and at other sermons and circulars. *Cabildo* and church records cover most of the complementary and conflictive issues affecting San Juan during the mid–nineteenth century.[65]

San Juan's town council minutes provide a good example of the vision and the language of modernization, order, safety, and respectability employed by the city elites between the 1830s and the 1860s. The *cabildo* in San Juan was dominated by members of the commercial and agricultural elite.[66] If granting land titles to build homes, regulating prices, allocating slave imports, controlling prices, and distributing licenses among members had kept the *cabildo* busy previously, by the third decade of the nineteenth century some of the items on their agenda had changed. Issues of public hygiene, infrastructure, demographic and fiscal statistics, public safety, urban renewal, public landscaping, and recreational space development came to dominate San Juan's town council meetings.

In 1824, for example, *cabildo* members complained to the governor about the poor condition of the roads connecting San Juan with its hinterland. They also responded to the governor's initiative to form a fire-fighting unit by proposing legislation limiting the construction of wooden huts (*bohíos*) inside the city and asking current owners to destroy existing ones within twenty days.[67] *Cabildo* members were particularly concerned about the huts in the Ballajá barrio. Ballajá was a prime location for public buildings and the *bohíos* in Ballajá were considered fire hazards. Business and hygienic concerns were on the *cabildo* members' agenda in 1829. In that year, the *cabildo* unveiled a new plan for a sewage system in San Juan and called for remodeling or relocating the main market, given the unsanitary conditions of the present site.[68] The town council also discussed the threat to public safety and order which street sellers—particularly *revendones*—posed to the city. Many of these street sellers were slaves, probably a majority of them women, who went outside the city walls to buy agricultural products that they would later sell inside the city for a cheaper price than the regular merchants charged. Since most of these *revendones* did not have vending permits, merchants considered them unfair competitors who operated outside the law.[69] *Cabildo* officials were also concerned about the mobility and flexibility that "suspicious" colored vendors had.

The town council had a busy year in 1836. One of the pressing concerns that year was labeling and numbering all houses, streets, and city blocks. This was common practice, according to one *cabildo* member, "in all civilized countries," not only because it made finding addresses easier but also because it facilitated the maintenance of demographic and tax statistics.[70] In

that same year, San Juan's town council also decided to fine street sellers, whom they charged were nothing but vagrants, chastised slave owners for allowing their slaves to rent themselves for the day to other people, allocated 100 pesos for a new girls' school directed by Doña Ambrosia Martinez, and repeated calls for prosecuting those who grew livestock and pigs inside the city.[71] Again, public safety, hygiene, racial fear, labor control, and trade were all mixed into the policies that the *cabildo* tried to get implemented in mid-nineteenth-century San Juan.

In the 1840s the *cabildo* began to deal more directly with all the plans to build some kind of beneficence establishment—which eventually led to the construction of the Casa de Beneficencia. At the same time, they became more aggressive in their attempts to "kick immoral people out of the city" by deportation or exile. In 1840 four women were deported because of unruly and immoral behavior that, in the *cabildo*'s opinion, caused the ruin of many otherwise honest men.[72] In 1847, the town council discussed the problem that beggars and vagrants were causing in San Juan. *Cabildo* members made a distinction between those who were beggars out of necessity and those who begged out of laziness.[73] The immediate enforcement of the laws against vagrancy and concubinage were the *cabildo*'s prescription for the problem.

Also in the 1840s, supplying the city with fresh water became a pressing issue for the town council. Of course, since water wells and cisterns were public spaces where poor and colored people gathered to work, it became important to police those areas and prevent them from becoming security risks and eyesores for the city. It is interesting that a critique of *revendones* in this decade adds a new rationale for their prosecution: the poor condition of their stalls, "of such ugly appearance in such a public and visited place, gives a very sad idea about the level of civilization of our country."[74] The *cabildo* also called for the renovation of a water well just outside one of the city gates leading to the La Marina barrio. The renovation was to take into account not only the practical need for water but also the desire to improve the look of one of the most important entry points into San Juan.[75] Other infrastructure projects were proposed in the 1840s, such as a new marketplace and several new hospitals.[76]

The *cabildo* began to face the city's serious housing shortage and its consequences in the late 1840s and early 1850s. Again and again, town council members tied the urban problems challenging their city to a general sense of modernization, progress, and well-being that many other urban centers were attaining. As early as 1849, for example, the *cabildo* considered "demoralizing" the fact that tenants were not paying their rent and that owners did not have the means to evict them. "Demoralizing, unsafe, and unhealthy" is how *cabildo* member Don Rosendo Marcos de la Vega described the housing short-

age in San Juan in 1862.[77] San Juan's housing crisis created a sad spectacle of poverty and immorality. Another *cabildo* member described the situation in these terms: "There is a general lack of morality among most of the house tenants in this city, since they neither pay their respective rents, nor are the landlords able in any way to evict them."[78] The housing shortage was also linked by the town council to the growth of poverty in San Juan. According to one town council member, the lack of adequate housing was the reason why "many naked or poorly dressed children accompanied by their poor and miserable mothers get out from their lugubrious dwellings to breathe fresh air in their porches."[79] To remedy some of the city's housing problems, council members urged the Spanish authorities to study the housing laws in Madrid and the local conditions of the San Juan housing market. The *cabildo* also wanted to receive information on all the latest urbanistic legislation in Madrid and other Spanish cities to see what changes could be applied to San Juan and to develop new housing guidelines for the city.[80]

Throughout the 1840s, 1850s, and 1860s, *cabildo* members pushed for their vision of what the needs of San Juan were. The coliseum needed to be restored and expanded "with the corresponding luxury and beauty in accordance with the civility and national spirit of the inhabitants of this city."[81] The need for a new marketplace, therefore, was justified not only to promote sagging sales in the city but also to eradicate the "foci of infection" that the old marketplace had become. The new marketplace needed to be in a ventilated locality.[82] The area outside the city walls also needed to be beautified both for hygienic and esthetic reasons. *Cabildo* officials hoped to make the area one of promenades and passive outdoor recreation.[83] They were also very aware of San Juan's ranking among other European, American, and Puerto Rican urban centers. In 1862 town council officials rejected a motion to allow city residents to get rid of their raw sewage by throwing it into the streets at night. Although they conceded that the move posed an easy solution to a difficult problem, it was considered an unacceptable option because "in towns of lesser importance this solution has been considered repugnant."[84]

The *cabildo* ended up supporting the removal of part of the city's walls in order to accommodate some of San Juan's housing and commercial needs. The *cabildo* reached this conclusion as early as 1865.[85] The opposition to this idea came from the military authorities, who feared jeopardizing San Juan's military effectiveness if the defensive system was altered. As San Juan faced one of its most difficult financial times in the 1860s, the town council addressed such issues as the commercial revitalization of the city, solving the city's housing crisis, finding funds and land for new government construction, and securing an adequate supply of domestic laborers for San Juan in case the abolitionist crusade became successful.

The Catholic Church also pursued a modernizing agenda for the city. The church's vision concentrated on developing a "family" discourse to be promoted in the late nineteenth century. During this period, interest in the family became more central to the hegemonic aspirations of both church and state. The anticoncubinage campaign, which will be discussed in more detail in chapter 4, was one front in the battle to direct Catholic families into a more orthodox way of life. Obviously, changes in the way the church defined family implied that women's roles and position in society would be affected.

The flagship in the church's efforts to disseminate and impose its vision of family on the second half of the century was the *Boletín Eclesiástico*. The *Boletín* was created in 1859 partly because the church could not rely anymore just on preaching and on the personal influence of priests to carry out its evangelical mission. As the church tried to regain its former ground, it needed new tools to compete with the ideologies of liberalism, individualism, and modernization. Also, as education improved slowly, the printed press became a more effective method of reaching elite and middle sectors of the population. The *Boletín* also served as a centralizing agent, where the clergy and the faithful could be kept informed, first-hand, of the hierarchy's latest concerns.[86] The church's position on family life was also articulated in the bishop's pastoral letters, which were then made available to the faithful by the parish priests. Unfortunately, San Juan's diocesan archive does not have many of those letters, making the *Boletín* an indispensable source of information.

After the church's attempts to eradicate the concubinage problem and to strengthen the sacrament of marriage, which receded during the mid-1860s, the Catholic hierarchy began to pay closer attention to the family institution per se. The new attention to the family responded to various motives. First, economic and political changes were altering the status and power of the male heads of households and placing more emphasis on the education, development, and growth of both children and women.[87] The patriarchal family, with its focus on the *pater familias*, became more inclusive, if still fundamentally hierarchical. Growing interest in the education of children and in the participation of women as role models (as either teachers or mothers) forced the church to be active in attempting to influence these two groups. Second, the church responded to the growing interest in the individual with an accentuation of community values, making the family unit the primordial cell of the community structure. Finally, the church linked the survival and well-being of society in general to family life, claiming the family as its locus of action and influence and, thereby, justifying to the state and to civil society its participation in the public arena.

The church's new attempts at defining family within a Catholic frame-

work began in the early 1860s. In a straightforward article, *"Deberes de los padres de familia"* (Duties of parents), published in the *Boletín* in 1862, the church stated its organic view of society based on the family unit. "Civil society rests upon the domestic society," stated the author, and the key to molding good citizens was the example provided by parents within the domestic household.[88] Although the article used the gender-neutral terms *jefe* (chief) and *padres* (parents), it was clearly aimed at male heads of households. Not once were mothers mentioned. The writer highlighted that the state's fortunes were intimately tied to family life: "It can be seen that the public good is identified with the most intimate relationships of the family."[89] The Catholic Church was sending a two-tiered message to civil society. On the one hand, the church claimed the family arena as one where its influence was guaranteed and beneficial, based on a spiritual argument. On the other hand, the church was telling the state that it was in the state's best interest—for the sake of the public good, morality, and safety—to allow the church to influence family affairs. The article continued to illustrate the potential criminal and rebellious path that children who were not properly nurtured and guided by their parents often took. Parents who did not educate their children well acted contrary to the will of society, nature, and ultimately God. The church was naturalizing the specifics of its family life doctrine within the rhetoric of the public good, order, and safety.

The church's vision of the role women should play within the family was quickly addressed by a series of articles in the *Boletín*. Prior to the publication of the article on fathers' duties, the *Boletín* published one that described the two role models Catholic women could aspire to: Mary or Eve. The church's belief in women's subordination to men in family matters was present in the article, although it argued that women exercised a great degree of influence over men's decisions. "In every great enterprise, a woman intervenes," claimed the author, stressing the importance the church would be giving to women from that moment on.[90] The church continued its attempts to recapture its past status and to become an influential force in Puerto Rican society again by asking women to join them, thus recognizing the influence women could have in society. Still, women were to have a subordinate role, always one of either support or detriment: "Women, located on men's side, always . . . strengthen or weaken them."[91]

If Eve's legacy had left women with an undignified stigma within the church, the tendency in the nineteenth century was to present another alternative to that legacy. The impulse given to Marian devotions and activities was part of the campaign to re-vindicate the image and role of women in society.[92] Associations like the *Hijas de María* served that purpose. The *Hijas de María*, a group that was particularly popular with Bishop Carrión, was a religious or-

ganization for single girls and adolescents. One could join the group after the first communion and would leave upon getting married. Using Mary as their guideline and their spiritual mentor, the goal of the *Hijas* was to promote models of virtue and piety, which would serve in the regeneration and moralization of Puerto Rican society.[93] Among the continuing requirements for group membership were to lead a pure and exemplary life, to attend confession and receive communion the first Sunday of each month, and to attend all of the religious festivities associated with the Virgin Mary. The group stressed Mary's intercessional spirituality and also deference to the church's hierarchy.

The role of women as nurturers, supporters, and intermediaries for men continued to be stressed in subsequent editions of the *Boletín*. Following instructions from Rome and the particular devotions of Bishop Carrión, the *Boletín* began a campaign in 1864 destined to promote the cult and worship of the Virgin Mary.[94] Part of the campaign included a special celebration on the day of the Immaculate Conception—Puerto Rico's patron virgin—and an increased effort to promote the activities programmed for Mary's month, May. Mary, "that beautiful and interesting model," was to provide women with a paradigm on how to use their "soft power" to benefit their families and, thus, society.[95] The church believed that women had the capacity to help regenerate society, through the family, in much the same way that Mary had regenerated women from the sinful lot that was Eve's legacy. Mary was the mediator, the one who could "take the sinful man by his hand" and take him closer to God, because "through her the most sinful man can be saved."[96]

If the *Boletín*'s metaphorical language failed to make alert readers aware of the mission the church had designed for women, priests made that connection clear in their preaching. A sermon entitled *"Deberes de los esposos"* (The duties of spouses), dated 1865, made the link between family, society, and women more clearly. The sermon's first lines precisely address this point:

> Women are an element of the highest importance in society. God has wanted to give her irresistible influence over man, whom she can conduct efficiently to the good in any of her three principal conditions: virgin, wife, and mother. Maybe since she was the cause of man's ruin, Providence has disposed that she also be his salvation. This is her mission, not only out of honor and grandeur, but also out of rigorous justice. [She] owes man a reparation, and God demands it perfect and complete. Oh, a thousand times happy is the woman who understands this mission and carries it out for the benefit of society as a whole.[97]

Women's role or mission was to be subordinated to men—a subordination that came from being the serpent's accomplice in the Garden of Eden—and

her greatest possible contribution to society was to help men realize their potential. Women were vital to society insofar as they were vital to men.

Women's subordination to men as heads of the family, in the Pauline tradition, was also encouraged: "if he is the head, she is the body, and if the head orders the body, it does not cause pain but, on the contrary, helps its well-being."[98] The submission of women was slightly nuanced by the priests' invitation to men to become women's "companions and friends" and to treat them with "nobility and consideration." Because women played such a crucial role within the family, even when subordinated to men, they were "the most important pillar of the conjugal edifice, the soul of the family, the center of the circle."[99] Women were the center because the day-to-day operation of the family depended on them and because even the family's head needed her support and sustenance in order to perform efficiently.

According to the church's teachings, women had two vital life paths to follow: virginity (associated mostly with religious life) or motherhood (in matrimony). When they joined men on the second path, women entered into another project of immense importance for society: family life. Marriage "is the primitive society, the beginning society, the type society, and, I dare add, the regulating society of the political society . . . This conjugal society is formed by just one man and just one woman and, like any society, has laws which point out the duties of the associates and whose observance permits their happiness."[100] The association of women and men to form a family was the basis for civil or political society. The church, having instituted marriage as a sacrament, had the responsibility to oversee, regulate, and guide family life.

The family was a consequential group also because it had the responsibility of continuing society through reproduction. The church clearly stated that "the goal of marriage must be the fecundity which would allow [the parents] to see their children's children."[101] Reproduction was not marriage's prime directive just because it allowed society to perpetuate itself. Reproduction within a Catholic marriage was also intended to multiply the faithful. The church "considers itself happy when Christian parents give them brave and numerous soldiers, gloriously equipped with the arms of Jesus Christ," because one of the most important responsibilities of the family was to socialize their children to become good Catholics.[102] The importance of abundant new "soldiers" for a church that had been under attack in Spain for the previous half century must not be underestimated. Since the Puerto Rican church wanted to revitalize its role in society, it was counting on a group of young faithful ready to defend their church and to increase its influence over civil society.

The church declared that the family was the source of stability and morality in society. Stability was an important concern, mainly because the church knew that invoking stability and order was the best way to attract the state's and the elite's attention, especially in the tumultuous 1860s. In their families, children were taught to be virtuous and obedient, qualities that would make them good citizens. According to the church, society's greatness was related more to the fate of the family than to any other factor. The sermon's author concluded: "Do not doubt this—the greatness, prosperity, and progress of society does not consist in the development of commerce, or in the expansion of its agriculture or the arts, or in the wealth of material riches, but on its morality, and its morality is in the family."[103] The author was making reference not only to liberal nineteenth-century parameters that defined prosperity and progress but also to the fact that Puerto Rico had been experiencing some of these developments throughout the nineteenth century. The family was firmly located at the center of the church's crusade to influence and participate in civil society. Within this crusade, and within the family, women had been assigned their role by the church's hierarchy.

The church knew that some of its views regarding the family and the direction in which it wanted to steer the family might become objectionable to the state and to liberal sectors among the elite and professionals. Although the ideal of the family's basic building block—hierarchy and obedience—was probably shared by both church and state officials, the ways to reach that common objective might not have been shared. The church attempted to exercise its claim at participating in civil society by arguing that a religious foundation for public education was the state's best bet for order and tradition. Issues like antinationalism, traditionalism, and antiliberalism had cemented ties between the church and the colonial state in Puerto Rico since the beginning of the century, at a time when church-state relations were tense in Spain and other countries.[104] The church issued a warning to those who celebrated the triumphs of secular elementary and primary education: "The enthusiasts will rejoice because it is a triumph over ignorance; they will congratulate the people on being initiated in human knowledge. And I fear that by virtue of being more instructed, [the people] might become more vain, more unruly, more interested in ill-fated novelties, more unhappy with their own condition, jealous of superior positions, more at odds with difficult jobs."[105] The church's warning was directed particularly to the more traditional sectors of society at odds with the changes occurring in the colony after midcentury. It makes reference to the discipline needed for "difficult jobs" at a juncture where the imminent abolition of slavery had many among the elite worried about finding abundant, reliable, and cheap labor. In a co-

lonial society where chaos and anarchy had been the foundational fears of the metropolitan state and its allies, the prediction that, if public instruction was not religious, "the universe will enter again into confusion and into chaos," probably struck a nerve with the local elite and colonial officials.[106] This was specially true in San Juan, which housed such a disproportionate number of members of the Spanish military and bureaucratic establishment.

One final, interesting feature of the articles promoting the cult of Mary and the importance of religious values in public education was the centrality they gave to San Juan. In one of the articles stimulating more devotional fervor for Mary's cult, the author calls for the dissemination of Marianism "from this Capital . . . into many other towns in our Island," although one would expect that religious devotions would have been more rooted in the island's countryside than in the urban centers.[107] The article is more indicative of the church's hierarchical view of society than of the actual strengths of Marian devotions on the island. The previously mentioned article on religious values as the foundation for public education warned that the increase in literacy had led many individuals of the lower classes to read materials that incited anarchy and rebellion. The writer warns that such things occurred in San Juan and that "what is practiced in the capitals will soon find imitators in the countryside."[108] The fear of widespread social and political upheaval led to the elitist premise that liberals in the urban centers would infect or pollute the more traditional people of the countryside with their incendiary ideas. This made San Juan a focal point in the Catholic Church's strategy to reinvigorate its influence over Puerto Rican society in the second half of the nineteenth century.

Puerto Rico, 1860s–1870s

By the late 1860s, the period in which this book ends, Puerto Rico was making a transition to a full agrarian, capitalist economy. Beginning in the late eighteenth century and throughout the first two-thirds of the nineteenth century, the island depended on slave-based production in order to enter and compete in the world's sugar export economy.[109] Coexisting with the slave-based sugar production was an extensive countryside still operating under the premises of subsistence agriculture.[110] These two production arrangements were already in crisis as early as the 1840s, as exemplified by the coercive *Bando de Jornaleros* (1847) and its attempts at guaranteeing a steady supply of laborers. In the 1870s slave-based production gave way to a free-labor market, as slavery was limited by the Moret Law (1870) and then abolished in 1873.[111] In this same decade, a significant rise in the cultivation and pro-

cessing of coffee in the mountainous municipalities of the island's interior undermined the basis for subsistence agriculture in that region.[112] The old economic order and its forms of production, labor supply, land tenure, and participation in the world market were gradually passing away.

The economic transformation experienced by Puerto Rico was clearly intertwined with changing political and social alignments and arrangements. Spain and its colonies were never the same after 1868, when revolts against the Spanish crown occurred in Cuba, Puerto Rico, and the metropolis, itself. The participants in these revolts shared a desire for modernizing transformations in the economic, political, and social arenas.[113] In Puerto Rico's case, even though the attempted revolt at Lares was unsuccessful, the uprising clearly warned the Spanish colonial officials that the years of keeping islanders totally out of politics were over.[114] Although many on the island did not share the particular agenda of the Lares insurgents, many social groups did share the need for a revision of Puerto Rico's traditional sociopolitical hierarchy. For the members of the merchant and agricultural elite, political parties became a platform from which they could ventilate their mutual or antagonistic perspectives about the island's economic and political future.[115] The slaves were ready for the long-awaited abolition, which, when finally granted in 1873, created a group of *libertos* (freedmen) who had to negotiate their new identity—in a world of collapsing sugar prices and increased competition—with planters and colonial officials. Artisans, already showing signs of forming a class consciousness, were busy organizing their own cultural and social organizations and creating mutual-help funds.[116] Women were also in the process of creating new bonds of solidarity and consciousness, ready for an increased role in public life. Not only were they more active in literature and the arts, but, as the nineteenth century ended, they began to develop a network of associations throughout Puerto Rico's most important urban areas.[117] Beginning in the late 1860s, the Spanish colonial order in the island was clearly being challenged and contested as it had never been before.

Conclusion

Members of San Juan's elite, Spanish colonial officials, and the church's hierarchy all had visions of what kind of city they wanted to live in and to build for the future. While some views were shared by the three groups—control over the working classes, building strong church-sanctioned families, adding recreational spaces, improving hygiene and public safety, and reenergizing the city's commerce, among others—there were several areas of tension and conflict. The local elite, for example, was frustrated by Spain's inability to reinvigorate economic activity in the city and by the repercussions of finan-

cial stagnation in the delivery of services and in building a more modern civil, secure, and economic infrastructure. Liberal elite members and professionals wanted more political participation and the abolition of slavery on the island. The Catholic Church feared secular trends that were popular among the more liberal and moderate sectors of the Spanish government and the local elite. Each group pursued different strategies—the elite through the *cabildo* and through literature; the church through the *Boletín Eclesiástico*; and the government through urban renewal and legislation—to push its particular vision. And, although not the primary focus of this chapter, members of the working and lower classes also had their dreams and ideas of what a modern San Juan should be like.[118] The lack of historical sources, unfortunately, has not made it easy to recapture many of the elements of that counterhegemonic vision.

Women were central to the modernizing plans of the city and, thus, were one of the groups more directly affected by the attempts to create a modern San Juan. Women of color needed to be controlled for both their labor and their reproductive potential. Elite women were to be educated to be exemplary wives and teachers whose nurturing influences would smooth the rough edges of the budding capitalist system and of family life in an urban context.

San Juan changed significantly from the mid–eighteenth to the mid-nineteenth century. From a Spartan garrison, it transformed into a complex commercial hub facing the challenges posed by an increasing population desiring the benefits and improvements of contemporary urban centers in Europe and the Americas. One of the elements fueling this transformation was San Juan's evolving demography. The urban and economic policies enacted by the Spanish government and their repercussions on the demographic and residential landscape of San Juan are the subject of the next chapter.

2

San Juan: Space, Population, and Urban Setting

One of the most popular images associated with the city of San Juan has been the old Spanish fortifications, which today still attract thousands of local and international tourists. Indeed, Puerto Rico's historiography has also accentuated San Juan's Spanish—and thus white—makeup as one of the city's most characteristic traits.[1] If it is true that San Juan housed disproportionate numbers of Spanish-born people in both the sixteenth and the twentieth centuries, it is equally true that this was not the case in the late eighteenth and the nineteenth centuries. Demographically, the majority of the population in San Juan between 1750 and 1850 was composed of people of color and women. When and how in the nineteenth century San Juan was transformed into a whiter, more masculine, and more Spanish city are the central concerns of this chapter.

Demographic Change in San Juan, 1750–1862

Many of the changes San Juan experienced between the mid-1750s and the first half of the nineteenth century were a response to the demands of an increasing population. San Juan was not alone in facing dramatic demographic changes during that period; Puerto Rico experienced a significant population increase beginning in the mid–eighteenth century. This increase continued well into the nineteenth century (see table 2.1). Puerto Rico followed general Latin American and Caribbean demographic trends, as the region also saw dramatic increases in its population rates throughout the same period.[2] High birth rates, combined with periods of reduced mortality, have been credited with being the driving force behind the demographic changes in eighteenth-century Puerto Rico.[3] San Juan's population also rose quickly in the late eighteenth century, but it is not clear whether this increase was a consequence of higher birth rates, as was the case for most of the island. What is clear is that San Juan received a considerable number of immigrants during that period.[4] African slaves, Irish immigrants, prisoners brought to

work in military construction, and refugees from the Caribbean all contributed to the increase in the city's population. Women also moved into San Juan in search of the opportunities for domestic work and other urban occupations that the city provided.

Since San Juan was the only official port opened for trade with Spain, the city was the island's economic center during the late eighteenth and early nineteenth centuries. Through this port, sugar, coffee, and other agricultural staples produced by the city's hinterland were exported. In addition to San Juan's economic progress, the military construction boom experienced by the city in the late eighteenth century attracted immigrants, both voluntary and involuntary. Even though San Juan also experienced population growth during the first half of the nineteenth century, the city's rate of increase lagged behind the island's general pace. If compared, for instance, with the boom experienced by the towns of Mayaguez and Ponce, San Juan's population increase was much more modest.[5] San Juan started to face higher rates of population increase again in the second half of the century.

Around midcentury people began to move in large numbers to the area surrounding the city's walls. Starting in the 1830s and 1840s, those of San Juan's population who could not afford housing within the walled city moved to the belt of extramural barrios developing on the southeastern outskirts of the city walls.[6] The Spanish government encouraged and facilitated the growth of these extramural communities. Because of this movement, or displacement, the barrios of Puerta de Tierra and La Marina emerged, absorbing a

Table 2.1. San Juan's Population (Selected Years)

Year	Population	% of Growth
1776	6,605	—[a]
1783	6,462	—
1803	7,835	21.2
1816	8,907	13.6
1827	11,484	28.9
1845	13,000	13.2
1859	13,627	04.8
1865	17,930	31.5
1874	21,847	21.8

Sources: Sepúlveda Rivera. *San Juan*, table 6.6, 162; De Hostos, *Historia de San Juan*, 21; and AGPR, Colecciones Particulares, Colección Scarano, CP-3, September 19, 1803.

[a]Indicates no increase.

considerable number of San Juan's people of color and working-class background. Havana, by comparison, also experienced a significant explosion of extramural barrio formation throughout this period. Most of the demographic growth in Havana, after the first decades of the nineteenth century, was on the expanding extramural barrios of Prensa, El Cerro, and Vedado, among others.[7] As in San Juan's case, the majority of the population living in Havana's extramural neighborhoods were nonwhites. The extramural barrios around San Juan would also experience a dramatic increase in population in the last third of the century, when rural migration into the cities accelerated in Puerto Rico.

A longitudinal assessment of the general composition of San Juan's nineteenth-century population is difficult because most of the census data, when available, just provide population totals instead of individual entries. In several census or parish tallies, however, the population was tabulated along gender and racial lines (see tables 2.2 and 2.3). A quick survey of the available census totals for the last two decades of the eighteenth century shows that the most dynamic demographic sectors of San Juan's population were people of color and women.[8] In a sense, San Juan shared the general eighteenth-century demographic characteristics of the rest of the island, as documented in the chronicles of Iñigo Abbad and Pierre Ledrú.[9] At the beginning of the century, the city's population was still predominantly nonwhite and female.[10] The city's racial and gender composition from the mid–eighteenth to mid–nineteenth century was strikingly different from the standard portrayal of the city, in which the Spanish, white, and colonial elements have been accentuated. In a way, the racial mix that Spanish officials dreamed of having in San Juan (and finally achieved after the 1860s) has been ahistorically applied by scholars to describe the population residing in San Juan throughout the colonial period.

The 1828 figures in tables 2.2 and 2.3 show the continued demographic imbalance in favor of women and nonwhites in San Juan's population.[11] The census data from 1833 and 1846 confirm the persistence of these demographic trends. Yet, by the late 1860s, San Juan's demographic scenario had changed dramatically. For the first time, the city had more white than nonwhite inhabitants. This "whitening" trend seems to parallel developments in the rest of the island during the second half of the nineteenth century. The increase in the number of white people in Puerto Rico during this period has been linked to the poor health and unsanitary conditions faced by people of color in the island and to changes in migratory flows.[12] In the second half of the nineteenth century, more people from Spain, France, and other parts of Europe came to the island. Most of these immigrants were white.

Table 2.2. San Juan's Population by Sex (Selected Years)

Year	Male	Female	Total
1802	3,657 (47%)[a]	4,178 (53%)	7,835
1828	3,881 (41%)	5,581 (59%)	9,452
1859	6,552 (48%)	7,075 (52%)	13,627
1865	10,320 (58%)	7,610 (42%)	17,930
1867	11,229 (58%)	8,009 (42%)	19,238

Sources: Córdova, Memorias, vol. 2, 397; AGPR, Fondo Audiencia Territorial, S-Regencia, C-5, 9, 11; and AGPR, Colecciones Particulares, Colección Scarano, CP-3.
[a]Percentage of total population in parentheses.

Table 2.3. Population Totals for San Juan by Race (Selected Years)

Year	Whites	Blacks[a]	Pardos	Mulattoes	Morenos
1802	3,023	1,195	2,011	1,210[b]	396
1828	4,150	1,945	2,011	n.a.	1,160
1859	6,397	1,254	n.a.	5,502[c]	n.a.
1865	8,886	3,765[d]	n.a.	5,279[e]	n.a.
1867	10,634	2,423[f]	n.a.	6,181[g]	n.a.

Sources: AGPR, Colecciones Particulares, Colección Scarano, CP-3, September 19, 1803; Córdova, Memorias, vol. 2, 397; AGPR, FAT, S-Regencia, C-5, March 9, 1860; C-9, December 31, 1865; and C-11, December 1867.
[a]Unless otherwise stated, all blacks included under this column were slaves.
[b]These mulattoes were slaves.
[c]This number combines free mulattoes and blacks. The 1859 data also include 474 foreigners for whom no racial data are available.
[d]This number combines 855 black slaves with 2,910 free blacks.
[e]This figure combines 1,441 mulatto slaves with 3,838 free mulattoes.
[f]This number combines black and mulatto slaves.
[g]This figure combines free blacks and mulattoes.

Another important change in San Juan's demographic structure was that by the 1860s the city had more male than female residents. This trend started in the late 1850s, and by the end of the 1860s, San Juan had undergone fundamental changes in the nature of its population. These changes would play a decisive role in the history of the city in the second half of the nineteenth century, when San Juan faced the transition from free to slave labor and the growing socioeconomic inadequacies resulting from continued Spanish colonialism.

How did San Juan's whitening process occur? Among the factors that helped was the closing of the island's slave trade midway through the century. No more slave imports from Africa meant that the black population growth depended solely on an increase in natural reproduction rate.[13] Although it is still unclear whether the island's slave population was reproducing itself naturally by midcentury, Francisco Scarano's studies about the demographics of slavery have suggested that this could have been occurring.[14] If Scarano is correct, the demographic stabilization resulting from a naturally reproducing slave population would have added males to San Juan's slave population, because the demographic imbalance in the city worked against male slaves. Even if the end of the slave trade did not bring demographic balance to San Juan, any disruption in the supply of slaves to the city would disproportionately affect the number of female slaves in the city, since females were preferred by masters for domestic work. The end of the slave trade, long delayed and fought against in Puerto Rico and Cuba, had a significant impact on the number of people of color in San Juan, particularly women.

The cholera epidemic of 1855, and some of the other minor epidemics that plagued the city around midcentury, also affected San Juan's demographic profile. Although the total number of casualties is still debated, the cholera epidemic affected the island's nonwhite population more severely than it did the white population.[15] In San Juan's case the epidemic helped the demographic whitening. Of the 549 reported deaths, 437 (80 percent) were of people of color and the remaining 112 (20 percent) were white.[16] Among the people of color who died from the epidemic, 228 (52 percent) were women. If infected water was, indeed, a major transmitter of the disease, it should not be surprising that women of color in San Juan—whose domestic chores were centered frequently around water, wells, and cisterns—could have been disproportionately affected by the epidemic.

Besides the effects of the end of the slave trade and of epidemics on the number of women in the city, several other factors might also explain the change in sex ratios. First, as a result of the collapse of the sugar economy, many workers moved from the neighboring coastal municipalities into San Juan looking for jobs. If these migratory flows to urban areas had attracted

more women than men in the past, the decline in agricultural production in San Juan's hinterland altered things. Men who were previously tied—whether voluntarily or not—to agriculture could now move to urban areas for jobs. Women's potential to move into urban centers and find work was less dependent on the state of agriculture, since women's economic opportunities in the countryside were more limited than men's. The city attracted women who could provide domestic services to the growing urban bureaucracies. San Juan received many female migrants from its nearby municipalities, although some women probably moved to the city's extramural barrios and to the Santurce-Cangrejos area.[17] Nonetheless, as the nineteenth century advanced, San Juan seems to have attracted more men than women into its urban contours.

General Migratory Trends and Spanish Urban Policy in Early Nineteenth-Century San Juan

One factor which undoubtedly played an important role in the city's changing demographic structure was immigration, both voluntary and forced. As early as 1828, two powerful migratory waves were beginning to make an impact on the city. First, African slaves were arriving in record numbers to satisfy the labor needs of sugar plantations. San Juan served both as a port of entry for many of these slaves and as a slave distribution center for plantations on the northeastern side of the island. Although the majority of the slaves brought to Puerto Rico found their way into municipalities where sugar production was concentrated, a significant number of slaves were bought by *sanjuaneros(as)* for domestic chores.[18] The importance of domestic slavery in San Juan explains why women outnumbered men among the city's slave population. I will discuss in more detail the demographic aspects of slavery in San Juan in my analysis of the 1833 and 1846 census data.

The other significant migratory wave affecting San Juan, up until the middle of the nineteenth century, was composed of white immigrants. These were the refugees from the South American wars of independence, foreign planters who moved to the island after the *Cédula de Gracias* (1815) was decreed, and other Spaniards—Canary Islanders and Catalans, for the most part—who were encouraged by the Spanish crown to come to the island in order to increase the number of white people in Puerto Rico.[19] Women made up a large subgroup of the white and Spanish migrants, especially widows arriving from war-stricken South America.

Migration into San Juan was not the sole reason for the city's demographic changes in the nineteenth century. Spanish colonial policy also had important repercussions on the composition of San Juan's population. Since the 1840s, government officials had targeted the barrios with the highest con-

centrations of nonwhites and women for the expansion of the city's civil infrastructure.[20] Most of the new construction in San Juan was built in the barrios of Santa Bárbara, La Marina, and Ballajá. Echoing arguments made at the time of the construction of the Casa de Beneficencia in the early 1840s, the governor argued that one of the advantages of building the new barracks at Ballajá was "converting some miserable wood and palm huts, which form a repugnant ensemble, into a solid and majestic building that would beautify perhaps the most abandoned part of the city."[21] The governor also emphasized that the new construction at the entrance of the San Cristobal fortress in the Santa Bárbara barrio would bring similar benefits. Many of the poor women, mulattos, and blacks, who made up the majority of the population in the barrios targeted for construction, were relocated outside the city's walls by the Spanish government.[22] Colonial authorities had plans, which never materialized, of building housing units for poor blacks and other people of color in Puerta de Tierra.[23] Government officials hoped to move indigent families from inside the city into these new units to ease housing and overcrowding problems. Although the government failed to build housing units in the extramural barrios, the displaced people themselves took on the task of constructing their own houses.

The *bohios* in which many of the residents from Ballajá, La Marina, and other poor intramural sectors lived were thought of as fire hazards by the Spanish authorities. Governor Norzagaray claimed that the *bohios* "more than dwelling houses are a pile of fuel soon to catch fire."[24] Throughout the century, town council officials tried, unsuccessfully, to prohibit the construction of these wooden houses inside the city walls. Given the racial fears of government officials, Norzagaray's words could have easily applied to his feelings about having large numbers of nonwhite residents living inside the island's capital city. Acting on these fears, Norzagaray banned people of color from Curaçao, who had just recently been emancipated, from entering Puerto Rico.[25]

By relocating large numbers of poor and colored people, the Spanish government also addressed public safety concerns. Poor and colored people were considered by the members of the white elite as unstable characters with the potential for rebelliousness. Pushing nonwhites outside the city protected *sanjuaneros(as)* from any sudden racially oriented uprising. Since the 1820s, Spanish policies had become more hostile and restrictive regarding the movement, rights, and activities of nonwhites in the city, a trend that culminated in Governor Prim's infamous 1848 *"Código Negro."*[26] Prim, fearful of the repercussions from the abolition of slavery elsewhere in the British and French Caribbean colonies, drafted a police code that prescribed harsh punishment

for any nonwhite—free or slave—found guilty of an act of violence against a white person.

Demographic Data from the 1833 and 1846 Censuses

I have discussed above some of the major tendencies that accounted for the demographic shifts in San Juan's sex and race ratios between the late eighteenth century and the 1860s. Since 1833 and 1846 are in the middle part of the period covered by this study, a close analysis of these censuses yields valuable clues to the demographic changes occurring in the city just prior to the 1860s—particularly the transition from a city with more nonwhites and females to one in which males and whites became the majority.

The manuscript censuses available for this study include information about only three (Santa Bárbara, Santo Domingo, and San Francisco) of the four city barrios.[27] These three barrios comprised nearly three-quarters of the city's total population during most of the period under study. Only a photocopy of an 1828 manuscript census is available for the fourth barrio, Fortaleza. The manuscript censuses include all the individuals—parents, children, slaves, servants, and *agregados*—living in a household and provide information on each person's sex, age, race, status, origin, occupation, relationship to head of the household, and house ownership and address.[28] Any researchers doing further demographic work on nineteenth-century San Juan will have to rely on the data from the parish records or hope that other manuscript censuses are found in the Archivo General.[29]

Since the data from the Fortaleza barrio will be missing in my analysis of San Juan's demographic trends, I analyzed some of these barrio's trends based on the 1828 data to estimate the effects of not including this barrio in the 1833 and 1846 analyses. The Fortaleza barrio had around two thousand residents, or approximately a quarter of the city's population, in the late 1820s and early 1830s. The 1828 census shows that a sizeable group of wealthy Spaniards and Creoles lived in this barrio. As a result of the significant presence of merchants, businessmen, and military officials, a high percentage of slaves (25 percent) lived in the Fortaleza barrio. The barrio's racial composition was: whites, 46 percent; black slaves, 25 percent; pardos, 17 percent; and morenos, 12 percent. The sex ratio for the Fortaleza barrio was 59 percent female and 41 percent male. Both Fortaleza's race and sex ratios were very close to those reported for the other three barrios in 1833.[30]

The data from the 1833 manuscript census show more women than men in San Juan (see table 2.4). Actually, the 1833 sex ratios are almost identical to the 1828 data: women made up about 58–59 percent of the population, while men made up the remaining 41–42 percent (compare tables 2.2 and

2.4). Thirteen years later, in 1846, the gender breakdown of the city's total population remained virtually unchanged. San Juan's sex ratios seem to have been unusual compared to those of other Puerto Rican towns in the 1840s. In the neighboring town of Guaynabo, women comprised 48.9 percent of the population in 1842.[31] In the sugar-producing municipalities of Ponce and Vega Baja, women made up 47.1 percent and 47.3 percent, respectively, of the total population.[32]

It seems that San Juan's particular urban setting—with more economic opportunities for women and the importance of domestic work—was responsible for sex ratios in which women outnumbered men. A similar gender imbalance favoring women was found in midcentury Dominican Republic.[33] In 1834 women outnumbered men in Bridgetown, Barbados.[34] Yet, a high degree of urbanization and the availability of domestic work did not produce similar sex ratios in Havana. In 1861 women in Havana comprised 48 percent of the city's population.[35]

The 1833 and 1846 data indicate that, despite moderate population growth during those years, the sex ratios remained stable. This stability seems surprising, considering all the immigrants arriving in San Juan throughout those years. As I will discuss later in this chapter, the sex ratios of the most impor-

Table 2.4. San Juan's Population by Sex: 1833 and 1846

Barrio[a]	Male	Female	Total
1833			
San Francisco	1,414	1,876	3,290
Santa Bárbara	877	1,092	1,969
Santo Domingo	838	1,267	2,105
Total	3,129 (42%)[b]	4,235 (58%)	7,364 (100%)
1846			
San Francisco	1,512	2,034	3,546
Santa Bárbara	816	1,219	2,035
Santo Domingo	982	1,422	2,404
Total	3,310 (41%)	4,675 (59%)	7,985 (100%)

Source: AGPR, Censos San Juan, 1833 and 1846.
[a]No data available for Barrio Fortaleza.
[b]Percentage of total population in parentheses.

tant immigrant groups coming into San Juan began to change slightly around midcentury. One can also assume that the stability in the city's overall sex ratios was tied to San Juan's ability to absorb domestic workers. As long as women found work attractive and available, they continued to migrate into the city.

Other important factors in the declining rate of population growth that San Juan experienced in the second quarter of the nineteenth century were the lack of available space within the city walls for new housing construction and the increases in rent. Renovating old houses to fit new housing demands was made very difficult by the strict military regulations on size and materials. Some poor women, particularly those who made a living as domestics, were affected by the high rents and were forced to move to the city's extramural barrios.[36] Such was the case of one Asunción Pérez Guerra, an orphan, who requested a plot of land in La Marina barrio. Pérez Guerra hoped to subsidize her "meager earnings" by cultivating part of her plot, something that was not feasible for residents in the intramural barrios.[37] As San Juan became a more expensive city to live in, the barrios of Puerta de Tierra, Cangrejos, and La Marina became the home of the city's lower economic sectors. This movement into the extramural barrios had an impact on San Juan's changing sex ratios after midcentury.

The stability in San Juan's sex ratios came to an end by midcentury. The 1859 data show some important changes from the 1833 and 1846 numbers of men and women in the city. In 1859 San Juan's population was almost sexually balanced. In the thirteen-year period between 1846 and 1859, the women's percentage of the population decreased from 59 percent to 52 percent. The decline in the percentage of women in San Juan's population continued into the 1860s. By 1865 men outnumbered women in the city, and the early-nineteenth-century sex ratios had been reversed: women made up 42 percent of the population and men made up 58 percent. Although the actual change toward a male numerical majority in the city came in the mid-1860s, the trend reversing San Juan's gender composition had been clearly established during the 1850s.

The 1833 census data on racial distribution show almost no variation compared to the city's turn-of-the-century patterns. San Juan was predominantly a nonwhite city in 1833 (see table 2.5), as it had been since at least the second half of the eighteenth century.[38] In 1802, for example, nonwhites accounted for 62 percent of the population of San Juan (see table 2.3). In 1833 this same group made up 58 percent of the city's population. Whites, nevertheless, constituted a considerable part of the population and had been the city's largest individual racial group since the beginning of the century. Among nonwhites, blacks made up 28 percent of the sanjuaneros(as) in 1833, while

mulattos and pardos made up 18 percent and 12 percent, respectively, of the population.[39]

The numbers of slaves in San Juan during the first three decades of the nineteenth century have been most difficult to fit into any discernible pattern. Table 2.6 shows that the slave percentage of San Juan's population ranged from 30 percent in 1802 to 20 percent in 1828. By 1833, the census data show, slaves accounted for 22 percent of the city's residents. Interestingly, San Juan's figures compared favorably to other urban areas on the island at around the same time. In Ponce, for instance, slaves comprised 23.3 percent of the population in 1834, while in Guayama the figure was 30.1 percent in 1828, and in Vega Baja it was 13.5 percent in 1837.[40] In Arecibo, slaves accounted for only 9.1 percent of the population in 1828. San Juan's slave population, though, was small compared with that of Havana. In 1827 slaves made up 49 percent of the population in Havana.[41]

Fortaleza had the highest number of white people of all of the city's barrios. One must remember that Fortaleza was the barrio where not only the governor but many members of the Spanish military, commercial, ecclesiastic, and bureaucratic elite resided. The quarter with the fewest white residents was Santo Domingo, which also housed the highest concentration of pardos (see table 2.7). San Francisco was the barrio with the smallest number of free nonwhites (mulattoes made up 15 percent of the population and pardos a mere 2 percent), and Fortaleza followed with just 29 percent. The high concentration of whites and blacks in Fortaleza and San Francisco can be partially explained by the high number of wealthy white merchants, officers, and colonial bureaucrats residing in these barrios—the same people

Table 2.5. San Juan's Population by Race: 1833 and 1846

	1833[a]	1846[b]
Blacks	2,586 (28%)[c]	2,033 (26%)
Whites	3,888 (42%)	3,461 (44%)
Mulattoes	1,675 (18%)	996 (13%)
Pardos	1,174 (12%)	1,370 (17%)
Totals	9,323 (100%)	7,860 (100%)

Source: AGPR, Censos San Juan, 1828, 1833, and 1846.
[a]Includes 1828 data for Barrio Fortaleza.
[b]Does not include data for Barrio Fortaleza.
[c]Percentage of total population in parentheses.

Table 2.6. Percentage of Slaves in San Juan's Population (Selected Years)

Year	% of Slaves
1802	31
1828	21
1859	9
1865	13
1867	13

Sources: AGPR, Colecciones Particulares, Colección Scarano, CP-3, September 19, 1803; Córdova, *Memorias*, vol. 2, 397; AGPR, FAT, S-Regencia, C-5, March 9, 1860; C-9, December 31, 1865; and C-11, December 1867.

who could purchase the most slaves in the city (explaining also the high number of blacks). It should not be surprising, then, to find that the barrios of Fortaleza and San Francisco had the highest percentages of slaves within their populations (see table 2.7). Santo Domingo, the barrio with the smallest number of white people, had by far the fewest slaves among its population. There is a definite correlation between the numbers of whites and of blacks and/or slaves in the city's barrios.

By 1846 San Juan's racial demographic trends were slowly beginning to move away from the trends of the century's first four decades. The percentage of people of color in the city decreased from 59 percent in 1833 to 56 percent in 1846 (see table 2.5). The respective percentages of slaves and mulattoes (in relation to the total population) decreased slightly, while pardos—the whitest of all the nonwhite groups—increased in number. The relocation of twenty-four families from the Ballajá sector (still part of the Santo Domingo barrio and an almost exclusively racially mixed community) must have negatively affected the numbers of nonwhites in the city in 1846.[42] The percentage of San Juan's white population increased slightly between 1833 and 1846. The process of whitening had already begun in San Juan during the mid-1840s, albeit slowly.

Although one out of every five residents in San Juan was a slave in 1846, the percentage of slaves out of San Juan's total population that year declined when compared to the 1833 data. As the slave trade began to shrink in the 1840s, San Juan's slave population began to experience some of the trends affecting other regions in Puerto Rico. The percentage of slaves in the general Puerto Rican population peaked during the 1830s and 1840s and then declined.[43] San Juan's slave population might have decreased more rapidly due

Table 2.7. Percentage of Slaves in San Juan's Population by Barrio: 1833 and 1846

Barrio	1833	1846
	(%)	(%)
San Francisco	28	24
Santa Bárbara	21	21
Santo Domingo	15	14
Fortaleza[a]	25	n.a.
Total	22	20

Source: AGPR, Censos San Juan, 1828, 1833, and 1846.
[a]Data available for Fortaleza Barrio are from 1828.

to the increased demand for slave labor in the sugar-producing municipalities after midcentury. Since the sugar-producing regions were in more desperate need of slave labor than were regions like San Juan (where slavery responded to the need for domestic labor), many sanjuaneros(as) sold their slaves to hacienda owners in Ponce, Manatí, Guayama, and Mayaguez.[44] The sale of slaves from San Juan into other parts of the island probably accelerated the shrinking of the city's slave population.

A few general conclusions emerge from the breakdown of San Juan's population by age, sex, and race. First, only whites had a somewhat sexually balanced population in 1846.[45] For nonwhites, women outnumbered men significantly between the ages of ten through forty-nine. These were not only the most productive years for most individuals but also the prime time for marriage and reproduction. Second, although the data are not conclusive, it seems that whites in San Juan lived longer than nonwhites. The number of whites did not begin to decline significantly until reaching the sixty-five-years-and-older cohort. For blacks and free people of color, the numbers show a downward trend beginning at ages forty-nine and fifty-four, respectively. Finally, there was a significant lack of children ages one through ten among all groups, even when accounting for under-reporting. The lack of children indicates that San Juan was a city of migrants, where natural growth and reproduction were offset by young and adult people moving into the city to seek economic and social opportunity.

Immigration by Sex and Race in San Juan, 1833 and 1846

The impact of immigration on the city provides some clues for understanding the demographic changes occurring in San Juan between 1820 and 1870.

Immigrants have always been attracted to national capitals, especially if that capital city is also a busy seaport.[46] Studies of nineteenth-century immigration into Puerto Rico have shown that a considerable number of immigrants came to San Juan. San Juan's role as a port of entry complicates making an assessment of the impact of these immigrants: many of them stayed in San Juan only as transients.[47] A famous example might serve to illustrate the difficulty in determining the impact of immigrants on San Juan's demography. Salvador Vives, who later became an important *hacendado* in Ponce, was listed as living with his family and renting a room in the Santa Bárbara barrio in 1823.[48] Vives, though, was a Spanish official who had been residing in Ponce since 1821. What was Vives doing in San Juan in 1823, and more importantly, should he have been counted in any demographic profile of the city in that year? Also, how representative was Vives of the people listed in the manuscript censuses? San Juan's role as an active port and as the capital of the colony, where visitors often came to resolve and negotiate financial and administrative matters, complicates the task of measuring population trends.

There still remains much to be studied about the demographic characteristics of the different immigrant groups—Canary Islanders, Catalans, Africans, and Dominicans, among others—which came to San Juan in the nineteenth century. The data on nationality provided by the manuscript censuses complement some of the previous studies of immigration in the first half of the nineteenth century, such as those of Estela Cifre de Loubriel and Rosa Santiago Marazzi.[49] Combining the data from these studies with those from the manuscript censuses, we can analyze the gender and racial composition of the most important immigration flows into San Juan between 1833 and 1846.

Between 30 percent (in 1833) and 24 percent (in 1846) of San Juan's population were people born outside Puerto Rico (see tables 2.8 and 2.9). By 1846 one out of every four *sanjuaneros(as)* was foreign-born. Immigrants from a number of places—the Caribbean, Spain, Costa Firme, Africa, and the Canary Islands, for example—were flocking into the city.[50] Moreover, these regions were not sending demographically balanced (in sexual and racial terms) populations into San Juan. Each of these regions was sending very specific types of immigrants into the city.

The migration of Caribbean people to San Juan, for example, seems to have been partially dominated by women. In 1833 women made up 57 percent of all Caribbean-born San Juan residents. That percentage jumped to 68 percent in 1846, with the number of Caribbean-born people in the city increasing only slightly (see tables 2.8 and 2.9). Many of the Caribbean immigrants came from Hispaniola, especially during the first half of the century.

San Juan received Spaniards and French residents from both the French and Spanish colonies in Hispaniola due to that island's territorial and independence struggles at the beginning of the nineteenth century. Many families sought refuge in Puerto Rico from the Haitian takeover of Spanish Santo Domingo.[51] One such immigrant was Doña María Gertrudis de Salazar, who came to San Juan from Spanish Santo Domingo and received financial refugee assistance from the government.[52] The turmoil in Hispaniola also motivated many of its residents to move to Cuba, especially to its easternmost municipalities. Santiago de Cuba, Baracoa, and Cienfuegos all received sizeable numbers of migrants from Hispaniola during the early decades of the nineteenth century.[53] Some contemporary observers have estimated that around 30,000 migrants left for Cuba from Hispaniola between 1790 and 1810.[54] It seems that about half of the immigrants to Cuba settled in the Santiago de Cuba region. Women—especially widows—comprised a significant portion of all the immigrants who came to Puerto Rico and Cuba from Hispaniola for political or military reasons.

The immigration from other regions of the Caribbean to San Juan (excluding Hispaniola) is more difficult to analyze. Also, the flow of immigrants from other Caribbean islands was not as numerically significant as that from Hispaniola. One factor that could have encouraged migration from the Caribbean into San Juan is commercial relations. San Juan was an active trading partner with Cuba, Saint Thomas, and other French and British Caribbean islands.[55] Other regions of the Spanish Caribbean also received numerous immigrants from the West Indies, especially after slavery was abolished.[56] The migratory flow of Caribbean people to San Juan was dominated by women

Table 2.8. Population of San Juan by National Origin and Sex: 1833

National Origin	Female	Male	Total
Puerto Rico	3,121	2,093	5,214
Caribbean	116	85	201
Spain	110	370	480
Sp. South America	480	183	663
Africa	443	331	774
Canary Islands	40	26	66
Total	4,310	3,088	7,398

Source: AGPR, Censos San Juan, 1833.
Note: Fortaleza Barrio is not represented in these figures, as no data were available.

Table 2.9. Population of San Juan by National Origin and Sex: 1846

National Origin	Female	Male	Total
Puerto Rico	3,602	2,220	5,822
Caribbean	159	76	235
Spain	109	477	586
Sp. South America	208	70	278
Africa	404	283	687
Canary Islands	23	49	72
Total	4,505	3,175	7,680

Source: AGPR, Censos San Juan, 1846.
Note: Fortaleza Barrio is not represented in these figures, as no data were available.

and nonwhites. Actually, several of the foreign Caribbean women in San Juan were domestics, street vendors, or small store owners. In an 1842 list of nonwhite foreigners residing in San Juan, for instance, women totaled twenty-four of the thirty-six persons included.[57] Eugenia Batista Raviné, for example, came from St. Croix and operated a *fonda*. Ana Cristina Martínez from Curaçao was a *dulcera,* while her countrywoman María Rafaela was a street vendor. Tereza Tristani, who came from St. Thomas via Ponce, was a seamstress; so was Rosa Gali from Curaçao. An 1856 listing of all foreigners residing in San Juan includes Rafaela Simón, a *dulcera,* and the sisters Leonor and Matilde Efre, hat makers, all from Curaçao.[58]

It seems that a number of these Caribbean migrants arrived in Puerto Rico as slaves and then became *libertos(as)*. Their special skills and trades made it easier for them to pay for their own manumission.[59] The 1842 listing of nonwhite foreigners again provides some clues about the change in status of some of these Caribbean migrants. Carolina Varloch, for instance, was a cook and a laundress from Curaçao who had become free thirty years earlier. Desideria Durecour, on the other hand, had just become a *liberta*.[60] Ceferino and his wife Rosa both came as slaves from Guadeloupe, and both had been manumitted. Yet, it is not clear whether all of these Caribbean-born residents of San Juan came into Puerto Rico as slaves. Perhaps some of them migrated to San Juan as a result of their newly found freedom and mobility after the British and French Caribbean islands declared emancipation. Although several scholars have documented that intra-Caribbean migration was a common phenomenon in the nineteenth century, the logic and conditions of a migratory flow into Puerto Rico from other areas of the non-Hispanic Caribbean remain areas to be studied.[61]

Another migratory flow, of higher volume and of greater political impact for San Juan, came from Costa Firme. The vast majority of these immigrants came in the late 1820s and early 1830s, fleeing from the turmoil of the South American wars of independence. Furthermore, several historians have recently pointed out that immigrants from Costa Firme kept coming to Puerto Rico well after the independence period, mostly as a result of the internal power struggles among the post-independence elites.[62] Puerto Rico and Cuba, the last two Spanish possessions in the western hemisphere, seemed ideal places (close to South America and developing economically) to migrate after the wars ended. San Juan, along with the port cities of Ponce and Aguadilla, received a considerable number of these immigrants.

The census data for San Juan show that most of the immigrants coming from Caracas, Coro, La Guaira, Maracaibo, Cumaná, Puerto Cabello, and Guayana were women (see tables 2.8 and 2.9). The military campaigns must have broken many marriages—some of them forever—and many women and children sought refuge in San Juan. Other studies of the overall migration from Costa Firme—not just to San Juan—have documented the fact that most of these migrants were women.[63] The data for San Juan show that between 72 percent (1833) and 74 percent (1846) of Costa Firme's migrants residing in the city were women. The Spanish crown also made migration attractive by providing financial support and incentives to the widows who relocated in Puerto Rico.[64] Yet, as many of the letters of these widows to the island's governor demonstrate, the financial support provided by the Spanish authorities was insufficient. Exemplary of the lack of adequate financial support for these widows was the petition of Micaela Vega del Toro, an immigrant widow from Costa Firme, who in 1830 requested a plot of land near the Royal Hospital.[65] She considered herself so poor that she thought the only way to leave behind something permanent for her children, in case she died, was to build a small wooden house on that plot. In assessing the impact of Spanish policies regarding widows from Costa Firme, one has to consider that the policies to alleviate the widows' economic hardships were not purely humanitarian acts. Taking proper care of these women and their families also had clear political implications. At a time when the island's loyalty to Spain could not be guaranteed, public charity ensured support and sympathy for the colonial administration.

The census data show a decline in the number of migrants from Costa Firme living in San Juan from 1833 to 1846. Actually, San Juan had 385 fewer residents born in Costa Firme in 1846 than it did in 1833. Although there are no reliable estimates about the migration from Costa Firme to Cuba, Julio Le Riverend believes that this migration must have matched that coming from Hispaniola between 1790 and 1810.[66] Since many of the Costa

Firme migrants came from urban centers, they probably relocated in those same areas in Cuba, preferably in Havana. These data coincide with the findings of other immigration studies, which suggest that the main volume of this migratory movement occurred during the first three decades of the century.[67] The volume and impact of this migratory flow in San Juan, which was so dominated by women, had receded considerably by midcentury.

If the migration of white Spaniards from Costa Firme included a significant number of women, the opposite held true for the migration of white Spaniards from the metropolis, itself, to San Juan. This migratory flow was almost exclusively male. This held true in both the 1833 and 1846 censuses. While in 1833 women comprised only 23 percent of all Spanish-born *sanjuaneros(as)*, by 1846 this percentage had decreased even further, to 19 percent. During this period, the number of migrants from the metropolis, itself, rose by 106 additional persons. The data from the San Juan censuses show that the percentage of these immigrants which were men kept increasing throughout that period. The majority of the new settlers from Spain were either government and military officials and/or merchants. Since there were very few women who participated in either commerce or government, it should come as no surprise that a majority of these Spanish immigrants were men.

Several authors have emphasized the significant sexual imbalance in the migration between Spain and its colonies of Spanish ethnic groups traditionally associated with commerce, especially Catalans and Basques.[68] The composition of these groups that migrated, in particular the Catalans, was mostly men. Many of these ethnic Spaniards were young, single men who migrated to cities where their relatives had already established solid commercial enterprises. As many as 60 percent of the Catalan men who moved to Puerto Rico—and the majority stayed in San Juan—were single.[69] Although some of these merchants returned to their native provinces as bachelors or sent home for a wife, many of them ended up marrying Creole women. This was a pattern that applied not only to Puerto Rico but to Cuba and Costa Firme, as well.[70] Marrying Creole women was an important maneuver for peninsular merchants in order to cement commercial and political ties with the local elite.

If the immigration of Catalans, Basques, and other *peninsulares* to San Juan was dominated numerically by males, the migration experience of Canary Islanders in San Juan seems to have been a much more sexually balanced one. Women made up a slight majority (61 percent) of the *Canarios* living in San Juan in 1833. The figures were reversed in 1846, when women made up just 32 percent of the Canary Island–born residents in the city. The census listed sixty-six *Canarios* in 1833 and seventy-two in 1846. Although not tra-

ditionally known for their role in commerce, *Canarios* comprised the second largest ethnic group among San Juan's midcentury merchants—13 percent of all regionally identifiable merchants.[71] *Canarios* also seem to have been active in the *pulpería* business.[72] Immigrants from the Canary Islands were usually considered to be more interested in becoming *jornaleros* and were often mentioned by local authorities as a potential solution to the labor shortage problem caused by the closing of the slave trade. In 1845, for example, Governor Méndez Vigo brought one hundred Canarian *jornaleros* to the island.[73] It is doubtful, however, that many of these *jornaleros* stayed to live within San Juan's urban environment. Yet, a number of those *Canario jornaleros* might have moved into the city's extramural barrios, as data from the 1845 manuscript census from Puerta de Tierra show. *Canarios* made up 16 percent of Puerta de Tierra's population, and most of them were listed in the census as either *jornaleros* or *labradores* (farmers).[74]

The data on African immigrants in San Juan refer to slaves or to *libertos*. In San Juan the percentage of immigrants from Africa decreased between 1833 and 1846. Between these years there were 87 fewer African-born persons in San Juan. The vast majority of the African-born in the city were black and slaves. In 1833, 91 percent of all Africans in San Juan were black, and 81 percent were slaves. By 1844 things were virtually the same, as 88 percent of all Africans living in the city were black and 80 percent were slaves.[75] Although Spain had technically abolished its slave trade in 1820, everybody in the Spanish Caribbean knew that the Spanish crown was not serious about cutting the supply of slaves to its colonies.[76] International pressure and rising costs began to make the importation of slaves into Puerto Rico more complicated and difficult as midcentury approached. The decline in the importation of slaves was probably partially responsible for the dwindling numbers of African-born residents in San Juan. Another reason for the declining numbers of Africans in San Juan was that *sanjuaneros(as)* began to sell their slaves to plantation owners in other regions of the island who were in desperate need of laborers.[77] Since many plantation owners were still willing to pay good prices for slaves, the sale of urban slaves also provided extra cash to San Juan merchants who were facing difficult financial times.

Between 1833 and 1846 there were more African-born women than men living in the city (see tables 2.8 and 2.9). In 1833, 57 percent of the African-born population living in San Juan was female. This percentage increased to 59 percent in 1846. Although the ratios and figures continued to be debated, most slave-trade scholars agree on the predominance of men in the importation of slaves.[78] Of course, the majority of the sex ratio studies have focused on either the slave trade, per se, or on the slave populations of slave societies in full expansion. In order to understand the sexual ratios of the African-

born in San Juan, the nature of urban slavery must be taken into account. The high number of female slaves in San Juan was related to urban slavery, where slaves performed many domestic chores for individual households or for members of the military, religious, or political bureaucracy.[79] A recent study on the sexual demography of slavery in Cuba, for example, has revealed two distinct sexual ratio patterns among urban and rural slaves.[80] In urban areas, where domestic slaves were most frequently found, women outnumbered men or the sexual ratios were almost balanced. This was especially true in the urban areas of Cuba's eastern side, where slavery and sugar cultivation were not that predominant. In rural areas, the traditional sexual imbalance of more male slaves was the norm. The pattern of a female majority among urban slaves was also generally true for the British Caribbean.[81] The higher proportion of female slaves in San Juan falls well within the parameters of urban Caribbean, slave sex ratios.

The Creole Population in Mid-Nineteenth-Century San Juan

Since I have done much analysis of the sexual and racial structure and the impact of the migratory flows that affected San Juan's mid-nineteenth-century demography, it seems appropriate to look also at the Creole population. By comparing the trends in the city's Creole population with those of the general population in San Juan, we will be better able to understand whether or not the demographic changes occurring in the city were determined by the impact of immigrants into the city or by other demographic forces.[82] Since Creoles made up a sizeable majority of San Juan's population, it is also important to study the characteristics of this group.

Between 70 and 76 percent of San Juan's population in 1833 and 1846 was composed of Puerto Rican–born people. As the data in tables 2.8 and 2.9 show, women were the predominant demographic force among the Creole population. In 1833 women comprised 60 percent of the total Creole population in San Juan. In 1846 women made up 62 percent of the city's Creole population, a group that had grown by 608 persons since 1833. The rather lopsided sex ratio may be explained by the migration of young women into the city looking for work in domestic occupations.[83] Another explanation could be the natural growth of the Creole population, but this hypothesis needs to wait until research in San Juan's parish records is done.

Turning to the racial breakdown of the Creole population, table 2.10 shows that the majority of the Creole population in San Juan was nonwhite, although whites constituted the largest of all the individual racial groups. There was virtually no change in the percentage of the city's white and nonwhite Creole population between 1833 and 1846. Comparing the percentage of whites among the Creoles and among San Juan's population in 1846, one

finds that Creoles tended less often to be white than the rest of the city's population. What becomes clear after analyzing the demographic data of San Juan's Creole population is that the midcentury trend toward more whites and males in the city was a phenomenon dominated by foreign immigration and by the gentrifying and segregating efforts of Spanish officials in San Juan—not by the demographic evolution of the Creole population.

Conclusion

The demographic data discussed in this chapter invite new conceptualizations of what city life was like in San Juan near the mid-nineteenth century. Up until the 1850s and early 1860s, San Juan was a city where a majority of the population was women and nonwhites. The colony's capital city depended as much on the transactions of affluent, white, peninsular merchants as on the laundry baskets of female domestics and the steady labor from slave artisans. This important aspect of the city's past has remained a neglected feature in Puerto Rico's historiography.

Overall, it seems that the main migratory movements into San Juan—those of African slaves and of Spaniards from both Costa Firme and the metropolis—influenced the sexual and racial ratio changes that had occurred in the city by the 1860s. Only the migratory flow that brought more men—metropolitan Spaniards—into San Juan seems to have been on the increase by 1846. The impact of the other migratory movements, in which women were more numerous, was in decline by this date. In the case of Africans, as the slave trade concluded, their overall numbers decreased in the city. Since the proportion of females within the slave population remained stable between 1833 and 1846, fewer African slaves in San Juan translated into fewer African women in the city. The women who migrated from Costa Firme affected the city's demography during the first three decades of the century. After 1830, however, immigration from South America became less important. On the other hand, Spaniards continued to arrive in San Juan throughout the century. Most of the colonial bureaucrats, the military and church personnel, and the merchant community residing in San Juan were not only predominantly Spanish but also male. This migratory flow affected not only sex ratios but also race ratios. As fewer slaves docked in San Juan's harbor, more Spanish whites made the city their home. Certainly the continuous immigration of these *peninsulares* into San Juan affected the city's demography. Not having parish record data on births and deaths, it is difficult to gauge the basic demographic trends that determined San Juan's transition to a city with a majority of men and whites. The data from the manuscript censuses do give us some important clues as to when these trends might

Table 2.10. Puerto Rican–Born Population in San Juan by Race and Sex: 1833 and 1846

Race/Sex Group	1833	1846
White/Men	419 (20%)[a]	502 (19%)
White/Women	415 (20%)	582 (23%)
Black/Men	283 (13%)	242 (09%)
Black/Women	272 (13%)	345 (13%)
Mulatto/Men	227 (11%)	181 (07%)
Mulatto/Women	184 (09%)	196 (08%)
Pardo/Men	142 (07%)	248 (10%)
Pardo/Women	140 (07%)	287 (11%)
Total	2,082 (100%)	2,583 (100%)

Sources: AGPR, Censos San Juan, 1833 and 1846.
Note: Fortaleza Barrio is not represented in these figures, as no data were available.
[a]Percentages of the total populations are shown in parentheses.

have begun, which migratory groups helped cause the trends, and what the sexual and racial distributions were in the city.

The demographic data analyzed above also yielded some important findings about influences on the city's demographic behavior after 1846. The significant sexual imbalance, for example, among the city's free, nonwhite population—particularly those between the ages of ten and forty-nine—had important consequences on other aspects of life. It affected, for example, the marital trends of certain racial groups in the city, such as pardos and mulattoes. The low number of children ages one through ten, among all racial groups, is a good indicator of the importance of migration to the city's demographic profile. San Juan attracted not only foreigners and *peninsulares* but also other Puerto Ricans from the hinterland.

If migration helped to shape San Juan's demographic profile, one has to remember the important role Spanish urban and immigration policies had in shaping the city's population. First of all, Spanish policies were partially responsible for immigration, as it was the crown's design to open the city and the island to refugees from Costa Firme and to African slaves. In Havana during the late eighteenth century, Spanish military construction in the city caused a dramatic push of poor and colored people into the extramural neighborhoods.[84] In nineteenth-century San Juan, Spanish officials were engaged

not in military but in new civil construction. The results, though, were similar to those in Havana three or four decades before. Local Spanish authorities orchestrated the urban policies that removed hundreds of families—most of them women and people of color—from the *arrabales* in Ballajá, Santo Domingo, and Santa Bárbara. These policies certainly had an effect on the number of nonwhite persons and families in the city. Other policies, subordinated to eighteenth-century military paradigms, limited the city's capacity to expand and update its housing stock. The lack of available and affordable housing also helped to produce many of the city's demographic characteristics described in this chapter. San Juan's slow transition into a city dominated demographically by men and whites was the result of a combination of the effects of Spanish urban and migration policies, population forces, and spatial-urban constraints.

3

Elite and Middle-Class Women in San Juan's Economic Life

Doña María del Pilar Romero was having a difficult time running the bakery of her deceased husband. After finding out that, as a result of another lawsuit, Romero was about to have her assets confiscated, five San Juan merchants filed an additional lawsuit against her for 3,495 pesos.[1] That money was originally owed by Romero's husband for flour he bought from the merchants. As a result of the second lawsuit, all parties agreed to make a listing and an appraisal of Romero's assets. For the time being, Romero's creditors had been pacified.

Although not all *sanjuaneras* inherited business and financial headaches from their spouses, Romero is representative of a substantial number of women in San Juan who operated businesses and used legal means to protect themselves. This chapter documents the participation of elite and middle-class women in the economic life of the city and also describes how certain economic sectors in which women were particularly active, such as real estate, were affected by the economic crisis that struck San Juan in the 1840s. On the other hand, other areas of employment, such as teaching, saw modest expansion during this period due to the liberalizing and modernizing impetus of the city's elite and Spanish government officials. This chapter also shows that women were using the resources the system provided—such as the courts—to fight for their rights and to loosen the ties of patriarchy. The modernizing social and economic projects of the elite, the Spanish government, and the Catholic Church all called for an expansion in the role upper- and middle-class women played in certain areas, such as teaching and beneficence. This expanded role, of course, was to occur always under the supervision of men.

Women and Commerce in the City

Commerce in San Juan encompassed big merchants, engaged in imports and exports, and small retailers, who sold everything from food to manufactured products. The volume of commercial activity in the city was one of the features that differentiated San Juan from other urban enclaves in Puerto Rico during the nineteenth century. Women played an active role in that commercial activity.

Although San Juan's import and export merchants played a dominant role in Puerto Rico's economic and political life throughout the nineteenth century, our understanding about their lives is still very limited. The city's merchants—conservative Scrooges or hardworking, ethnic, "self-made men" in most historical accounts—have not received the attention that the merchants of other Latin American port cities have received.[2] We know more about the merchants of other Puerto Rican cities, such as Ponce or Arecibo, than we know about those from San Juan.

The nineteenth-century merchant class in San Juan—which was dominated by foreigners—traced its roots to the opening of commerce with other Spanish ports, besides Cadiz, in the late eighteenth century. One of the Spanish crown's attempts to diversify Puerto Rico's commerce involved granting exclusive contracts to the Compañía de Barcelona and to the Compañía de Aguirre-Aristegui. Although both companies proved to be major financial failures, they created contacts between Catalan suppliers in the metropolis and agents in San Juan. It should come as no surprise, then, that a considerable majority of the city's nineteenth-century merchants—and an even higher number of the most important ones—were Catalans.[3] Other Spaniards, particularly the Basques, were also well represented among the city's merchant class. Emigrés from the wars of independence in South America also made up a significant number of San Juan's merchants, although many of them were first- or second-generation Spanish ethnics who had also grown to dominate commerce in other Spanish-American cities.[4] Many of these South American immigrants were of either Catalan or Basque descent. Creole merchants comprised a very small percentage of the city's merchant class.

San Juan's merchants were responsible for exporting tropical staples produced on the island to Spain, Europe, and North America. Yet, merchants seldom played just one role within the city's economy. Those who exported goods also imported them, and maybe even retailed them. Many of them also became hacienda owners by receiving whole or partial estates as payments, especially when times were not prosperous for sugar or coffee producers. A significant number of San Juan's merchants also represented Spanish, European, and North American trading and shipping companies on the

island. During much of the first half of the nineteenth century, most of the trade between San Juan and the United States was controlled by Sidney Mason, a New Englander.[5] Mason was perhaps typical of many of San Juan's ubiquitous merchants: he traded, owned haciendas, and was the U.S. consul in the city.

One important source of revenue for San Juan's merchants was importing basic foodstuffs from Spain. Flour was perhaps the most important of all the imported staples coming from Spain. By midcentury the importation of flour from the port of Santander to the island was controlled by the firm Viuda y Sobrinos de Ezquiaga. This firm was founded and managed by the Basque families of Ezquiaga and Izaguirre.[6] Flour was also imported from the United States, but the Spanish authorities heavily taxed U.S. flour to protect the Santander producers.

There is little evidence that women played a central role in running any of the leading mercantile establishments in San Juan during the period under study. The lists of merchants, both from the censuses and from the periodical lists of the merchants' guild, do not include any women. In a study of the nationalities and intermarriages of nineteenth-century merchants in San Juan, only one woman merchant was identified: María Vidales, a *quincallera*, or a kind of small retail merchant.[7] Women did appear among the ranks of the retail merchants, although their presence among this group was not important either. Yet, despite the absence of women from these lists, it would be misleading to dismiss them altogether from the world of big commerce.

Several of the bigger merchant firms in San Juan, such as Viuda de Irrizary y Sobrinos and Viuda de Ezquiaga y Sobrinos, included widows among their owners. The respective widows of these firms did not participate in the day-to-day operations and decisions of the firms, but their capital was needed to maintain the business or to get the business started. In 1861, for example, when Don Bartolomé Elzaburu and Don José L. Aranzamendi—two of San Juan's most important merchants—reorganized their old firm Elzaburu y Compañía, they made Doña Laura Elzaburu (widowed sister of Don Bartolomé) a partner because of her financial contribution: 15,000 pesos of capital. Don Bartolomé, who put up 35,000 pesos, and Don José Lucas, who contributed 20,000 pesos, would run the firm in cooperation with four *dependientes* (clerks).[8] Doña Laura did not participate in the daily running of the business in which she had invested a considerable amount of capital. Another widow, Doña Antonia Oliva de Chiques, associated with other San Juan merchants to form Chiques y Nusa—a general store combining *pulpería, mercería*, bakery, and *botica*—located in the nearby town of Guaynabo. Doña Antonia's capital investment was 4,104 pesos (which included the locale),

while her partners, Don Fraterno Chique and Don Manuel Nusa, invested 1,409 and 1,703 pesos, respectively. Their association, notarized in 1856, was to last six years, and the male partners would be responsible for running the operation. Doña Antonia, according to the agreement, would receive a stipend of 300 pesos a month.[9] Women also played an important role as silent partners in many of San Juan's commercial houses. Doña Lorenza Pérez, the widow of Don Antonio Guarch, was a key partner in Caracena y Cia.[10] Her business deals were managed by her *apoderado*, Don Pedro Guarch, who was also her brother-in-law. Doña María Asunción González de Geigel was also a silent partner in the *sociedad mercantil* Geigel & Cia. in San Juan.[11] She was the widow of Don José Geigel.

It was not unusual, either, to have women, particularly married ones, running the family business in the absence of their husbands, fathers, or brothers. One of San Juan's most prominent merchants, Don José Lucas Aranzamendi, for example, entrusted his wife, Doña Escolástica Astarloa, with running his businesses in 1844.[12] Aranzamendi was suffering from poor health at the time. Another merchant, Don Pedro Ramón Vazquez, issued a power of attorney to have his wife, Doña Rufina Urbina, administer his financial affairs while he was away on a trip.[13] So did Don Manuel Olpiano Lizardi for his wife, Doña Manuela Hernández, and Don Andrés García Pimentel for his wife, Doña Ysabel Huertas.[14]

Women, through family alliances and marriages, played an important role in securing and providing the capital needed for many commercial ventures. The key role that women played in guaranteeing the success and the continuation of family businesses in San Juan is comparable to the experience of merchants in other Latin American cities.[15] In Cuba, for example, intermarriage was a crucial strategy in maintaining capital and resources among the top five slave-importing consortiums.[16] As perpetuators of business capital, widows of successful merchants kept at least half of their husbands' estate under Spanish inheritance law. This was a considerable amount of any estate, especially if the marriage had generated many inheritors, who were bound to receive only even portions of the remaining half. The role of widows and the control of their capital were crucial for the survival of business and family fortunes. Yet, there were very few instances in the historical record of married women or widows exercising open power within San Juan's merchant firms.

Since the daughters of merchants would inherit capital from their parents, intermarriage among merchant families was an important way for the elite to guarantee perpetuating their status and wealth. Intermarriage was an important strategy for many immigrant merchants, too. Many Catalans, Basques, and other immigrant merchants tried to cement economic and social ties

with members of the Creole elite through intermarriage. There seems to have been a tendency among immigrant merchants—many of whom migrated to the island young and single—to marry members of the Creole military, social, and agricultural elite.[17] In the 1830s and 1840s, nearly half of all the San Juan wholesale merchants were married to Creole women.[18] Don Benito Carreras, for example, was a Catalan merchant married to Puerto Rican–born Doña Monserrate Del Valle.[19] Another Catalan merchant, Don José Viñas, married another Puerto Rican woman, Doña Josefa Bufarres. Don Juan Sola, a merchant from Caracas, married Doña Margarita Flores from San Juan.[20] The census and notary records from San Juan provide ample evidence of the attempts by immigrant merchants to marry Creole women.

By marrying into the local Creole elite, the newly arrived merchants not only cemented future economic alliances, but also found a better way to incorporate and integrate themselves into their new surroundings. Marrying the daughters or nieces of the local military and agricultural elite—these family members would have been first-generation Creole at this time—would have made sense considering that the marriage would give the merchants access to San Juan's "old money." These marriages were probably also very advantageous from the vantage point of San Juan's Creole elite families, who were probably facing economic difficulty as sugar production moved to the southern and western municipalities. Access to the merchant's family capital and commercial connections could mean the salvation for a cash- or credit-starved hacienda.

For non-Spanish immigrant merchants, marriage might have been not only a convenient and efficient way of cementing social and economic ties with the local elite but also a mechanism to advance their naturalization process. Spanish law required naturalization in order to conduct business as a merchant. To be naturalized, non-Spanish merchants had to either marry a Spaniard, reside on the island for five years, or have a Spanish business partner.[21] One non-Spanish merchant who married into San Juan's local elite was Sidney Mason. Mason married Doña Margarita Dorado, the daughter of Don José A. Dorado y Serrano, a high government official in San Juan.[22] Mrs. Mason's sister, Doña Clemencia Dorado, married Don José Ramón Fernández, another merchant, who, in association with George Latimer, took over Mason's firm in the 1840s.

Marriages and kinship ties also proved beneficial to those conducting business between the former Spanish colonies in South America, especially Venezuela, and the metropolis. This business, channeled mostly through the *Depósito Mercantil*, was a profitable one for San Juan's merchants up until the 1840s.[23] The *Depósito* allowed Spanish merchants to buy raw materials—like cotton for the Catalan clothing industry—in the newly independent South

American countries and to reexport it to Spain via San Juan. One of the merchant families that benefited the most from this arrangement was the Guarch family. The wives, for example, of the Guarch brothers Antonio and Pedro were from Cumaná and Cadiz, respectively.[24] These were two of the key ports that the *Depósito Mercantíl* in San Juan was trying to unite, and most certainly the Guarch family's commercial relations served to enhance their business's success.

Women also provided merchants with an important way in which to secure parts of their capital. Spanish legislation protected certain parts of married women's own financial resources, particularly the dowry, from potentially unscrupulous husbands. Male merchants probably tried to manipulate this protective legislation in order to protect some of their assets, especially during difficult economic times.[25] A merchant could transfer assets to his wife's personal estate to prevent some of his potential creditors from gaining access to his capital. This seems to have been the strategy of Don Domingo López and his wife, Doña Petronila Martínez. Martínez acknowledged in her will that, due to the political instability in Costa Firme and "in order to better assure our interests," the couple's joint marital estate had been placed under her name.[26] In her will she wanted to clarify that the property—haciendas and slaves—was commonly shared and not just her own. It is safe to assume that López and Martínez were not alone in employing a financially defensive tactic in times of economic uncertainty. Data from the notary and trial records show that it was common for creditors to go after wives' estates and that the courts tended to protect the independence of women's personal assets in these cases.[27] Clearly, more research is needed before we can tell whether this was a common strategy or not. Yet, regardless of whether women were receiving property as part of their husbands' selfish strategies or as an indication of their personal importance, the fact that women legally controlled such property must have been an empowering situation. Should a merchant decide to play with the legal protection granted to his wife's assets, the wife could have been placed in a condition of potential leverage, since, at least technically, those assets were her private property.

Many women owned or co-owned several plantations. Doña Bárbara Michel y Polo, for example, owned the hacienda San Toribio in Caguas. Her hacienda was worth 12,000 pesos in 1808. When she sold half of the estate to Don Juan Rodríguez Calderón, they agreed that Calderón would be "the active voice in the hacienda, with faculty to buy and sell as he saw fit."[28] Doña Estevanía Vergara de Sánchez, widow of merchant Don Elias Yriarte, took control of the sugar mill San Luis in Caguas when the original owners of the mill lacked the cash flow to keep it operating.[29] In 1856 Doña Bárbara Dávila Ramirez, a widow, sold an *estancia* of 193 *cuerdas* in Pueblo Viejo to Félix

Pizarro, a Bayamón resident.³⁰ The *estancia,* which included a house, was sold to Pizarro for 3,250 pesos. Doña María Asunción de Córdova, another widow, sold a plantation of hers, located in El Roble (Rio Piedras), to Don Santiago Prieto.³¹ Prieto paid 6,000 pesos for the plantation's 130 *cuerdas,* which also included a wooden house. In 1861 Don Manuel F. Fernández, a San Juan merchant, purchased 87.5 *cuerdas* of land in Bayamón from Doña Inés de los Reyes, a single San Juan resident.³² Fernández paid 1,312 pesos for the land De los Reyes had inherited from her father, a former artillery colonel.

Women were also busy buying and selling slaves in San Juan. San Juan's merchants were very active in the importation of slaves up until the 1840s.³³ The evidence from the notary records shows that elite women bought and sold slaves with relative frequency. Doña María del Amparo Fortun appeared selling or buying slaves four times in 1844, for example. One of the slaves she sold, Trinidad, was one Fortun had bought from merchant Don Antonio Guarch in 1841.³⁴ Another of the slaves Fortun sold, a shoemaker named Antonio, she had bought recently in Ponce.³⁵ Fortun was married to Don Laureano de Castro, who always gave his approval for the transactions. Another example of a *sanjuanera* actively buying and selling slaves was Doña Tiburcia Fragoso, who appears in four transactions in 1829. Fragoso, for example, bought the child Santiago for 150 pesos in January and later sold him to Don Pedro Vidal for 224 pesos in April.³⁶ Fragoso also bought slaves from important *hacendados* like Don Fernando Fernández, who sold her the sixteen-year-old Beatriz from his sugar mill, Santa Ana, in Bayamón.³⁷ In 1827 Fragoso sold a thirty-nine-year-old Creole slave, Inés, to Francisco Biera, a freedman from San Juan.³⁸ In 1861 Doña María Sánchez de Montijano, a widow, was also recorded at least four times buying and selling slaves. Montijano, for example, sold a slave to the Sociedad Mercantil J.E. Cabrera & Cia for 350 pesos.³⁹ She also sold a slave, which she had inherited from her mother, to the future vice-president of the Junta de Damas, Doña Consuelo Peralta.⁴⁰ Fortun, Fragoso, and Montijano are but three examples of the numerous women who appear in San Juan's notary records purchasing or selling slaves.

It is difficult to assess how many of the slaves bought and sold by elite women were destined for domestic chores. Probably a majority of these slaves ended up serving in their masters' households. Some of them were also destined for the sugar haciendas surrounding the city's hinterland. Since women owned or co-owned some of these haciendas, it makes sense that they bought slaves for their estates. Yet, could the high volume of women active in the slave market be another indication of attempts by husbands and fathers to protect family assets by placing them under the control of their wives and

daughters? Although the available evidence does not allow a clear conclusion to be reached, it seems likely that families utilized every strategy possible to defend their property, particularly in the difficult economic times of the mid–nineteenth century.

Barry Higman has noticed the frequency of female ownership of slaves and the high number of female slaves in the Caribbean city of Bridgetown. He has attributed the correlation between female slave owners and female slaves to the "concentration of female owners in enterprises requiring large numbers of domestics."[41] This situation seems to have been the case also in San Juan, where many of the most active female slave buyers and sellers were women with households housing numerous domestic slaves.

Women and San Juan's Real Estate Market

The issue of home ownership and renting in the city of San Juan is inevitably related to women. Women played an important role in the city's real estate business. Although it was not really an occupation, many women in San Juan derived their livelihood from renting rooms and houses to others. Since the women who owned these rooms usually came from the city's upper and middle sectors, I have decided to integrate my analysis of the participation of women in the city's real estate business with the discussion of the economic participation of upper- and middle-class *sanjuaneras*.

Real estate was one sector of San Juan's economy in which women were clearly very active. A combination of business interest, limited access to participate in other economic ventures, and inheritance laws helps to explain the presence of women in the world of property transactions. Inheritance probably played an important role, for widows received half of the common goods (*mancomún*) in marriage, and daughters could receive considerable properties and assets from their parents through either inheritance or dowry.[42] Elite women often ended up owning property by themselves outright, or they owned shares of land or houses which they could use to enter other business transactions.

As I mentioned earlier, another explanation for the fairly high number of women owning houses or renting rooms could be that fathers and husbands were trying to protect family assets and property through the women of the family. After all, real estate could also be considered part of what women managed everyday, as part of their domestic chores, since they were the ones who took care of houses and rooms. For a woman to rent several rooms of her house was probably less of a foreign experience than to manage a *bodega* or a pastry shop.

San Juan experienced a private construction boom during the first half of the century, both inside and outside the walls. Based on data from 1820 prop-

erty lists, one could argue that San Juan was already a "very compact and highly utilized city."⁴³ The governor and the town council records indicate the numerous petitions made to the Spanish authorities during that period, requesting lots in the few open spaces inside the city or in the growing extramural communities of La Puntilla and Puerta de Tierra. In 1830, for example, Micaela Vega del Toro—a *morena* who had migrated from Costa Firme—requested a lot near the Royal Hospital in order to build a house.⁴⁴ Gregoria Pérez, a widow who was left with two sons and scant resources, requested land in La Puntilla in 1831.⁴⁵ The town council denied Doña Carmen Arustria's request to build a wooden house—although she could build one of masonry (*mampostería*)—on San Sebastián street in 1847.⁴⁶ There were many more people requesting land and building permits during the first half of the nineteenth century. Many of those appealing to the governor's mercy and sense of justice were women who had been left with no other alternative in their attempts to try and secure a house or a room.

The open spaces left within the walls quickly became urbanized by midcentury. Many of the standing houses experienced architectural and structural changes to cope with the housing demands of the growing population. The walled city had virtually no more space open for new housing construction. Further limiting expansion were the military restrictions, which kept buildings to a maximum of two stories in order to prevent interference between the city's military batteries and potential incoming enemy ships.⁴⁷ The construction and development of San Juan's extramural barrios—which were also under military regulatory measures—was part of an attempt to increase the city's housing stock.

The real estate market changed significantly as a result of the constraints in urban construction and the demands of the growing population. Although data on inflation or real prices are still lacking, a comparison between the property values in San Juan indicates the escalating nature of the city's nineteenth-century real estate market. In 1820 there were only six units priced over 10,000 pesos. Only one unit was priced at 20,000 pesos, which was the city's top residential property value. In contrast, the 1859 data showed nineteen units priced over 20,000 pesos and four over 30,000 pesos. The most valuable property in 1859 San Juan was priced at 35,000 pesos.⁴⁸ Basically, what was a scarce, high-priced housing market (in relation to the economic resources of the city's residents) got worse as the second half of the century progressed. San Juan became, even more so than before, a city of boarders and renters.⁴⁹ Women played an important role—as clients and owners—in this housing market.

In what was a very tight housing market, women seemed to have owned a considerable number of properties. An analysis of the 1820 property lists

shows that, out of 708 units, women owned 261 units (37 percent of all the units).[50] By 1859 there had been just a slight decline in female ownership, as women owned 34 percent of the privately owned units.[51] Several women possessed more than just one house. In 1859 Doña Monserrate Crosas de Márques, for example, owned at least seven houses ranging from 1,500 to 12,000 pesos in value. Doña Concepción Peña had six houses, the least valuable one being priced at 5,000 pesos. Doña Magdalena de Rivera owned five, and so did Doña Rosario Sarabia. Multiple house ownership allowed these and other women to rent several of these units, which probably became a more lucrative and appealing financial venture as the century advanced. Also, even if one owned only one house, it was common to rent rooms and space within your own household.[52]

Evidence of women's active participation in San Juan's real estate business does not come just from the property census data. There is ample documentation from the notary records and the conciliation trials, which illustrate that women often played the role of landlady. Doña Bárbara Dávila, for example, leased a house and a brick oven to Don Antonio Andino in Guaynabo.[53] In 1860 Doña Margarita Vizcarrondo de Padial took a couple of her many boarders to trial in order to evict them for not paying their rent on time.[54] On three separate occasions—in 1844, 1845, and 1852—Doña Manuela Aldao appeared in court trying to evict or get rent payment from different boarders.[55]

Women in San Juan seem to have been fairly successful in dealing with their legal battles (especially those having to do with real estate), which became increasingly frequent during the second half of the century.[56] Actually, a significant proportion of the cases women brought as plaintiffs to San Juan's lower courts were related to real estate issues, particularly payment schedules and evictions. Although the rulings were mostly related to the agreement by both sides or to the judge's application of local real estate laws, in more than one case the fact that the plaintiff was a woman who depended on the rent for her livelihood helped the judge rule in favor of the female plaintiff.

Widows seem to have played an important role in San Juan's real estate market. Doña Margarita Vizcarrondo de Padial, who was attempting to evict some of her tenants in court, was a widow at the time these lawsuits were taking place. Two other women, for example, who owned multiple residential properties in San Juan were widows: Doña Genara Hernaiz de Sevilla and Doña Francisca Valladolid. As table 3.1 indicates, widows made up a majority of the women who owned houses in San Juan.

Many widows probably received property through inheritance. This property was not always easy to keep, as many widows found out when forced to

Table 3.1. House Ownership in San Juan by Sex and Marital Status: 1833 and 1846

	Married	Single	Widowed	Total
1833				
Female	7	54	119	180
Male	132	48	28	208
Total	139	102	147	388
1846				
Female	10	65	69	144
Male	113	42	24	179
Total	123	107	93	323

Source: AGPR, Censos San Juan, 1833 and 1846.
Note: Data from Barrio Fortaleza not included.

sell inherited property in order to fend off the relentless creditors of their deceased husbands. The court records show more than one widow being hounded by her late husband's communal debt. Doña María de la Asunción González, for example, was forced to mortgage a house on San Jose street in order to pay Don Domingo Verasa, a creditor of her late husband, Don José Marcelino Geigel.[57] Doña Estevanía Vergara de Sánchez, another widow, was forced to sign a refinancing contract with San Juan merchant Don Elías Yriarte in order to keep her sugar hacienda operational. Vergara de Sánchez had inherited the troubled hacienda—San Luis in Caguas—from her deceased husband.[58] The courts, while sympathetic to the plight of widows (both as landladies and as renters), were very aware of the severe housing shortage in the city. Court officials were also on the lookout for potential inheritance mismanagement by widows.[59] The courts had to balance the protection and safety net the law provided for widows with the need to ensure that family wealth, in the form of inheritance, was properly transmitted to the younger generation.

Widows were important players in the rental business. It seems that one of the survival strategies for widows in San Juan was to rent houses or rooms as a means of financial security. Such was the case of María Vázquez, a widow who rented three rooms as her form of receiving income.[60] Ironically, Vázquez was sued by María Rodríguez, herself a widow, for failing to pay a thirteen-year-old debt of 315 pesos. Vázquez agreed to use the collected rent from two rooms to gradually pay the debt.

The housing conditions in San Juan deteriorated as the century progressed, not only in terms of availability and pricing but also in quality. More rooms were subdivided to accommodate the growing population. The number of female renters was virtually the same as that of male renters in 1833 (see table 3.2). By 1846, however, the situation had changed, as the majority of the city's renters were women. The increase in the number of female renters is probably related to the decrease in new construction and home ownership in the city. It is also connected to the increase in the number of female heads of households which San Juan faced in the 1840s.[61] The high number of women renting rooms and/or apartments in San Juan is also a sign that women were more actively managing their lives than is usually thought.

Sanjuaneras as Small Business Owners and Operators

Moving away from the world of big warehouses and of slave sales, one finds that among San Juan's small middle strata of retail merchants, storekeepers, and artisans, women seemed to have been more publicly visible. Smaller merchants, who served as retailers and played intermediary roles in the economy, sold just about everything from food to clothing to semimanufactured goods. The establishments considered under the category of retailing had a variety of names: *pulperías* (grocer's shop), *lencerías* (linen shop), *mercería* (haberdashery), *quincalla* (hardware store), *bodega* (grocers), *taberna* (tavern), and many others. The differences often depended on the kind of goods being sold, on the size of the commercial establishment, or on the amount of capital needed to start and continue the business.

Table 3.2. San Juan's Room Renters by Sex and Barrio: 1833 and 1846

	Santo Domingo	Santa Bárbara	San Francisco	Total
1833				
Female	129	89	201	419
Male	96	101	234	431
Total	225	190	435	850
1846				
Female	154	106	210	470
Male	135	80	224	439
Total	289	186	434	909

Source: AGPR, Censos San Juan, 1833 and 1846.
Note: Data from Barrio Fortaleza not included.

Most retail establishments, especially those dedicated to selling food and/or durable goods, were run by an association of two or three partners. The capital needed to run some of these stores varied; it could range from just a couple of hundred to several thousand pesos. A study of storekeepers in nineteenth-century San Juan found that the capitalization for *bodegas* ran between 9,000 and 10,000 pesos, for *mercerías* around 7,000 to 10,000 pesos, and for *pulperías* under 2,000 pesos.[62] In a city where currency was scarce and credit was expensive, even a small capitalization for a modest retail shop was a risky venture.

In Jay Kinsbruner's study of San Juan's shopkeepers, which considered *pulperías* to be the lowest entrepreneurial commercial activity in the city, women did rather poorly. Out of 111 *pulperos(as)* listed in the merchant's guild in 1826, only three were women; in 1851, none of the 102 *pulperos* were women.[63] One can attribute the decline and the low numbers to unreliable reporting, especially since other archival evidence does show women active in the *pulpería* business. For example, a list of *oficios* by street in 1820 revealed that only two *bodegueros(as)* were women: Catalina Casales and María Alexandra. Yet, on that same list, ten out of the eighteen *ventorilleros(as)* recorded were women.[64] A different 1820 inventory of *riqueza mercantil* listed the same two *bodegueras*, plus two *mercería* owners, Doña Josefa Nova and Doña Cecilia del Moral, and seven female *pulpería* owners.[65] Two 1840s lists of city merchants located next to the main plaza record two women, Doña María Altagracia Mares and Doña Marcelina Pastrana, without providing their specific type of business.[66] It appears, however, that the economic stagnation felt in San Juan around midcentury, especially between 1850 and 1870, was particularly felt by women shop owners. An 1859 *derrama* (tax) list included wholesale merchants, *merceros, quincalleros,* and *pulperos,* but no women were included on it.[67] In another listing of commercial establishments—including *pulperías, quincallas,* billiard parlors, sweet shops, tobacco shops, *chocolaterías,* and hat shops—no women were listed.[68] Although the possibility of poor record keeping cannot be ruled out completely, the retail business records in San Juan show that the number of women active in this economic activity declined as the century advanced. The difficult times experienced by the city's commercial community seem to have affected women more seriously than men. Women retailers in San Juan were more vulnerable to the effects of a stagnant or declining economy than their male counterparts.

The lack of women in the *pulpero* inventories is nuanced by the references to several women either buying or selling *pulperías* by themselves or in association with others. Bárbara Dolores, a widow, owned a *pulpería* and sold it for 1,247 pesos in 1831; Francisca Feyjoo bought one for 1,983 pesos in

1852 from Goenaga, Pesquera y Compañía.[69] Antonia Rodríguez owned a *cordonería* in 1854. An interesting factor revealed by Kinsbruner's study was that most *pulperos(as)* rented the locale for their stores, and that women were often the owners of the space where the stores were located.[70] Given the high participation of women in the real estate market, the situation in the *pulpería* business does not seem that unusual. Don Diego Méndez, for example, rented the room where he had his *pulpería* from Doña Clara Torres Vallejo.[71] The renting agreement among *pulperos(as)* suggests that some women might have been silent partners in these stores, providing capital and financial resources, while men took care of the *pulperías*' day-to-day affairs. Actually, Kinsbruner's study noted the importance of silent partners in the *pulpería* business.

One final note of interest about the *pulperos(as)* was that the business was dominated by Spaniards, predominantly Catalans and Canarians, as was the case among San Juan's wholesale merchants. Out of the twenty-one *pulperos(as)* residing in the Santa Bárbara barrio, seventeen were Spaniards, one was Cuban, one was from Costa Firme, and two were from Puerto Rico.[72] The same tendencies of intermarriage and close kinship ties that held true for wholesale merchants also seemed to apply to *pulpería* owners. Marriage was also a vehicle to cement commercial and social ties for *pulpería* owners.[73] *Pulpero* Juan Rodríguez from Galicia, for example, was married to Doña Tiburcia Fragoso from San Juan.[74] Don Vicente Rubio from Madrid was another *pulpero* who had a Puerto Rican wife, Doña Moncerrate Mañur.[75] Small *pulpería* owner Francisco Almentero, a Spaniard, was married to Benita Delgado, a Creole seamstress.[76] In *pulperías,* as in wholesale commerce, the lines between business and family interests were often blurred.

Women were also active in some food-preparing and -serving establishments like bakeries, sweet shops (*confiterías*), and hostels (*hospederías*). Although in other Caribbean cities, such as Kingston, women played an important role in running hostels and inns, I have found no similar evidence in San Juan.[77] The only traveler who describes staying in an inn, Mr. Edward Emerson, noted that the innkeeper was an English-speaking mulatto.[78] He also noted that the accommodations were quite mediocre. At least one woman owned a recreational establishment: Doña Ramona Saviñon was the owner of a *gallera*—a cockfight arena—located in the basement of a *pulpería* on Luna Street.[79]

Although many food-preparing and -serving establishments were still dominated by men, women were often found managing, comanaging, or just working in them. There are several instances of women running these establishments, which usually implied being an artisan in the confection of bread, pastries, hot chocolate, or candy. Doña Celestina Solano, for example, owned one such sweet and coffee shop around San Juan's main plaza, or Plaza de

Armas. In 1856 she was forced to close her business because of the alleged failure of the building's owners to provide water and sanitary facilities.[80] The 1820 inventory of trades in San Juan lists María Monserrate Nuñez as having a chocolate store, and María del Carmen Rener and María Rosario Morales as making sweets.[81] There were also various *dulceras* listed on the 1846 censuses, among them María de las Angustias Morales and María Cambien. In several other cases, the slaves of a baker or a *confitero/a* were listed along with their masters. These slaves were, most probably, apprentices. The baker, Don Pedro Cami, for example, had five of his slaves listed as bakers.[82] Pío and Josefa were two slaves who had their trade listed as *confiteros(as)*. Laureano and Cayetano were two slaves who made chocolate. Interestingly enough, the owner of these two *chocolateros* was not a chocolate maker himself, but a silversmith.[83] Slaves and freedmen traditionally have been well represented among the food-preparing establishments and artisan shops throughout Latin American cities, and San Juan was not an exception to this pattern.[84]

Women as Teachers and Government Employees

Another important area of San Juan's economy—and one in which women did not participate much—were the services provided by professionals. Some in San Juan's small professional class were closer to the upper classes by the status of their trade—for instance, doctors, notaries, and lawyers. Other sectors of the professional class, such as teachers, received lower status and remuneration. Most professionals provided their services through the Spanish government; those who did not were closely regulated and controlled by it. All lawyers, notaries, scribes, and other officials engaged in official documentation, legal transactions, and permits either bought their positions from the government (as did the notaries) or had to receive a special permit from the crown in order to practice publicly. Other groups closely monitored by the Spanish crown were physicians, surgeons, pharmacists, and other medical officials. Physicians and surgeons who were not employed by the governor or the town council were employed in church-sponsored hospitals. Health and medical professionals, or any professionals, for that matter, were not abundant in San Juan during most of the nineteenth century.[85] Partly responsible for this shortage was the lack of access to secondary and higher education. The island had no local university and very little elementary and secondary education, and the opportunities and resources for study abroad were limited.[86] Throughout most of the century, San Juan faced a shortage of medical and legal professionals, a situation that did not begin to change until the last quarter of the century.

Most teachers were employed by the state, although the church controlled some schools; there were a few small, privately owned schools. Yet, any pri-

vate and church-sponsored educational institution needed the approval and licensing of the local authorities. Women as teachers found a public role (albeit a limited one) within the state's structure. The first recorded recruitment of female elementary schoolteachers by San Juan's town council was in 1799.[87] Four women were selected to head schools for girls, one in each of the city's four barrios. From the little we know about these schools, it seems that they were oriented toward catechism and teaching women's skills such as sewing and cooking. At the time, most girls, if they were to receive any kind of education at all, were schooled at home by members of their own families.

The disparity between the number of schools available to girls and those available to boys in San Juan was considerable. In 1864, for example, San Juan had thirty-three schools (twenty-nine public; four private), of which only nine taught girls.[88] These nine schools served 165 girls, while the other twenty-four schools had an enrollment of 485 boys. There were some private tutors servicing elite children, but the numbers of tutors and of students serviced by these tutors are hard to determine.[89] Although there have been different estimates of the number of schools in San Juan throughout the nineteenth century, it is clear that there were significantly fewer opportunities for girls to go to school than for boys.

The *cabildo*, along with the governor, kept control of the applications for teaching jobs, teachers' salaries, and schools' budgets. In 1832, for example, two women—Cecilia Pagán and Baltazara Torres Benítez—petitioned the town council to take Celestina Cordero's teaching position once the latter retired.[90] Celestina Cordero, although allegedly insane and suffering from ill health, continued teaching until 1853. That year, Doña Josefina Antoñaura de Gallardo requested Cordero's position, arguing that the town council should expand primary education for girls, particularly for white ones.[91] Since there were more applicants than openings for teaching jobs in nineteenth-century San Juan, prospective teachers wanted to secure future openings far in advance. The *cabildo* always argued that limited financial resources kept them from creating new schools or opening new teaching positions. Yet, in 1856 the governor relaxed some of the requirements pertaining to female teachers in response to a shortage of certified teachers.[92] Still, the number of girls being educated and the number of female teachers hired remained very low.

The town council kept loose control over the performance of teachers and students in San Juan's schools. The Bishop of San Juan granted certificates to teach catechism in primary schools until 1849; the governor and the town council administered regular teaching permits.[93] In San Juan, many refugees from the South American wars of independence became schoolteachers. Their impeccable political credentials—loyalty to the crown and fear of any kind of subversion—made them ideal candidates, according to the Spanish au-

thorities, to train and teach the young.[94] After 1849, potential teaching candidates presented their credentials to the members of the Junta de Instrucción.[95] This Junta became the governing body pertaining to the examination and certification of teachers.

The working conditions and the financial remuneration experienced by female teachers were very poor. They earned 50 pesos annually in the early part of the nineteenth century.[96] In 1836 Doña Ambrosia Martínez received 100 pesos a year from the *cabildo* in order to run a school for teenage girls.[97] The last raises granted (before 1870) by the *cabildo* for female teachers were in 1847, when the salaries of Celestina Cordero, Doña María Toribia Requena, and Simona Perales were increased from 100 pesos to 150 pesos annually.[98]

All through the nineteenth century, female teachers earned less than their male counterparts. While female teachers made 100 pesos annually, male teachers earned at least 480 pesos.[99] In 1865, when the first serious attempt at reorganizing public education on the island was made, the unequal pay practice became further institutionalized in the first salary scale created. Female teachers received two-thirds of the salaries of male teachers.[100]

The lesser pay received by female schoolteachers, in comparison to that of their male counterparts, was not the only financial inequity present in the education of *sanjuaneras* in the nineteenth century. In the awards ceremony of an island-wide calligraphy competition, only one of San Juan's schools for girls—that of Doña María Auñon—participated, as opposed to five boy's schools.[101] The winners were awarded medals and books, except for the three girl finalists, who were awarded purses and notebooks. Interestingly, none of the three female finalists was from San Juan. An 1874 inventory of the facilities and furniture available in San Juan's schools reveals the big discrepancies between the resources available for boys' schools as opposed to those for girls' schools.[102] Out of thirteen public schools surveyed, seven were for girls. The schools administered by Doña Dolores Barbosa, Doña Elena Martínez Gandía, Doña Rosa Curet, and Doña Faustina González all had fewer furnishings than the boys' schools. In three other schools—two of them for girls—all the supplies and the furniture were purchased with the teachers' own money. One school—the girls' school of Doña María Eugenia Iglesias in Cangrejos—had no furniture or teaching materials. If these were the material conditions of San Juan's schools for women in 1870—after more concerted efforts to improve the nature of schooling had been developing since midcentury—it is not difficult to imagine an even more deprived, austere, and unbalanced scenario for women's education during the first half of the decade.

Besides teachers, the Spanish government had very few other women on its payroll, particularly if one excludes those providing domestic services. In

nineteenth-century San Juan, I have found only isolated examples of women working for the government. One such example was Doña Catalina Henrr(?) de Riera, who in 1855 petitioned the *cabildo* for the position of "titular midwife."[103] The existence of midwives, nurses, and wet nurses, although not frequently documented in the archival material, was an important part of San Juan's medical life. Lack of hospitals and trained physicians made midwives indispensable for most births. The Spanish state, at first, tried to regulate midwives and other nonprofessional practitioners of medicine. In 1838 the salaries of doctors, surgeons, midwives, and bloodletters (*sangradoras*) were set by the government. Colonial officials also ordered that midwives should be allowed to perform natural births on their own—without issuing any prescriptions—given the scarcity of obstetricians in the city.[104] Then, in 1846, the governor informed the town council that within the Casa de Beneficencia a school for midwives would be created.[105] As the century advanced, midwives and apothecaries were seen as part of popular, not scientific, medicine. Another health-related job that women in San Juan seem to have performed was that of *loquera,* or asylum nurse. These *loqueras* worked at the Casa de Beneficencia. Tomasa Cipres was the only *loquera* working at the Casa de Beneficencia when she died in 1845.[106] Cipres was to be temporarily replaced by Josefa Belén, an inmate at the Casa who used to be her assistant. Josefa Belén, for her help, was paid two reales a day. An 1851 salary list from the Casa de Beneficencia indicates that the *loquera's* yearly salary was 200 pesos.[107] The Casa de Beneficencia also employed another female, a *Directora de Niñas*. The role of this director, who was paid 300 pesos in 1851, was to oversee all of the activities related to the young girls in the Casa.[108] This job was often entrusted to the wife of the Casa's top administrator.

There was also a group of women who moved up and down in San Juan's class and social hierarchy and who depended on the Spanish government for their livelihood. These were the widows or children who received either military or civil service pensions from their deceased husbands or fathers. For some of these women, the pensions added financial resources to a well-established inheritance or continuous family wealth. For others, pensions were the difference between barely making ends meet and not surviving.

Pensions from the Spanish government were not automatic or easy to come by. The town council, though, seems to have been particularly merciful in the cases concerning their former employees. The *cabildo* did oblige María Tirado's petition, as she and her daughters were left penniless after the death of her husband, Antonio Martínez, who had been the town council's concierge (*portero*).[109] The widow of another *portero*, Doña Ysabel Guerra, also got a pension from the town council.[110] Guerra's advanced age seems to have influenced the town council's favorable decision. Yet, another elderly woman

was not as lucky in her pension dealings with the town council. Maybe the fact that she was not a widow of a *cabildo* employee made a difference in her case. Doña María Toribia Requena asked the town council for a lifelong pension after having worked for thirty years as a schoolteacher.[111] Her school was closed, and Requena claimed to be living in poverty and ill health. The *cabildo* did not act on Requena's request.

Funding never came easily for military and civil service pensions. When Puerto Rico received the significant migratory flow of refugees from the South American wars of independence, many of the migrants were widows and orphans. To display solidarity, show the responsiveness of the Spanish crown to those who were loyal vassals, and ease the financial situation of those areas receiving large numbers of migrants, the Spanish authorities created an inheritance tax designed to assist widows and orphans. In 1825 the government forced a three-peso tax—which had been previously designed to raise funds for the war against France—and asked the local priests and scribes to enforce collection of it.[112] This *mandas-pías forzosas,* as the tax was called, helped to collect a significant number of funds for the South American widows and orphans. In 1856 the governor asked for a voluntary contribution to raise funds to provide for the widows and orphans left stranded by the cholera epidemic on the island.[113]

Widows' and children's pensions usually had a number of strings attached to them. Many pensions were discontinued in the case of remarriage (widows) or marriage (daughters). Doña María de la Paz Chico, for example, was entitled to an orphan's pension after the death of her father, Captain Don José Chico.[114] The Spanish treasury informed Chico that she would not receive any money for the time she was married, first to Don Sebastián Baergas, and then to Lt. Colonel Don José Zalazar. Both men were deceased at the time of the letter from the Spanish treasury. The rationale behind the rule eliminating pensions in case of marriage or remarriage probably came from the perception that women and children were persons who needed to be taken care of.[115] The moment a man became a part of their lives, it was assumed that widows and/or orphans no longer needed state support.

Women in Artisan Trades

Master artisans and other high status artisans were also among San Juan's middle sectors in the mid–nineteenth century. One of the few trades in which women were involved and which seems to have had some status was making and repairing clothes. A significant number of women in San Juan were *modistas* (couturiers), weavers, dressmakers, and seamstresses. Women ran shops related to all aspects of clothing and dressmaking. A North American traveler in San Juan, for example, was surprised to find the widow of a South

American diplomat running a hat store.[116] Antonia Rodriguez, who was associated with a male *pulpería* owner, had a *cordonería* (string shop) in 1854.[117]

The number of women who worked designing, sewing, or repairing clothes was very high in San Juan. Of course, the census data only enumerate women who did this for a fee and did not include the hundreds of women who sewed as part of their domestic responsibilities. In 1846 there were almost as many seamstresses as there were servants and laundresses in San Juan (see table 3.3). On occasion the census made a distinction between *modistas* (couturiers) and *costureras* (seamstresses), but the number of *modistas* reported was minimal. Seamstresses, therefore, made most of the clothing for the city's residents. There was high demand for this service in a city that housed the governmental, religious, and military bureaucracies. Military uniforms, priests' garments, and slaves' outfits probably provided steady work for a considerable number of women.

Seamstresses in San Juan seem to have come from higher class, racial, and economic strata than women in occupations such as laundresses, domestics, and cooks. As table 3.4 indicates, nearly all of the 422 seamstresses identified in the 1846 census were free women. This contrasts heavily with the number of free women who were either cooks or servants. Only laundresses had a higher percentage of free women among their ranks, but they still were 20 percent lower than the figure for seamstresses. Table 3.5 shows the racial composition of women in San Juan whose occupations were related to dressmaking (like seamstresses) or to domestic work (like laundresses and ser-

Table 3.3. Women's Trades in San Juan by Barrio: 1846

	Santo Domingo	Santa Bárbara	San Francisco	Total
Washers	148	135	72	355
Cooks	34	5	45	84
Servants	n.a.	182	267	449
Mondongueras	4	3	n.a.	7
Ironers	n.a.	n.a.	1	1
Seamstresses[a]	104	230	108	442
Other[b]	1	n.a.	n.a.	1
Total	291	555	493	1,339

Sources: AGPR, Censos San Juan, 1846.
[a]Includes three *falderas* or skirtmakers.
[b]Refers to a *cam(a)*, which I have not been able to identify.

vants). Most of these "working women" were women of color.[118] Four out every five working women in San Juan in 1846 were women of color. Close to half of them were black.

Another indication that seamstresses were economically and socially better off than other *sanjuaneras* with domestic occupations is provided by home ownership patterns. Seamstresses were among the most likely of all working women to own their homes (see table 3.6). Laundresses also ranked high among working women in terms of house ownership. Any other working women, besides seamstresses and laundresses, were very unlikely to have come close to owning, or even renting, a house or a room. Seamstresses lagged behind laundresses in the data on room renting. Clearly, house ownership and room renting were particularly difficult for working women like cooks and servants, who probably lived with the family they worked for. Also, it seems that both seamstresses and laundresses probably received better wages than servants and cooks. The higher propensity of domestics to be slaves (when compared to laundresses and seamstresses) probably means that these domestics could not be living independently. The number of seamstresses and laundresses who owned their houses or rented their own rooms also gives us a rough idea of the number of working women who were single parents, lived alone, or were widowed.[119] Around 18 percent of all seamstresses and 24 percent of the laundresses were listed as single mothers, widows, or maidens.

Table 3.4. Women's Trades by Legal Status and Barrio, San Juan: 1846

	Santo Domingo		Santa Bárbara		San Francisco		Total	
	Free	Slave	Free	Slave	Free	Slave	Free	Slave
Washers	123	25	97	38	44	29	264	92
Cooks	4	23	1	4	3	43	8	70
Mondongueras	4	—	3	—	—	—	7	—
Servants	—	—	35	147	19	270	54	417
Seamstresses[a]	96	8	228	2	108	—	432	10
Ironers	—	—	—	—	1	—	1	—
Total	227	56	364	191	175	342	766	589

Source: AGPR, Censos San Juan, 1846.
[a]Includes three *falderas*, or skirtmakers.

Table 3.5. Female Domestics and Seamstresses in San Juan by Race and Barrio: 1846

	Santo Domingo	Santa Bárbara	San Francisco	Total
White	72	117	62	251
Black	75	216	271	562
Mulatto	66	218	n.a.	284
Parda	78	n.a.	160	238
Total	291	551	493	1,335

Source: AGPR, Censos San Juan, 1846.

Table 3.6. House Ownership of San Juan's Female Domestics and Seamstresses: 1846

	Owner	Did Not Own	Rented Room	Total
Washers	13	343	96	452
Cooks	0	86	9	95
Mondongueras	1	6	1	8
Servants	0	472	0	472
Seamstresses[a]	16	426	78	520
Other[b]	0	2	0	2
Total	30	1,335	184	1,549

Source: AGPR, Censos San Juan, 1846.
Note: Data from Barrio Fortaleza not included.
[a] Three *falderas* (skirtmakers) were included along with the seamstresses.
[b] "Other" includes one ironer and one *cam(a)*, an occupation I have not been able to identify.

There were some women who held occupations traditionally associated with male artisan trades. The 1846 census, for example, listed two women who worked as carpenters, one who worked as a shoemaker, and another who was a bricklayer. These women probably worked with their husbands or partners. Other women worked as cigar makers. Although cigar making is usually considered a male artisan trade, in Puerto Rico, Cuba, and parts of Mexico there were plenty of women working alongside the men in cigar shops.[120] The shops were sexually segregated, as women usually prepared the tobacco fillers and wrappers so that the men could actually do the cigar rolling. In San Juan, for example, Doña Josefa Más is listed as a *fumacera* in 1846.[121] Her father, Don Ramón Más, was also a *fumacero*. María Belén Fauco was a young parda woman listed as a *fumacera*. She was also the daughter of another *fumacero*, Claudio Fauco. It seems that women had a long presence in the cigar making business; the Junta de Beneficencia's plans in 1821 included teaching *sanjuaneras* cigar making skills (in addition to sewing classes).[122]

Conclusion

This chapter has focused on two major themes. The first one has been to show that women were active participants in most of the crucial areas of San Juan's economy. If the level of economic participation by women in nineteenth-century San Juan is surprising, this is probably more a reflection of myths and misconceptions than of any close scrutiny of the historical record. Previous studies have always focused on the exceptional nature of women's activities in the past; had I wanted to emphasize that aspect, there were plenty of such "exceptions" in nineteenth-century San Juan—such as, for instance, the widows of Gonzalez and Ferrer, who owned and operated a printing press/bookstore and binding shop.[123] Yet, this chapter was designed to show the continuous, quotidian, crucial participation of *sanjuaneras* in the city's economic life.

Elite women, with the possible exception of widows, usually influenced and participated in economic life in indirect ways. In the world of wholesale and retail trade, women's capital was important in order to start and to continue businesses and partnerships. Through inheritance and intermarriage, elite women allowed planters and merchants to perpetuate their status and wealth. Elite and middle-class women were also actively involved in the slave market. Among the small professional class, women were present only in the field of education. Female teachers were consistently underpaid and underequipped in comparison to their male counterparts. Still, in a period of eco-

nomic contraction, the state's plans for an increased investment in the education of girls provided some promise of future employment. As the second half of the nineteenth century advanced, both the city's elite and the Spanish government paid increasing attention to the education of women. This educational drive intended to provide a more secular education geared toward preparing girls to be modern and confident mothers and home managers in the future.[124] The Catholic Church, as we will see, fought the secularization of education, and particularly of women, with increased vigor after the 1850s.

One area in which elite and middle-class women played an important role in San Juan's economy was in real estate. At different moments throughout the century, women owned between 34 and 37 percent of the available houses in the city. Women were also incredibly active tenants and landlords. In a city where housing was a scarce commodity, women played a pivotal role in controlling, and being affected by, San Juan's real estate market.

This chapter has also shown some of the responses and the effects that the changing San Juan economy had upon women. The difficult times experienced by the city after the 1840s affected the number of women involved in small retailing and shopkeeping businesses. Even when one accounts for faulty bookkeeping, it seems that more women who owned *bodegas, mercerías,* and *pulperías* were driven out of business after the 1840s. Staggering debt, lack of currency, and the shortage of housing had a negative effect on the high numbers of women who either owned or rented houses or rooms. If real estate was some sort of feminine realm of economic activity, the difficulties of this business must have seriously undermined the financial stability of many women and their families. The economic pain felt by women in upper and middle sectors—coming from commerce, agriculture, or real estate—must also have affected the capacity of these women to employ and support domestics. As a matter of fact, the rise in the prices of basic foodstuffs and of slaves after the 1840s caused havoc in the supply of domestic workers in San Juan.

Sanjuaneras—mostly elite ones—actively employed mechanisms such as courts or petitions to influence and improve their lot in the city's life.[125] The historical record shows that women fought tenaciously to keep their businesses open and their rental apartments profitable, and to receive a fair price for their services. Men, it must be remembered, were also suffering during San Juan's tough times. In all-out competition for increasingly scarce resources, the inequities of patriarchy, race, and class all surfaced to impede the well-being of women. Given these circumstances, it is not surprising to find women—at least in middle and upper sectors of society—fighting to abolish

or reform the structures that helped to perpetuate their subordination in the economic and the social spheres. The struggles for better and expanded education for women, for more control over family decisions, and for more access to public participation were all related to the attempts by *sanjuaneras* to fight the difficult times that the city had faced since the 1840s.

4

Through the Back Door: Lower-Class Women in San Juan's Economic and Social Life

In the introductory chapter, I told the story of Bernarda Baez, the black woman who worked as bell ringer in San Juan's cathedral church. The invisibility of Baez's work—she did the actual bell ringing, while a man took the credit for it (both during her husband's illness and after his death)—is typical of the way lower-class women have been portrayed in Puerto Rico's economic history. Lower-class women's efforts and contributions to society and to the economy have been ignored and misrepresented. There is also another side to Baez's life. Not only did she make the best out of the economic opportunities life presented her with, but she seems to have done well, particularly for a woman of color. Thirteen years after she was fired from her job in the cathedral church, Baez appeared as the owner of two modest houses in San Juan in 1859.[1]

Bernarda Baez's story is a fitting metaphor of the way in which Puerto Rican history has traditionally approached the economic participation of women in the nineteenth century. In this chapter I will address the changing and constant roles lower-class women played in the key areas of San Juan's nineteenth-century economic life, stressing the importance of their contributions to the economy. Their economic participation was not limited just to domestic work, as lower-class women often worked in smaller retail shops or in food, drink, and lodging establishments. Still, women played an important role in the domestic arena by doing most of the washing, sewing, and cooking. Domestic work was a crucial component in an urban economy that housed sizable bureaucracies. Female domestic slaves, for example, were a fundamental component of San Juan's economy. Their importance became evident as the debates about abolishing slavery gained momentum and sanjuaneros(as) pondered how to guarantee a reliable and cheap domestic labor force after abolition.[2] Finally, this chapter will look at the effects that

the elite's and the Spanish colonial authorities' modernizing campaign and the city's economic crises had on lower-class women's lives—particularly the anticoncubinage campaign targeted at lower-class women and men in the 1850s. Through this campaign, colonial and ecclesiastical authorities tried to alleviate the labor shortage on the island and in San Juan through moral reform.

Street Vendors, Peddlers, and Food Sellers

We have already seen that women participated in the upper and middle tiers of commercial activity in San Juan. There was also a lower level of retail activity in the city which included street vendors, peddlers, food sellers, and small shop owners. *Sanjuaneras* were very much a part of this kind of economic activity, which required little capital and addressed the needs of the lower stratum of the city's population. It was also the kind of economic activity which came under the increased scrutiny of the *cabildo* and the governor by midcentury.

Women seem to have been well represented among the very small grocery shop owners. As the data from the 1846 censuses show, many women operated *quincallerías, ventorillos,* and other small vending establishments. These smaller stores required even less of a capital outlay than did *pulperías*. The *ventorillos* probably sold low-quality spirits, fruits, and vegetables produced in San Juan's neighboring municipalities. The 1820 data show that women were a majority of the owners or overseers of *ventorillos*. The 1846 census data show that women of color often operated this kind of shop. Gertrudis Tanco, for example, a thirty-four-year-old black widow, was one *ventorillera* listed in the 1846 Santa Bárbara census.[3] Another *ventorillera* listed on that census, Juana de los Santos, was a twenty-six-year-old black single woman.

The data from the 1846 census indicate that *sanjuaneras* were engaged in a variety of small retailing trades. The San Francisco barrio included three women among the *fonderos(as)*: Juana Asabud, Antonia Chupani, and Catalina Munero. In the Santa Bárbara barrio, both Gertrudis Tanco and Juana de los Santos were listed as *ventorilleras*. In the same barrio, Ana Gabriel and Carmen Dorado also were *revendonas*. Margarita Santiago worked as baker, along with several slaves, in Don Pedro Cami's bakery. The Santo Domingo barrio also had numerous cases of women listed in small retailing. María Cambien and María de las Angustias Morales made candy and sweets. Ana María Guzmán, Guadalupe Rijos, Emilia Cristina, Rafaela, and Josefa were listed as *vendedoras* (saleswomen). The fact that four of these women were black and the other a parda means that these women were probably street vendors and not established retailers.

Women's presence was also strongly felt in businesses that sold prepared or cooked food. The predominance of women as cooks probably translated into more control and participation in running retail food establishments. Since most of the cooking in nineteenth-century San Juan was done at home, most of the businesses selling prepared food catered to very particular customers: travelers, soldiers, and sailors, among others. Prepared food was also sold in locales oriented toward relaxation, entertainment, or overnight lodging. These food, entertainment, and lodging businesses were not looked upon as respectable establishments by the church, the government, or the elite. They were also considered suspicious locales where the underclass could meet to engage in rowdy or immoral behavior or where seditious or revolutionary activity could breed.

Tourism was not a developed industry at the time. A majority of the city's distinguished visitors, who were probably in San Juan for business, had probably arranged to stay with a respectable family or with a business associate. Such was the case of Ralph Waldo Emerson's brother, Edward Bliss Emerson, who traveled to San Juan in 1831 for health reasons. After initially staying in a poorly kept inn, Emerson landed a job with the U.S. consul, Sidney Mason, and moved to Mason's house as part of his contract.[4] Most eating, entertainment, and lodging establishments had a bad reputation among the city's elite. In 1862, for example, the *cabildo* called for real enforcement of the laws regulating selling damaged or spoiled food in *fondas*, inns, and other dining businesses.[5] The combination of the domestic orientation of these establishments, the inferior economic status of women, and the general immorality the elite associated with women of color all help to explain why so many women operated and controlled these kinds of establishments. Basically, no "respectable" women would have been involved in these kinds of businesses.

Fondas are one example of such eating and drinking businesses. The San Juan data indicate that many of the women who ran *fondas* were widows. The three *fonderas* listed on the 1846 census were widows. Juana Asabud was a fifty-year-old white woman who had migrated from Costa Firme.[6] Since Asabud rented the room where she lived, it is not clear whether she owned a *fonda* or just operated one. Doña Antonia Chupani, on the other hand, seems to have owned her *fonda*. Chupani was a thirty-four-year-old widow from Spain. She received help from two of her daughters and from two female slaves in running her establishment. Another *fondera* was Catalina Munero, a seventy-year-old parda widow. Munero, a native from Santo Domingo, apparently ran her *fonda* with the help of her five grandchildren, with whom she also lived. Curiously enough, Munero and her family were next-door neighbors to one of San Juan's most important merchants and slave traders, Don Casimiro Capetillo.

Mondonguerías were another example of food-selling establishments usually run by lower-class women. *Mondongo* (tripe) is a kind of stew prepared with the intestines and other inner parts of cows and pigs. In San Juan, the *mondongueras*—women who prepared *mondongo*—were, for the most part, women of color. Many of them were the wives or partners of butchers, most of whom lived near or in the Santa Bárbara barrio. The slaughterhouse was located outside the city wall just east of the La Perla garrison.[7] The town council had designated an area contiguous to the slaughterhouse for the *mondongueras* to conduct their sales and collected a tax from the *mondongueras* for allowing them to operate their stores.[8] Other *mondongueras* sold their product in their homes or in small road houses outside the city walls. Before the slaughterhouse moved outside the city wall, it was located on east San Sebastián Street (Santa Bárbara barrio). The street section next to the old slaughterhouse was commonly referred to as the "street of the *mondongueras*."[9]

Spanish authorities were always suspicious of *mondonguerías* because they were frequented by blacks, mulattos, *libertos*, and other "questionable characters." One of San Juan's *alcaldes* accused Dominga Muriel and Justa Santana of selling *mondongo*.[10] The *alcalde* argued that their shops were not sanctioned by city authorities and that, by staying open until late at night, their shops provided a potential meeting place for runaway slaves and other delinquents. In another incident, the Spanish authorities told Maria Concepción that, if she continued to sell *mondongo* near the road leading to Puerta de Tierra, she would be punished. Her punishment was to force her to become a domestic servant.[11] Since Spanish authorities feared that racial and anticolonial conspiracies might brew within these *mondonguerías*, strict vigilance was kept over these establishments. Yet, regardless of the harassment by the authorities, *mondonguerías* remained popular establishments among city residents, especially among blacks, mulattoes, and pardos.

Women in the food and entertainment business benefited from the patronage and the presence of artisans, *peóns*, and other construction workers. When the road between Cangrejos/Río Piedras and San Juan was being built, and later when the Carretera Central was being constructed, many women set up food *ventorillos* in the vicinity to feed workers and travelers.[12] Women also owned or operated entertainment establishments, such as billiard rooms and *galleras* (cockfighting rings). Although cockfights were banned by several governors, Doña Ramona Saviñon owned a *gallera* in the cellar of a house on Luna Street in 1861.[13] On top of the gallera, Don Juan Pacheco ran a *pulpería* with a billiard parlor.

An even more modest operation was selling food and other items on the city streets. Many women who had other forms of employment, such as domestic service, still had to sell food on the city streets or door-to-door in

order to supplement their incomes. In this case, San Juan followed the Caribbean pattern identified by Sidney Mintz regarding the control women exercised over food markets.[14] Prepared foods and produce were sold at the city markets. Slaves and recent *libertos* were very active as street and market vendors. In San Juan, as in other Latin American cities, the small income generated by these activities allowed many urban slaves to purchase their freedom.[15] Angela Fernández was one such slave. She was a servant for Doña Francisca Gómez, and she sold food on the city streets on a part-time basis.[16] Another slave woman raised 350 pesos to manumit not herself but her son.[17] Her owner was petty enough to make the slave woman pay the two pesos that the notary charged for the bill of sale.

The practice of allowing slaves to rent themselves seems to have been widespread in San Juan in the mid–nineteenth century. It was probably a very easy way for masters to receive additional income in times of economic hardship, as slaves had to give their owners a substantial part of the outside income they received.[18] Usually, slaves paid their masters a daily wage and then would try to rent their services to somebody else in the city. In this arrangement, female slaves received not only additional cash but also an increased level of independence from their masters. It was the pernicious effects of this independence that *cabildo* officials pointed to when legislating to curb these self-rental agreements.[19]

Most of the *revendonas* and street vendors listed on the 1846 census were women of color. Ana Gabiel was a *revendona* who lived on the Santa Bárbara barrio. She was a thirty-five-year-old single, black slave who rented her own room and lived alone. Another *revendona* was Carmen Dorado, a sixty-year-old widow, African-born and black.[20] It also seems that the majority of the women who sold food or produce on the city's streets were either single or widows. Some of the single women had children to take care of, as was the case of street vendor Ana María Guzmán, a forty-year-old, black, single head of household who had four young children to provide for.[21] Guzmán was from Curaçao. Some of the other street vendors seem to have been young, single women trying to make ends meet for themselves. Rafaela, for example, was a street vendor who lived with a large household as an *agregada*. She was forty years old, single, and black. Another *agregada*, Emilia Cristina, was also a forty-year-old, single street vendor. Cristina was parda.

The city of San Juan was full of such street vendors, something about which merchants and transporters always complained to the Spanish authorities. It seems like the scenario of women, particularly women of color, working as street vendors and *revendonas* was also typical of other Caribbean cities. Kingston officials, for example, repeatedly passed legislation prohibiting people of color from selling in the city's streets.[22] Back in San Juan, the *cabildo*

often received complaints from city merchants and muleteers about the activities of street vendors. In one such case, bakers in San Juan protested the fact that street vendors were selling bread baked in Río Piedras.[23] The *cabildo* on several occasions chastised those who ventured into Palo Seco, Cangrejos, and Guaynabo in an effort to buy directly from farmers and then resell their products on the streets of San Juan.[24] Not all street vendors, though, were outside the law; many of them had licenses from the government and paid taxes.

Gertrudis Rodríguez was a *mondonguera* who asked the town council for a license to operate a small pig yard in the city.[25] The pigs were to be sold in the slaughterhouse and to the other *mondonguerías* located just outside the slaughterhouse. Rodríguez, who already had the pig yard, was still requesting a license ten years after her original petition.[26] In 1853 the *cabildo* agreed to grant Rodríguez the long-awaited permit, but only if she agreed to clean the yard daily. Again, town council officials were concerned about the hygienic conditions of San Juan's public and commercial spaces and about the problems of animal breeding in a congested city. Unfortunately for Rodríguez, the governor reversed the *cabildo*'s decision on the grounds that breeding pigs within city limits was prohibited by the *Bando de Policía y Buen Gobierno*.[27] In 1859 the town council was still fighting to have those families breeding animals near the slaughterhouse put an end to that practice.[28] It is unclear whether Rodríguez still had her pig yard at that time.

One last service that was "sold" in the city was sex. Prostitution had been present in San Juan's history since 1526, when the Spanish crown authorized the creation of a brothel to respond to the sexual needs of the overwhelmingly male population in the city.[29] As in many port cities, prostitution remained a part of San Juan's life through the nineteenth century. In 1824 Governor de la Torre prohibited brothels in the city.[30] This and ensuing punitive legislation seems not to have deterred prostitution in San Juan. Town council officials also seemed concerned about the practice of female slaves being rented for prostitution. According to the town council, this was one of the immoral consequences of allowing slaves to rent themselves in the city. One of the difficulties in fighting slave prostitution was the fact that the slaves often did not need to be full-time prostitutes. They could perform other kinds of domestic and vending jobs, making policing difficult.[31] By the 1870s, prostitution had again become an important concern for city officials. In 1876 the municipal government issued regulations for the practice of prostitution.[32]

Domestics in Nineteenth-Century San Juan

Aside from the busy rhythm of merchants, storekeepers, and artisans, San Juan's economy was highly dependent on a variety of domestic services, most

of them offered by women. Domestic service included all the activities that kept a household running: cleaning, repairing and making clothes, cooking meals, washing and attending infants, and caring for sick and elderly people. Many women performed these tasks as part of their unremunerated role as housewives or daughters, while others performed these services for a fee in the open market (while maintaining responsibility for their own domestic family obligations). Domestic slaves, of course, were an exception, because, for the most part, they were not paid for their services.

San Juan's urban environment, tied to the presence of large military, religious, and governmental bureaucracies consisting mostly of men, had a high demand for domestic services. The cathedral's clergy, the military, and the Captain-General's staffs had to be fed daily; their quarters needed tending, and their uniforms required cleaning and maintaining. The city always provided an abundant supply of potential customers for domestics.

It has not been easy to document the history of the women who washed, cooked, ironed, and sewed in nineteenth-century San Juan. Most of these women were not members of the city's elite. Documentary evidence follows property, economic transactions, and financial resources, things that were not abundant in the lives of most of San Juan's domestics. Therefore, the contributions of these women to San Juan's society and history have gone unrecorded and unappreciated.

One of the most common forms of domestic employment for women was to become laundresses (see table 3.3). Laundresses could be full-time help at an elite family's house or at a state, church, or military institution. Other women provided their washing services to several clients. These women usually gathered their clients' clothes and took them elsewhere to wash them. Since washing was a physically demanding chore, many slaves were given this task. At least a third of San Juan's laundresses were slaves (see table 3.4). Some slaves washed clothes for the person or the family that owned them. Others sold their washing services to persons other than their masters as a source of extra income. As I have shown before, *cabildo* officials usually complained about the liberty these slaves had and recommended that the masters put an end to this self-renting practice.[33]

Washing was no easy chore in a city that lacked accessible supplies of potable or fresh water. In many towns and villages in Puerto Rico, women could wash their clothes in the nearest river. San Juan, the tiny islet, had no such nearby rivers. In Havana a similar freshwater-supply problem had been solved, at least partially, through the construction of an aqueduct in 1835.[34] But *sanjuaneros* did not possess the financial resources to imitate the Cuban solution. San Juan's residents were forced to rely on several springs from which to obtain the city's water needs.[35] One was located near the Condado

area, next to where the Puente de San Antonio was located. This spring's water volume and quality were among the best available to the city's residents. Another spring was located close to the Puntilla area, but the water there was not healthy and had been abandoned in the late sixteenth century. Finally, the inlet of Miraflores had a spring that provided excellent water. The Miraflores spring was used throughout the nineteenth century to provide water for the ships anchoring in San Juan's bay.

The city also received drinking water from the rivers in nearby Guaynabo, Puerto Nuevo, Río Piedras, Cataño, Palo Seco, and Bayamón. The water was brought into the city in small boats or in carts, if coming from Río Piedras. After reaching the city walls or the dock, the water was distributed in the streets by water bearers.[36] In times of severe droughts, the *cabildo* increased the amount of water brought from the hinterland in order to satisfy the city's demand.

Water was also accessible in several small wells located among the city's plazas. There were wells near the San Justo gate and in the plazas next to the Carmelite and Franciscan convents.[37] Most of these wells were opened or rebuilt during the late 1830s, but the water supply of the wells was not abundant. The *cabildo* was forced to buy water pumps from the United States in order to try to increase the water supply of the wells in the plazas.[38] These wells were closed later in the century due to the continuing problems extracting water and the repeated criticisms of church officials about the noise and tumult such public spaces—often crowded with the laundresses and their children—brought to their holy quarters.

Most of the laundresses took their bundles of clothes to the wells or to the small fountain in the Condado spring. Others carried water to their houses (or collected water in an *algibe*) in order to do their job. In both cases, the job entailed walking a considerable distance and carrying a heavy load of either water or clothes. The wells and fountains became centers for women's gatherings.[39] Many laundresses must have spent hours chatting among themselves as they performed their jobs. They probably brought their children along to help with the wash and to keep them under parental supervision. The tasks of drying the clothes and ironing them concluded what was a very labor-intensive and physically demanding job.

The constant occupation of important public spaces placed laundresses at odds with city authorities. It is fair to say that laundresses made colonial officials uneasy. First, many of San Juan's laundresses were women of color. This immediately made them vulnerable to suspicion, surveillance, and control. The predominance of people of color in San Juan's population, up until midcentury, exacerbated tensions in a colony perpetually in fear of a slave or mulatto uprising. The authorities looked upon the gatherings of laundresses

as perfect breeding grounds for seditious activity. Also, these gatherings were predominantly female-oriented, and that must have increased the uneasiness of the male officials in charge of surveillance and order.

Both church and crown officials complained about the lack of decorum and order which often reigned at the city's wells and fountains. As the city grew more conscious of the latest European trends in the use of public spaces and plazas, the spectacle of laundresses in these plazas became very objectionable. Late in the century, city officials actually drafted plans for the construction of a huge fountain and washing place (*lavadero*) outside the walls.[40] This *lavadero* would have been located in the Puerta de Tierra barrio, where the unruly behavior of the laundresses would prove less of an eyesore to the Spanish officials and to the city's elite. Disguised under the facade of urban development, hygiene, and progress, the move to push out the poor and colored women who washed the city's clothes was really a defensive move by the elite and a metropolis afraid of the dislocations caused by the unpredictability of the postabolition world. Due to lack of funding, the *lavadero* in Puerta de Tierra never materialized.

The laundresses' threat to the colonial establishment was not just potential but real. Laundresses had organized collectively on several occasions to demand proper working conditions. The laundresses from the Hospital de la Caridad once complained and went on strike because there was not enough water in that hospital's cistern to supply their needs.[41] They wanted the town council to allow them access to the cisterns in Ballajá. For the laundresses, no water translated into no work and no pay. The laundresses were also able in 1856 to wrestle a salary increase of 1 real per dozen items from the chief of the Military Hospital, Don Pablo Canto.[42] Upon becoming chief, Canto wanted to improve the quality of the laundry service. He accomplished this after negotiating the salary increase with the laundresses.

Another incident that reflects the tensions caused by laundresses gathered in public spaces was the angry dispute in 1857 between laundresses using the Condado fountain and the *alcalde* from Cangrejos.[43] The *alcalde* instructed the women to leave the premises of the fountain because they were making too much noise and were trespassing on private property. After an angry exchange, which the *alcalde* believed could have taken place only with dishonorable women, the women replied that the *alcalde* had no jurisdiction over those grounds. The laundresses argued that the *alcalde* unjustly removed them from the fountain and took their grievance to the governor. The navy chief defended the laundresses by stating that the navy had jurisdiction over coastal areas, like the Condado region, and that they had no problem with the presence of the laundresses at the fountain. The *alcalde's* letter to the governor

survived in the historical record, but the latter's reply did not. The city's laundresses clearly were not going to allow anyone to push them around.

These accounts of defiance, solidarity, and collective organization by laundresses should not obscure the tremendous vulnerability that these women experienced in their daily lives. As women who, for the most part, performed their work in public areas, the guarantees awarded to respectable women—those protected by remaining indoors or "private"—did not apply.[44] Laundresses and other women who were forced to work outside their homes were open prey for any kind of abuse: verbal, physical, or sexual. Not only were these women vulnerable to attack, but they had few resources available in order to vindicate themselves after such incidents. The civil courts' records document the "reasonable doubt" that men (or other women) could throw upon a woman just because the nature of her business required that she be outside her house, enter clients' homes, or travel the city streets unescorted. In a civil suit, Pasqual García, a soldier, dismissed any connection between his having entered the grounds of Juana de Dios González's house and the possibility of their dating by arguing that, since González's mother was a laundress, it was obvious to assume that he entered their house just to pick up his laundry.[45] Usually a man's entrance into a single woman's house would, at least, hint at the possibility of courtship or seduction. But this was not the case with "public" women like laundresses González and her mother. The public persona of these women made them vulnerable both in the public realm and within their private homes. Their venturing into public wiped away most of the protection home awarded women. The patriarchal system placed laundresses and other domestic working women in double subordination: economic, limiting them to jobs destined to generate a low income; and social, making them fair game for physical and sexual denigration.

Another type of domestic service was child care. There is evidence that many women of color served as nannies in San Juan. Others served as wet nurses. The slaves who worked as nannies not only took care of babies inside the house but took the infants for strolls or accompanied more grown-up children on their trips to school, church, or friends' houses. Labor leader José Mauleón Castillo, for example, remembered being accompanied to school and back home by a male African slave.[46] One of the baby daughters of the liberal intellectual Don José Julián de Acosta was cared for by a mulatto woman named Juana.[47] Many of the domestic slaves who were listed as servants (*criado[as]*) probably performed these duties as part of their daily routine.

It was not just working outside the home that threatened the security of domestics. Servants, cooks, nannies, and other domestic workers who seldom ventured out of the master's or employer's house, although supposedly

protected by those for whom they worked, faced sexual and physical abuse in the workplace. This abuse ranged from extreme forms of corporal punishment to unwanted sexual advances and verbal abuse. Alejandro Tapia y Rivera, for example, recalled meeting a slave owner who had the teeth of one his female domestics removed because she failed to serve him rice the way he liked it.[48] Another case illustrates the slippery world in which many domestics lived in San Juan. Doña Mariana Llovera sued Don Jaime Sastre to have him marry her or "repair the damage" of having two sons with him by giving her a dowry.[49] Sastre claimed that Llovera moved into his house to work as a servant and that he had paid her for such services. Furthermore, Sastre added that the sexual relations they had were consensual and that he had never promised to marry Llovera. In the course of the trial, Sastre also said that, prior to working for him, Llovera did not live with his father, as she claimed, but lived in a whorehouse and was not, obviously, a virgin. Llovera argued that Sastre was lying, but the judge ultimately sided with Sastre. Although several factors probably influenced the judge's decision, it is clear that Llovera's status as a servant—a plebeian woman who lived under the same roof with an unmarried man—damaged her credibility at the time she wanted to have her honor restored.

Some slaves and domestics probably served as midwives. Most of their jobs were, in a way, extensions of the domestic realm of women's lives. Although most midwives were not certified by the city, they operated under the watchful eye of the Spanish authorities. Many domestics also provided nursing services, which mostly entailed providing company and surveillance and attending to patients' basic necessities. There was a need for very specialized kinds of nursing services, as the case of young María de Jesús demonstrates. She was a mulatto woman who had been left to the care of the navy's Contador. When she contracted the *mal de bubas*—a type of venereal disease—she was shuffled back and forth between the Casa de Beneficencia and the Hospital de la Caridad. Finally, since her disease was considered contagious, the Casa's director decided to have her moved to an isolated house where she could recover. María was taken to the house of "one of those women who takes care of people with venereal disease."[50] Unfortunately, these nurses seldom appear in censuses or other kinds of traditional documentation.

Domestic Work and the Fear of Abolition in San Juan

The importance of domestic work in San Juan's urban economy is shown in the role that the future supply of domestic work played in the debate over abolishing slavery in Puerto Rico in the second half of the nineteenth century. As plantation owners considered who would work in their sugar estates

and on what terms if slaves were given their freedom, the elite in San Juan and the Spanish authorities worried about securing domestic workers for the city.[51] Not that *sanjuaneros(as)* were not concerned about the future of agricultural estates on the island, but their more immediate needs in the city required an abundant, steady, and reliable supply of domestics to maintain the quality of life that elite and middle-class city residents were growing accustomed to. Since the 1840s, city officials had been claiming to have a shortage of workers. Of course, the problem was not that there were not enough people in San Juan but that it was becoming increasingly difficult to have workers accept the working conditions offered by city employers.

The city's economic woes also had an effect on the domestic labor market. Slaves, which until 1873 were the most important source of domestic labor in the city, had become more expensive by the mid-nineteenth century. Not only did the price of slaves increase as the demand for bonded labor rose at a time of limited supply, but the costs of maintaining slaves also increased in San Juan.[52] For those who could not afford to buy slaves, renting them for a day or a prolonged time was an expensive alternative. The economic crisis that affected San Juan after the 1840s undermined the long-term viability of urban slavery and complicated the efforts of elite and middle-class families to secure domestic workers.

Spanish colonial authorities were not particularly creative in their policies oriented at securing domestic workers for the city's elite, professional, and middle-class families. The often-employed model of creating lists, forcing workers to carry passes and report to central authorities, and imposing fines on those who disregarded the regulations was copied, with occasional modifications, by the governor and the town council in dealing with urban domestic workers. In 1858, for example, the governor requested all municipalities to prepare a list of all available domestics and agricultural workers.[53] It is significant that the government equated the importance of agricultural workers—usually considered the backbone of the island's plantation economy—with that of domestic workers.

The regulation of domestic workers continued in the 1860s. In 1864 San Juan's *cabildo* created a listing of available domestic workers to complement a set of regulations regarding contracting domestic workers. To be included on the list, domestic workers—women or men—had to be fourteen years of age or older, who rented their home care, cooking, washing, or cleaning services.[54] In the municipal listing, information regarding the employment history of each domestic worker would be included. The town council's regulations, primarily concerned with securing labor for the city, punished those who disregarded the regulations and the listing with imprisonment, perform-

ing public works (for men), and fines (for women). The problem of domestic workers seemed to continue to bother city officials, for another set of regulations was issued in 1871.[55] Elite *sanjuaneros(as)* and Spanish colonial officials were busy trying to prepare the domestic labor market in San Juan to meet the potential dislocations to be caused by the abolition of slavery in 1873.

Lower-Class *Sanjuaneras* and Anticoncubinage Efforts

Although the state's and the church's campaign to eradicate common-law marriages and concubinage was supposed to apply to people of all racial and socioeconomic groups, the reality of the origins and the enforcement of the campaigns proved to be different. There was an urge by both the Catholic Church and the Spanish authorities to eradicate concubinage around mid-century. It seems likely that most of the church's pro-marriage and pro-family rhetoric was a response to the low marriage rates among the island's population.[56] Also, the high incidence of female-headed households could have been part of the reason why church and state officials began an aggressive pro-family and charity campaign in the second half of the nineteenth century. As I have shown elsewhere, about 47 percent of all the heads of household in San Juan were women in 1846.[57] Although female heads of households were a common phenomenon in the Caribbean and in Latin America during the nineteenth century, the rates for San Juan are incredibly high even by regional standards.[58] Finally, the fact that beneficence, as I will discuss in more detail in the next chapter, was oriented to solving the family problems of unprotected single mothers and trouble-prone children shows the magnitude of the problem the Spanish authorities faced in the city.

Although a full study of concubinage and common-law marriage practices in nineteenth-century San Juan is beyond the scope of this book, a quick review of some of the data generated by the campaign against concubinage and vagrancy waged by both church and state officials will show how the state, church, and local elite tried to intervene and police the sexual and family life of lower-class women and men in San Juan. The anticoncubinage campaign waged around mid–nineteenth century by state and church officials attempted not only to eradicate the practice and to control parishioners' sexuality but also to help solve the island's labor shortage by branding culprits as vagrants and pushing them into forced labor.[59] The lists of *amancebado* couples that I have found for San Juan—1855, 1861, and 1863—clearly indicate the class and race bias of the campaign. The lists also provide some indication as to how the anticoncubinage efforts affected *sanjuaneras*.

Church and state opposition to concubinage was not a nineteenth-century novelty. Church officials had been vigorously denouncing and preach-

ing against concubinage since the mid–eighteenth century.[60] Most of the evidence regarding eighteenth-century efforts comes from the pastoral visits made by bishops. The prelates were consistently appalled by the high number of *amancebados* encountered in their visits. Women, according to the bishops, were central to the problem because they enticed men into such immoral relationships.[61]

The church had been only moderately successful in getting Spanish colonial officials to seriously prosecute and punish *amancebados* in the eighteenth century. Things changed in the nineteenth century, particularly after the governorship of Miguel de la Torre, who ensured closer collaboration between state and church officials.[62] The labor shortage claimed by *hacendados* and government representatives by the 1840s allowed the state to focus on fighting vagrancy. Vagrancy, church leaders had been arguing for decades, was one of the ill consequences of concubinage. The church's argument seems to have been taken up by Governor Pezuela in 1849, who believed that concubinage was problematic because, "among other things, it diminishes the number of arms available for work."[63] Pezuela's coercive legislation, however, did create different punishments according to one's sex. While precise punishments and fines were listed for male concubinage offenders, female offenders' punishments were left up to the government's discretion.[64] Finally, church and state officials also collaborated in other areas related to guaranteeing an adequate supply of workers for plantation owners, such as allowing laborers to work during religious holidays during harvest time.[65]

The town council's interest in the problem of concubinage certainly increased in the 1840s. References to joint policing with ecclesiastical authorities and to lists of the guilty couples appeared frequently in the *cabildo's* minutes.[66] The town council clearly linked the problem of concubinage to the labor crisis the city seemed to be facing.[67] Enforcing the law against *amancebados* was crucial, from the *cabildo's* perspective, to draw more workers into the city's labor pool.

The lists of *amancebados* which I have found do not include the whole city of San Juan, except for the 1855 list. The breakdown for the number of couples living in concubinge is: 177 couples in 1855, 201 couples in 1861, and 148 couples in 1863.[68] It is difficult to determine whether the change in the number of couples reflects a diminution or increment of concubinage or a variation in reporting and policing techniques. Still, one can make the conservative estimate that the city had between 400 and 600 persons officially listed as *amancebados* between 1855 and 1863.

The 1855 list has no street addresses or job listings, but we can determine something about the class background of the persons listed by looking at whether they were referred to as *don* and *doña* as an indicator of status. Out

of the 354 men and women in the list, only thirty-one (18 percent) men were listed as *dons* and twelve (9 percent) women as *doñas*. Clearly, most of those involved in concubinage were not members of the city's elite (or, if they were, the authorities were protecting them). The law required listing only those couples living together. So, an *amancebado* couple in which one of the partners listed another permanent residence—something far easier for the rich than for the poor—would not appear on the lists.

The 1855 listing also includes details of how the *amancebados* had responded to the charges brought by church and state officials. The law allowed *amancebados*, as well as those accused of vagrancy, the opportunity to change their situation before a second warning was issued. According to the list, three options were provided: agreeing to marry each other; agreeing to separate; or ignoring the initial warning. In this second part of the 1855 list, only the men were asked to respond to the first warning. This is not surprising, since nineteenth-century church and state officials considered that the burden of these illicit relationships fell upon the men.[69] Thirty-five men replied that they were making the arrangements to get married. Men in this group expected to get married, on average, within the next four months. Most complained about lacking the financial resources to get married; others blamed the church for bureaucratic delays in paperwork and licenses. One man, León Quiñones, asked for an eight-month deferment in order to free his enslaved partner Polonia. There were forty-three men who claimed that they had separated from their partners, although they did not provide the reasons for their decision. The largest group of men, ninety-four, ignored the first warning and failed to appear before the authorities to discuss their status.

The 1861 and 1863 listings provide street addresses for the *amancebados*. Unfortunately, these listings do not provide any information regarding the response by those identified as *amancebados*. It is clear from the 1861 and 1863 listings that there was a correlation between high numbers of *amancebados* and less wealthy barrios. Barrio La Marina, the only extramural barrio included on the listing, had by far the highest number of *amancebados*. Furthermore, the listings provide the occupations of a few of the individuals. Except for a *pulpero,* all the occupations identified were artisan or maritime occupations.

The only recorded instances I have found in the town council's minutes about individual concubinage cases were of two couples living in the Puerta de Tierra extramural barrio.[70] Lucas Ramos was discovered living in concubinage with Manuela Marrión, even though both were married to other people. In this case the *cabildo* prosecuted them for double adultery. Bernardo Bultrón

lived in concubinage with one of his slaves—with whom he had several children—even when his legal wife lived in one of San Juan's intramural barrios.

A brief look at the limited data on concubinage lists in mid-nineteenth-century San Juan corroborates that poor and colored people in the city had different practices for arranging amorous and familial relationships. This is consistent with other research in San Juan which has provided data on heads of households, marital status, and family structure in the city and has shown that there were differences between the ways men and women, whites and blacks, and freed persons and slaves experienced family life.[71] In the case of the anticoncubinage campaign, these differences were exploited and manipulated by the local elite and colonial officials to guarantee access to an increased labor pool, and they were part of the agenda to create a modern, safe, and respectable San Juan, particularly as the threat of the abolition of slavery became more real.

Conclusion

Domestic work has always been associated with women. I have shown the different kinds of paid domestic service in which *sanjuaneras* were involved: washing, ironing, cooking, cleaning, and sewing. In San Juan, most of the domestics were women of color. Of the noncommercial occupations held by women, seamstresses seem to have had a higher level of economic and social status. Laundresses, due to the nature of their job and to the city's water supplies, had greater opportunity than any other group of working women to meet in a common area—at wells and fountains—to work and share. I also showed that laundresses, when their interests were on the line, did stand up against Spanish authorities. Poor and colored women were also active in small food and entertainment establishments, such as taverns and *mondonguerías*. These food stores were looked upon with suspicion and scorn by the city's elite. Many poor women also traveled the uneven and muddy streets of San Juan, selling food or drinks door-to-door.

If the data about the high number of female heads of households, the late age of first marriage, and the absence of extended families in San Juan are not enough to convince scholars that traditional assumptions about family life in nineteenth-century San Juan need to be reassessed, the statements from the contemporary church officials might. The campaign against concubinage waged by church and state officials was an acceptance that the Catholic family model was in crisis. The colonial and ecclesiastical authorities also wanted to alleviate the labor shortage on the island and in San Juan through moral reform. Although the campaign had the intention of attacking a labor shortage problem, it was a clear signal that many in the city, especially nonwhites

and the poor, repudiated or disregarded the church's proscriptions. The large numbers of common-law marriages and extramarital relationships were part of an alternative view among the popular classes regarding the marriage and family life model of the city's elite. Both church and state had other reasons to eradicate common-law marriages and female-headed households. These women, many of them women of color, represented living challenges to the uniform discourse of a "proper place" for women, of submission, and of dependence which was needed in the racist colonial society that Spain and the local elite wanted Puerto Rico to continue being. Submission and dependence were also key ingredients in the colonial formula, particularly as San Juan tried to transform itself into a modern city in the second half of the nineteenth century. Making sure that women, the poor, and other nonwhites obeyed the church's and the state's law was important in order to guarantee the colonial order on the island.

5

Venturing into the "Public": Women, Beneficence, and Education in Nineteenth-Century San Juan

In previous chapters, we have seen how elite women participated in several important areas of what traditionally has been considered part of the "public" economic sphere: trade, retailing, and real estate. Although women's participation in these areas has seldom been acknowledged (it certainly was not highlighted, with rare exceptions, by nineteenth-century Puerto Rican men), some elite women accumulated a wealth of economic experience throughout the century. Still, elite women were not allowed to actively participate in politics or any other institutional context that required governance over others.[1] The transformations Puerto Rico experienced from the 1860s on—among them increased attention to education and beneficence—opened a space for elite women to participate in the city's life in a more public role. The more liberal ideology embraced by the local elite and by Spanish authorities in the nineteenth century envisioned women—particularly elite women—playing an enlarged role in society. Even the Catholic Church saw the guided participation of women in certain public affairs as appropriate. As we will see, mid-nineteenth-century *sanjuaneras* were ready for the challenges of running or co-running charity and educational institutions. They were ready for these challenges in alliance and in competition with the church, the state, and other sectors of the elite.

In this chapter, I will focus on the Casa de Beneficencia and the Junta de Damas. The first provides an excellent example of the historical legacy of implementing beneficence reforms in a colonial setting and shows the convergence of modernization ideology with the backwardness of colonial fiscal and political policies.[2] Through the history of how the Junta de Damas was started and who was vital in getting it started, I analyze how the first sign of the development of a "women's consciousness"—the emergence of women's organizations such as the junta—was also part of a larger class-based and

racial effort by San Juan's elite. This effort was an attempt to face the challenges that social, political, and economic uncertainty and turmoil brought to Puerto Rican society from the 1850s to the 1870s.

This chapter presents the major forces that facilitated the entry of elite *sanjuaneras* into the management realms of beneficence and education. These forces included previous experience by elite women in matters of charity and education; the change in attitudes and needs from the Spanish colonial state and the Catholic Church regarding the involvement of women in public, institutional, governance situations; and the changing needs of San Juan's elite in the face of turning political, economic, and social events of the 1850s to the 1870s. During midcentury, the state's poor performance as a provider of beneficence and education prompted the church and the city's elite to take action to organize alternative institutions that would address the needs in those areas.

Elite women in San Juan played an important role in this move, since many had acquired significant managing experience in the past and could easily make the transition into areas like charity and education, which were considered extensions of their family, or private, roles. The women who belonged to the Junta de Damas had experience in economic and legal affairs and had extensive family and business ties with all sectors—peninsular and Creole, conservative and liberal—of San Juan's elite. Finally, it is important to remember that even though women's organizations, such as the Junta de Damas, served as a mechanism to galvanize elite women's consciousness regarding female solidarity, these women's organizations must also be seen within the context of a classist and racist response from San Juan's elite to the disruptions that abolition, a shortage of domestic workers, economic downturn, and political uncertainty (among other influences) brought to the city in the period between 1850 and 1870.

Charity and Beneficence in Early Nineteenth-Century San Juan

The history of how the Spanish ideals of beneficence were transplanted and then put to practice in San Juan has just started to attract scholarly attention.[3] Beneficence institutions experienced significant changes, in both ideology and organization, from the beginning of the nineteenth century on. Early in the century Spanish liberals passed the control over most educational and charitable institutions to the state. Charity, an old church concept of assistance which accepted the fixed nature of class inequalities and privilege, began to give way to *beneficencia*.[4] Beneficence legislation was intended to allow the Spanish state—at least in theory—to care for the individual's health and well-being, beginning "in the mother's womb, [and continuing]

through childhood, old age, sickness, [and] all periods of one's miserable life."[5] The state was responsible for ameliorating and eradicating poverty in society and saw beneficence as a way to make marginalized citizens into productive members of society.

One of the key elements in running beneficence establishments was that they were to be, for the most part, financially self-sustaining. Beggars, indigent people, orphans, prostitutes, prison inmates, and just about any marginalized person (excluding the physically or mentally ill) could all be rehabilitated through work. This rehabilitating work, in turn, would help the state pay for the costs of running these establishments. This mentality was familiar to post-Bourbon reform, colonial officials in Puerto Rico, who had been hearing the Spanish authorities theorize on how the island would only prosper when its government became self-financing. Furthermore, beneficence also allowed the state to exercise direct control over the unproductive—and thus potentially troublesome—elements in Spanish society; in the case of incorrigible individuals, it allowed the state to remove them from the public eye.[6]

In 1821 the Spanish liberal Cortes created the Juntas de beneficencia, which were under the jurisdiction of the town councils, to administer asylums, poor houses, orphanages, and other such institutions. The juntas were also an efficient way to challenge part of the church's influence and power. In San Juan, where the constant political changes in Spain made any long-term implementations of peninsular policy virtually impossible, the concrete legacy of beneficence had to wait until the second half of the nineteenth century to flourish. This was particularly true of those beneficence provisions that related to or affected women. The juntas remained largely inactive during the reign of Fernando VII and the periods of political control by the moderates.[7]

No new facilities were built in San Juan after the Junta de beneficencia was created. The junta, under the *cabildo*'s auspices, simply took control of the few existing charitable institutions in the city. Women were not included among the members of the junta in San Juan. The creation of the junta, therefore, was a step backward in women's attempts to participate more fully in public life. At least since the last third of the eighteenth century, Spanish women had been directing or helping to administer charitable institutions in Spain.[8] In San Juan, there is no evidence of similar managerial involvement prior to the nineteenth century. The fact that the junta did not include female members and did not allow women to be members of the governing body of any beneficence institution until late in the century was a negative development in the enhancement of women's interests in the city.

Between 1821 and the late 1850s, the Spanish state took responsibility for

funding and directing the island's beneficence institutions, combining the modernizing and progressive trends of the period with new mechanisms for social and labor control. Prison reform, for example, suggested that inmates worked on public construction projects to help pay for their food, clothing, and shelter expenses.[9] The state was also extending its realm of influence and power over areas previously dominated by the church. Yet, in other Spanish territories like Cuba, the history of beneficence was different. In Cuba, it was the powerful oligarchy that privately funded most beneficence work through the first two-thirds of the century. Havana's Casa de Beneficencia opened its doors in 1794 and was almost completely financed by private donors.[10] In the 1860s, the Casas de beneficencia of Havana, Santiago de Cuba, and Matanzas received almost no support from the Spanish state. Only the casas at Sancti Spiritus and Trinidad received financial assistance from the Spanish treasury. The Cuban planter class was powerful enough to pursue a modernizing agenda—combined with its own need for social control—with little or no help from the Spanish state.[11] The difference between the source of funding and the control over beneficence establishments is an example of the fundamental differences between the Puerto Rican and the Cuban planter classes in terms of economic and political power. In Cuba, planters could push aside both church and state interests to pursue their class projects. In Puerto Rico, the weakness of the planter class forced the state to take larger responsibilities in several domains to make colonialism viable, even if their performance in these areas was mediocre at best.

There is evidence of attempts by members of San Juan's junta to incorporate women's problems into beneficence institutions—like *casas de amparos* (workinghouses)—which were not originally intended to benefit women. One of the central concerns of San Juan's junta in its struggle with the church over control of the Concepción Hospital was the needs of poor, sick women.[12] The only other major hospital in the city, the Hospital Militar, had some beds allocated for poor patients. Unfortunately, since women were not allowed in the Hospital Militar, poor women had no place to go for medical attention. In their correspondence to the governor, the *cabildo,* and the ecclesiastic governor, members of San Juan's junta cited numerous depressing anecdotes regarding the fate of poor and sick *sanjuaneras*. One such case was that of Florentina Campos. In a report filed along with her application for a beggar permit, Campos was diagnosed as suffering from elephantiasis.[13] Junta members complained that, since the church had destined the beds at the Concepción Hospital for wealthy sick immigrants from Costa Firme, there was no place where Campos could get free and adequate medical attention. In their struggle with the church's hierarchy over the hospital, San Juan's junta

members listed many examples of indigent sick women whose conditions, like Campos's, could have been alleviated through proper and timely medical care.

There were other examples of the interest shown by San Juan's junta members in the problems affecting the city's female population. The governor forwarded the junta a royal decree ordering the construction of a *casa de ámparo*. This house was to be a combination of a vocational school, where poor people could learn artisan trades, and an employment agency of sorts, where unemployed or underemployed craftsmen could go for temporary work. The junta's subcommittee, which drafted the workinghouse's feasibility study, concluded the following: first, the project was probably too costly for San Juan's town council; second, since some of the trades suggested in the royal decree did not exist in San Juan—due to the lack of manufacturing—only carpenters, coopers, cigar makers, blacksmiths, and locksmiths were needed; and third, a separate wing should be added to the building to house women who would learn sewing and cigar-making skills.[14] The junta subcommittee members felt that women could produce cheap uniforms for the city's troops and clothing for the hacienda's slaves. It is significant and telling that the subcommittee suggested a separate wing for women, as the original governor's decree made no reference to women whatsoever.

According to junta members, lack of steady work was the reason many poor women had "fallen" into a life of vice and immorality. It should not be surprising to find San Juan's junta members—composed of officers and members of the high clergy and of the city's commercial establishment—concerned with improving and controlling the fortunes of poor and colored women. After all, the city's demography was tilted in favor of these two groups. Since the early nineteenth century, it seems, the presence of many poor and colored women had worried members of San Juan's elite enough to have them push to make local alterations to beneficence proposals and orders coming from the Spanish crown.

The Casa de Beneficencia

No important beneficence projects were developed or constructed by the colonial authorities in San Juan until the second third of the nineteenth century. The idea of constructing a *casa de recogidas* (reformatory for women) and a *casa de beneficencia* dated from 1813, although the projects remained frozen until the late 1830s. In 1838 Governor Baños resurrected the plans to build the reformatory for women in order to remove women from the city's prison because of their vulnerability to dangerous male criminals.[15] Once the funding, architectural plans, and location were approved, the building

was constructed between 1840 and 1844.[16] In 1841 the town council stopped using the term *casa de recogidas/reclusión* to refer to the building and started calling it the Casa de Beneficencia.[17] The origins of beneficence efforts in San Juan were tied, at least early on, to attempts to control and protect some sectors of the city's female population, particularly the poor and colored ones.

The casa became, then, a multipurpose beneficence establishment. Government officials hoped that those committed to the casa would

> find a loving hand that wipes their tears and gives them bread for their sustenance, which, if received before, it was through the charity found in the streets. Find a father who consoles their afflictions and encourages them to work; a master who teaches them their duties to God and Society; a compassionate friend who succors them and provides the resources they need to become useful to themselves and to their country.[18]

The casa served people from both sexes, received people from all of the island's municipalities, and catered to the needs of many groups: the mentally ill, the indigent, orphans, prostitutes, problem children, widows, and others.[19] Most beneficence establishments proposed by the metropolis were to be self-sustaining and were also expected to train artisans and other laborers. The change in the casa's name probably indicated that, for colonial officials, establishing a reformatory for women was too narrow a project in a financially limited city with so many beneficence needs. The change in the plans of the casa's mission shows the pressing labor and control needs that the Spanish authorities needed to satisfy to keep the elite's support.[20] It was probably no coincidence that the Casa de Beneficencia's construction began in the same decade when the island faced a severe labor shortage and when the Spanish government tried a number of repressive antivagrancy and anticoncubinage laws.

The stories of the women committed to, or who had relatives committed to, the Casa de Beneficencia provide interesting insights into the practice of beneficence in nineteenth-century San Juan. Although the casa housed both women and men, the majority of the remaining documentation concerning the casa pertains to women.[21] One 1845 listing of mentally ill patients, for example, includes fifty women and twenty men.[22] Even in the cases where boys and men were brought to the casa, women figured prominently in the case files. Most of the records of boys taken to the casa show that almost all of them were brought over by their mothers (usually single mothers or widows) or by another female relative. Among the women who became inmates at the casa were mentally ill patients, slaves pending trial, orphans, common

criminals, beggars, adulterers, and a syphilis patient. Women, poverty, race, and beneficence were clearly intertwined in mid-nineteenth-century San Juan.

Among the most common groups of people taken to the Casa de Beneficencia was the mentally ill. Severe cases were brought to the casa, as were minor or temporary cases. Financial family difficulties as much as medical reasons influenced the decision to have someone committed to the casa. Doña María del Rosario Márquez was taken to the casa after being insane (*loca arrematada*) for twenty-six years.[23] Márquez's husband could not place her in a hospital with his salary of fifteen pesos per month. Since the Casa de Beneficencia did not have the necessary medical resources to help Márquez, she was transferred to the Hospital de la Concepción. There are no further records indicating Márquez's recovery or relapse. Doña Blasa Muñoz was also committed to the casa after the evaluation from the *comisario de barrio* (commissary). The commissaries' written evaluations—in questionnaire form—were mandatory for admission to the casa.[24] Muñoz, who was living with her sister in La Marina barrio, had been mentally ill for the past eight years. Since the family lived in poverty, Muñoz's sister had no choice but to send her to the casa.

Occasionally, a mentally ill patient was declared "cured" and allowed to return home. María de los Angeles Ayala was one such case, and she was permitted to leave the Casa de Beneficencia because her insanity had been cured.[25] There was no information regarding the reasons leading to Ayala's confinement and subsequent release, and it is difficult to assess how typical her case was. If the definition of what constitutes mental illness or insanity is contested today, it was no less subjective a term in nineteenth-century San Juan. It seems that certain forms of excessive or abusive behavior, combined with the subjects' incapacity to perform any productive function for their respective families, guaranteed serious consideration for admission to the casa.

The beneficence notion of making individuals industrious and productive struck a parallel chord among those marginalized and impoverished sectors of society that had a difficult time taking care of "unproductive" family members. The case of Paula Peña exemplifies this tendency. Peña was in the city jail waiting to be transferred to the Casa de Beneficencia for insulting another woman during mass.[26] Peña's sister, Victoria, asked to take Peña back to her house and promised to keep her closely monitored. Not only did Victoria pledge to keep her sister under control, but she argued that Peña was a very "useful" (*útil*) person when she was not suffering from insanity. Peña, her sister argued, was a very good seamstress. The director of the casa agreed to have Peña released, provided she was not afflicted with any infectious disease.

The story of Doña Josefa Sánchez and her brother Pedro illustrates another notion of utility which played an important role in justifying commitment into the Casa de Beneficencia. Pedro Sánchez got his sister admitted into the casa because she was mentally ill and because he did not have enough financial resources to take good care of her.[27] About a month after Doña Josefa had been committed, casa officers received notice that Doña Josefa had property and assets of her own, which her brother had just sold. Casa officers argued that those financial resources could have been used to get Doña Josefa private care. A lengthy investigation revealed two possible scenarios. The first was Pedro Sánchez's version, in which he claimed that his sister had sold a wooden house on San Sebastián Street to Don Gabriel Más while she was still sane. Sánchez also claimed that his sister did this of her own free will and that he did not receive any money from Doña Josefa. Más confirmed Pedro Sánchez's version and testified that he had paid Doña Josefa 1,000 pesos. The second possibility was that Pedro Sánchez had manipulated his mentally incapacitated sister into selling the house and then, after having her committed to the casa, used the money to pay some of his debts. City and *beneficencia* officials could not agree on which version to believe, so they decided that the matter would be better handled by the courts.

The state found it desirable to have the mentally ill confined. Under the definitions of mentally ill or insane, many troublesome and rebellious elements of San Juan's society could be disciplined. Actually, many of the descriptions of the behavior of the individuals who were being considered for confinement at the casa involved words like *escándalo* (scandalous), *excesos* (excesses), *peligrosa* (dangerous), and *descontrolada* (out of control). Cándida Aguilar, for instance, after spending a month out of the casa, was confined again because she had "gone back to her excesses and scandals."[28] She was held at the city jail pending permission to send her back to the casa. Doña Josefa Sánchez, whose case I discussed previously, was considered mentally ill because she would wander for days without returning to her house, and thus the family feared that she "might attempt taking her own life."[29] The "frequent scandals given on the streets as a result of her bad conduct" caused Micaela García to be committed by San Juan's town council into the Casa de Beneficencia.[30]

The mentally ill were considered a group of people who challenged, to a certain extent, Spanish authority and control. San Juan's *cabildo* saw some of these cases as pertaining more to the realm of security than to that of charity or beneficence: "[This case] deals not with an act of charity, but of the neighborhood's security, due to the danger which a madwoman without home or attachments could cause."[31] The *cabildo* was clearly showing the other face of Janus. Beneficence, even when directed toward a very identifiable,

medically ill group, was ultimately tied to the attempts of San Juan's elite and colonial authorities to secure a stable, safe, labor-abundant, and productive society at the expense of the city's poor and marginalized sectors.

Another group of women confined to the Casa de Beneficencia were those either awaiting civil trials or serving short sentences. The first group of women ranged from slaves with pending theft trials to women accused of adultery waiting for an ecclesiastical divorce hearing. Basically, the casa could serve as a "deposit" (*depósito*), or a neutral safe place, where women, slaves, and others who were legally under the jurisdiction of other adults waited for trial. These people were often separated from their guardians or masters. For instance, during the conciliation trial between Don José Coste and his slave Micaela regarding her manumission through *coartación*, Micaela had to stay for a couple of days at the casa.[32] After Micaela won her trial, she was allowed to remain in the casa for up to three days until she found another master willing to buy her as a *coartada*. Coste had to pay for all of Micaela's expenses while she stayed at the casa. Another slave, Ysabel, was also detained at the Casa de Beneficencia.[33] Ysabel was awaiting trial, accused of stealing a watch from Mr. Augusto Brergeoin.

Former slaves from neighboring Caribbean countries also found themselves at the Casa de Beneficencia as the Spanish authorities pondered their legal status. The survivors from the slave ship *Majesty* found themselves in just such a confusing situation in 1859.[34] According to international law, the 434 survivors from the *Majesty*—which was smuggling African slaves into Puerto Rico in defiance of Spanish-British treaties—were freedmen. Given the racist nature of Puerto Rican society and the high demand for laborers, the governor decided to declare the survivors *emancipados* and to relocate them to the Casa de Beneficencia. From the casa these *emancipados* could be consigned to plantation owners in need of labor. The consignment period was to last five years, and plantation owners were responsible for the religious and educational upbringing of the former slaves. The *emancipados* were clearly slaves in all but technical, legal terms.

Slaves and *emancipados* were not the only ones detained at the casa, as the case of Doña Josefa Aldrey demonstrates. In 1856 she was confined pending her adultery trial.[35] Since Aldrey was accused of adultery by her husband, Don Miguel Sanjes, he had to pay for all of Aldrey's expenses at the casa, both for the waiting period before the trial and for the duration of the trial. Five years later Aldrey was convicted and given a two-year sentence.[36]

The trials of the women deposited in the Casa de Beneficencia often took place on the casa premises. Doña Ana Petrona del Toro had been in the casa awaiting her divorce trial against her husband, Don Matías Deija.[37] Deija had accused Del Toro of committing adultery with Don Francisco Tessa. During

the conciliation trial, Del Toro expressed no objections to a separation of "body and bed," but she demanded a liquidation of the marriage's assets so that she could receive the property and money she was entitled to. Deija claimed that there were no such assets because their marriage had produced only debts. After Del Toro denied her husband's statement, the judge suspended the trial because further divorce proceedings were not within the jurisdiction of the conciliation trials and because the two sides could not reach an agreement.

When women were not being committed into the Casa de Beneficencia, themselves, many were busy trying to convince the *cabildo,* the governor, or *beneficencia* officials to allow a family member into the institution. A vast majority of the people petitioning the casa for space on behalf of orphans, mentally ill people, elderly persons, or unruly people were women. Almost all of the petitions to San Juan's *cabildo* came from mothers asking to have their children (and/or themselves) accepted at the casa. Many mothers claimed that they were unable to support their children financially. The *cabildo,* for the most part, denied these requests, arguing that the children were better off learning a trade under the auspices of one of the city's artisans or attending the schools for poor children supported by the *cabildo's* funding. Doña María Espino, for example, asked to have her son José Fabriciano enter the Casa de Beneficencia in order to get an education.[38] The *cabildo* quickly replied that the casa was not the place for José, because he should be attending school. Another mother was concerned that her lack of financial resources might be directing her son onto a path of vagrancy.[39] So, Luiza Bacallat petitioned the *cabildo* to take her son Santiago into the casa. Santiago was rejected because the *cabildo* thought that he should be entrusted to a master artisan who could teach him a trade and turn him into an industrious man.

San Juan's town council and the director of the Casa de Beneficencia were not altogether consistent in their review of petitions to enter the casa. People were rejected because their needs could be better served elsewhere—such as at a hospital, a school, or an artisan shop—or because there were no more spaces available. The *cabildo* stated forcefully and clearly that their overall selection criteria for entrance into the casa were "to accept [in the Casa de Beneficencia] the destitute and orphan who have no parents or resources whatsoever; and if the petitioner did not give her child at the right time the education he needed, it is not just that his going astray is paid by public funds at the expense of a poor person who might be in true need."[40] The town council was rejecting the petition of Saturnina Bazán, who had asked the casa to take her incorrigible son. After the *cabildo's* eloquent policy statement, they added that they would take Bazán's son only if she paid for his expenses while at the casa. The town council also rejected a petition from

Doña Rosario San Just de Guerra to have the orphan Tomás Gavin—who was under her guardianship—committed to the casa because he was a burden and needed to learn a trade.[41] San Just was told to send her "adoptive" son to a master artisan.

Payment of room and board seemed to have eased the Spanish authorities' policy and space restrictions governing entrance into the Casa de Beneficencia. Many parents were told that their children would be better off elsewhere, but the bottom line was that the casa would take them if they could pay for their own expenses. The authorities were not concerned—should one be able to pay—with losing valuable space for those "truly needy and destitute children and elderly" the casa was supposed to house. Concepción García's son, for instance, was another incorrigible child who was accepted into the casa the same day that Saturnina Bazán's son was rejected for the same reasons.[42] Why the difference? García could pay four pesos a month for her son to stay in the casa, and Bazán could not. Luisa Hernández was another woman who could not pay the cost of keeping her four children at the casa. A native of the Canary Islands, Hernández became a widow and was left with four children and no resources.[43] Town council members voted down Hernández's request because it would be too costly to the public treasury to take Hernández and her children into the casa. A month later, town council members changed their minds and allowed two of Hernández's children into the casa.

Class and family status was another element, besides outright payment, that invited the flexibility of the Spanish authorities in accepting requests for confinement to the casa. Undoubtedly, there was a high correlation between high class and family status and financial well-being, which would have prompted casa officials concerned with costs and revenue to be receptive to candidates who came from financially secure backgrounds. However, this attitude seems to have contradicted one of the major ideological tenets of beneficence. The case of Doña Juana Millano illustrates this point. She was the widow of former artillery lieutenant Don José López and the mother of four children. Her oldest son, a ten-year-old, was an unruly character with a history of petty thefts and gambling. Millano testified that she had tried all the available methods of discipline and science, "exhausting all the possible punishments, with lashes, lock-ups, and other forms of stimulus" and still could not control her child. The casa director wrote to the governor saying that, even though he thought the casa was not the appropriate place for this child, he would make room for him because "you cannot say 'no' to a mother's plea."[44] The irony of this case was that Spanish beneficence officials constantly said no to many poor mothers' pleas.

Lack of space was another consideration that *beneficencia* officials used to deny entry to several petitioners. The absence of documentation makes it

difficult to tell the actual living conditions and the number of inmates at the casa. Lack of space, however, was a crucial element in the supposed reason for not allowing Doña María del Rosario García's two sons into the casa. García, a widow, had three daughters and two sons. García was probably betting on the opportunities that an education could open for her two sons (who were older than the three daughters) and hoped that the children would contribute to the family's welfare. Her two sons would gain "the first element which a man must possess . . . a solid moral background through education."[45] The casa's director suggested that only one of the two sons could be accepted because of overcrowding problems. Lack of space was also alluded to in denying Doña Celia Aguirre's request for taking her son José into the casa. Aguirre was a widow who thought that placing José in the casa would partially relieve her of financial burdens and allow her to be a better provider for her other children.[46] The *cabildo* denied Aguirre's petition, claiming not to have any more empty beds. Less than a month before Aguirre's petition was discussed, the *cabildo* allowed María Ignacia Morales into the casa. She was an orphan and a nurse.[47] The *cabildo* agreed to have her committed to the casa only if she worked as a nurse at the establishment.

Labor Shortages and the Financing of Beneficence

The way in which the Casa de Beneficencia was financed provides some solid insights into the relationships among beneficence, productivity, and social and labor control. From its inception, the casa counted on a number of sources of funding: a percentage from ticket sales at the theater, a percentage from meat and slave taxes, local contributions and loans, and other ad hoc appropriations from the Spanish government.[48] These sources of funding were unstable and forced casa authorities to rely heavily on either the work that the inmates could do themselves or on the payment of fees by those inmates whose families had solid financial resources. The use of inmates to generate income to run the casa was also consistent with the beneficence ideology of promoting self-sustaining institutions and self-improving inmates. The Casa de Beneficencia in Havana, which was established in the late eighteenth century and was funded almost entirely with private donations, also had its inmates work as a way to help themselves and the institution.[49]

In San Juan's casa many of the female inmates did laundry work for the nearby military garrisons and for the military hospital. The governor thought it was very creative to use the inmates' labor to maintain the casa and keep it financially solvent. How crucial this labor arrangement was can be seen in the desperate letters the casa's top administrator, Don Domingo García, sent the governor and San Juan's *alcalde*. García told the Spanish officials that a combination of releases and sick women at the casa had caused a significant

shortage in the number of laundresses available to fulfill the casa's contractual obligations with the military hospital. Without the money the hospital paid for its laundry, the casa, García argued, would find it difficult to pay its bills. García proceeded then to ask for at least ten women to do the job, either from among those accused of *mala conducta* and presently serving time at the city jail or from among those who could be "recruited" from the city's poor barrios (*arrabales*).[50] *Mala conducta* was a general term that could include prostitution, petty theft, disturbing the peace, or any number of other violations of the codes of appropriate behavior.

Were city officials picking poor women from the city's barrios and accusing them of *mala conducta* just to fill domestic labor quotas at the Casa de Beneficencia? Although there is not enough evidence to fully substantiate this claim, it is clear that the casa was used as an employment agency of sorts for domestic workers. Don Ulises Alvarez, for example, petitioned the *cabildo* for a girl from the casa who could become a domestic servant for his wife.[51] Alvarez promised to care for the girl as if she were his own daughter. The *cabildo* granted Alvarez his wish on the condition that he take one of the orphaned girls from the casa. Another petition for a domestic servant from the Casa de Beneficencia, which was approved by the *cabildo*, was that of Doña Ana María Crosas de Vidal.[52] Again, the petitioner promised to take good care of the girl and to treat her like family. The case of the consignment of *emancipados* to the plantation owners further corroborates the role of the Casa de Beneficencia as a state agency for labor control disguised under beneficence ideology.

The petitions for domestic servants came at a time when such services were in high demand in the city. The changing demographics, the effects of the cholera epidemic, the rising slave prices, and the growing fear of abolition all contributed to create a tight and constricted labor market for domestics in San Juan during the second half of the nineteenth century. The Spanish authorities drafted lists of domestic workers in order to identify potential laborers and control their work more efficiently. San Juan's town council decided in 1864 to draw up lists of women and men over the age of fourteen who "for a wage [would] dedicate themselves to the constant servicing of others' homes, by either cooking, washing, attending to the tidiness of the home and family, or any such analogous occupation."[53] The Casa de Beneficencia benefited from the scarcity of domestic servants in the city. San Juan's case was part of a late-nineteenth-century pattern of beneficence institutions supplying domestic workers in Latin American cities at times when those services were scarce.[54]

The case for the Casa de Beneficencia serving as a labor agency for female domestic workers is strengthened by the casa's role in connecting young male

children with local master artisans. Spanish authorities responded to many requests to help unruly and rebellious boys, prescribing a heavy dose of work. What is interesting about telling parents to send their boys to work with an artisan is that Spanish and local officials had been complaining for some time about the lack of available and qualified artisans in the city.[55] The Casa de Beneficencia's attempt to push boys in that direction is another example of how the Spanish colonial state manipulated beneficence ideology to serve their own labor and policing interests. In a way, the beneficence goals of facilitating employment to the poor and destitute and of finding a new home for orphans were fulfilled by the casa's domestic and artisan work arrangements. Whether these newly found employers and families were beneficial to the poor women of San Juan remains, at best, an open question. Yet, the testimony from many abused, battered, and continuously impoverished *sanjuaneras* clouds the state's official discourse of progress and rehabilitation through beneficence.

An asylum that housed such a diverse population with only limited resources proved to be ineffective. Most accounts of the conditions and facilities of the Casa de Beneficencia from 1844 to the late 1860s stress as common problems the lack of attention received by many inmates, the unsanitary conditions, the promiscuity among inmates of different sexes, and insufficient staffing.[56] A trend toward building independent beneficence establishments for all affected groups began between 1859 and 1861, probably as a response to the lack of appropriate facilities at the Casa de Beneficencia. The financial difficulties affecting San Juan's economy certainly did nothing to diminish the demand of people seeking assistance from the state. This trend coincided with collaborative efforts in beneficence and education between sectors of San Juan's elite and the Catholic Church. As a result of the unsatisfactory work the colonial state had done in the field of beneficence, these sectors allied in order to provide for the labor and control needs that the state was not able to satisfy. The entrance of the church and of San Juan's elite into beneficence work was an indication of the growing capacity and need of these sectors to challenge the state in the public arena.

The Catholic Church and Beneficence in Mid-Nineteenth-Century San Juan

In San Juan, the state's poor performance in administering beneficence encouraged the church and members of San Juan's elite to become actively involved in financing and running beneficence institutions. The upper classes in San Juan were not economically powerful enough to control and contribute to beneficence like their Cuban counterparts could. For the church, taking a more active role in beneficence was part of a steady counter-offensive

intended to regain some of its previously held influence and status. As I mentioned in chapter 1, after decades of being ideologically and financially ostracized, the church of the late 1850s was ready to reestablish its control over those areas where it had previously been involved.

Charity was a perfect place to start. Members of San Juan's elite—women, especially—saw beneficence as an arena where they could pursue their class agenda without threatening the state's interests. From the late 1850s through the 1870s, the city's bourgeoisie became more active in the public arena, creating organizations ranging from literary associations to political parties. For women, working at beneficence establishments was seen as an extension of their private, family-oriented duties of nurturing, caring, and educating. The state's poor performance in the areas of beneficence and education made it easy for both the church and *sanjuaneras* to pursue their reform-oriented projects as complementary to the state's efforts.

The construction of a new insane asylum illustrates how inadequate the state's efforts were in the area of beneficence. Between 1860 and 1861, the new asylum, to be located just north of the Casa de Beneficencia, began construction to separate the mentally ill in the casa and alleviate overcrowding.[57] The asylum was not finished, however, until 1873 because of lack of funds. During the construction period, the unfinished structure was used for multiple purposes, among them housing wounded Spanish soldiers stationed in San Juan upon their return from the Dominican War of Restoration.[58] Unfortunately for *sanjuaneros*, the Spanish authorities' delay in completing the asylum was not exceptional but, rather, characteristic of Spain's incapacity to deliver infrastructure and services throughout the nineteenth century.

In the period between 1859 and 1865, the church sponsored the opening of a number of beneficence establishments. In San Juan, the church partially funded the Casa de Párvulos and the Asilo San Ildefonso. The former, opened in 1865, was a school for small orphan children, both rich and poor, which charged one peso a month for their care throughout most of the day.[59] Bishop Carrión almost single-handedly funded the Casa de Párvulos when it opened; later, private and governmental donations sustained it. Bishop Carrión's financial contribution to the Casa de Párvulos—close to 50,000 pesos—indicates that the church's midcentury monetary crisis was probably being reversed.[60] The church's other new efforts in the area of beneficence also point toward the beginning of a financial recovery.

The Casa de Párvulos was staffed by nuns from the order of the Hijas de la Caridad. The demand for the services of the Hijas de la Caridad was indicative of the new approach the Puerto Rican church had taken regarding women's participation in religious establishments. Bishop Carrión and other members of the church's hierarchy—like the Cathedral Chapter's dean, Gerónimo

Mariano Usera—wanted to bring to the island female religious orders committed to beneficence work. Dean Usera went as far as to travel to Spain to recruit women to form a new religious order dedicated to missionary work in charity establishments and schools in the Antilles.[61] After he organized the *Religiosas del Amor a Dios* (Sisters of God's Love), Usera took the order to Cuba, where he was reassigned.

The women from San Juan's elite responded well to the efforts of the Catholic Church to increase the number of female religious orders and vocations. Poet Alejandrina Bénitez de Gautier, for example, wrote a lengthy poem celebrating the arrival of twenty-six members of the Hijas de la Caridad to San Juan in 1863 to assist beneficence establishments.[62] The poem was published in the *Boletín Eclesiástico* and heralded the arrival of the nuns as an example of San Juan's sophistication as a modern city facing its mandate of education and social welfare in a religious and moral way. Other elite *sanjuaneras* thought that the female religious provided the perfect group of workers to collaborate with in running beneficence hospices and schools.

The church's hierarchy now thought that women had a nurturing and caring mission to accomplish, not just in the privacy of family life—still the highest calling for women—but also out in the public arena. The church also saw the potential of channeling Marian devotions into the public space of beneficence and education.[63] Female religious orders accentuated this perspective. The growth of female religious orders also diminished the extraordinary demand on the few clergy available on the island. The church wanted to have women venture into the public arena under its guidance and with specific and narrowly defined tasks.

The church's appeals for the enhanced role of women's influence in family and public matters coincided with the coming of age of many women in San Juan's elite. In an era of growing individualism and increased questioning of the inflexibility of Spanish colonialism on several fronts (like politics, journalism, and trade, for example), *sanjuaneras* were ready to show that they could put their well-known qualities of nurturing, teaching, and caring together with their not-so-well-known qualities of managing and administrating.[64] What better areas than beneficence and philanthropy for women to showcase the convergence of their skills and to use maternalistic ideology to justify public-sphere participation? The new developments in beneficence and education allowed women to take advantage of a fissure in Spain's patriarchal colonialism.

The Asilo San Ildefonso and the Junta de Damas

The history of the foundation of the Asilo San Ildefonso provides good insight into the convergence and the tensions between the church's and

sanjuaneras' interests. A group of elite *sanjuaneras*, encouraged by the church's hierarchy, petitioned the Spanish government to create a beneficence establishment dedicated to primary education and vocational training for poor children. The original guidelines of the *asilo* called for a religious orientation in the children's education and training. The governor, after receiving the proposal, asked Bishop Carrión for his impressions and suggestions.[65] The Bishop quickly alluded to the religious nature of the project and suggested that the *asilo* be placed under diocesan jurisdiction according to Spanish and canonical law. The governor and the women organizing the *asilo* seem to have ignored the Bishop's arguments, since his viewpoint was not considered in the draft presented to the crown for final approval. The guidelines approved by the crown granted the church some influence in the *asilo's* affairs, requiring that two members of the Cathedral Chapter be included in the *asilo's* board of directors.[66] Not only were church interests catered to by this decision, but it also shows the lack of support for the idea of an autonomous women's organization. The crown's orders also made the governor the "vice-protector" of the establishment, clearly subordinating the female board of directors to the state's jurisdiction. The fact that the organizing women, the governor, and the crown decided to ignore Bishop Carrión's arguments shows the interest that these groups had in keeping a prudent distance between social and religious establishments.

Certain aspects of the *asilo's* approval process are very important. First, women of San Juan's elite were ready to claim a public role in the daily life and administration of the city's affairs. *Beneficencia,* as an area of interest, was a natural extension of their charitable qualities and an ideal place to display the managerial skills that elite women had been acquiring and employing while running commercial and real estate ventures. Second, the Puerto Rican church of the 1860s was very willing to reclaim part of its lost influence and power, particularly vis-à-vis the state. The Bishop's insistence on diocesan control over the *asilo* and the later presence of two members of the Cathedral Chapter on the board of directors clearly indicates this. Third, both church and state were not ready to see an independent and autonomous group of women running a public establishment. That would have granted women too much power. Mechanisms to maintain the subordination of this group of women to both state and church authorities were quickly established. Finally, the colonial state—even when financially burdened and managerially incompetent—was not ready to allow the church to regain the prestige and power that had been stripped from it throughout the century.

Still, after the guidelines were approved by the Spanish crown, the *asilo* altered part of its mandate. Instead of being open to poor children of both sexes, the *asilo* dedicated itself to providing primary education to underprivi-

leged girls. By the mid-1860s, the establishment served around seventy girls. Fifty or so of the girls were interns, and they were almost equally divided between those who could afford to pay—the fee was sixteen pesos per month—and those poorer ones who were not required to pay.[67] Initially, the *asilo* was staffed by volunteers and by paid teachers who were contracted by the board of directors. After 1863 the Hijas de la Caridad took control of the day-to-day operation of the *asilo*, while the Junta de Damas attended to the financial responsibilities of the institution.[68] Yet the number of nuns assigned to the *asilo* was small. In 1870, for example, only three nuns worked at the *asilo*.[69] The Hijas, although under the ecclesiastical authority of the Bishop, reported both to the Junta de Damas and, ultimately, to the governor.

Information about the work of the Junta de Damas is not abundant. Besides some scattered references to several members of the board of directors after 1861, I have only been able to find the names of the original group of women who composed the first board of the *junta*. The first board of directors consisted of:

Doña Escolástica Astarloa de Aranzamendi—President

Doña Consuelo Peralta de Riego Pica—Vice-president

Doña Harriet F. Brewster de Vizcarrondo—1st Secretary

Doña Aurelia M. de Vizcarrondo—2nd Secretary

Doña Socorro González de Capetillo—Representative

Doña Demetria Charbonier de Fuertes—Representative

Doña Concepción Vidal de Hernaiz—Representative

Doña Josefa Sevilla de López Pinto—Representative

Doña Emilia Linares de Lázaro—Representative

Doña Nicolasa Cantero de Romero—Representative

Doña Julia Antonia Montilla de Arroyo—Comptroller

Doña Julia Skerret de Saldaña—Treasurer[70]

An analysis of the social background of the members of this group shows that several of the women had already been active in real estate or business transactions. For *junta* members, managing the *asilo* became a golden opportunity to show their talents within a sphere that would not necessarily challenge the patriarchal hierarchy. The class background of the members of the Junta de Damas also shows the concrete class interest that was behind beneficence ideology.

The first president of the Junta de Damas was Doña Escolástica Astarloa de Aranzamendi, wife of Don José Lucas Aranzamendi, a wealthy San Juan merchant of Basque origins.[71] Astarloa, a native of La Guaira, Venezuela, was approximately forty-eight years old at the time of her election. She had family connections to other important immigrant merchant families in the city, like the Elzaburus and the Goenagas.[72] Astarloa must have been active in her family businesses, since her merchant husband entrusted her with all his business interests when he suffered from poor health in 1844.[73] Also, in case Aranzamendi died, Astarloa was given tutorship of the couple's five children, something that was far from automatically done in nineteenth-century wills. It seems that the experience Astarloa had gained by participating in her husband's businesses made her an ideal candidate for the overall management of the *asilo*. Astarloa also seems to have been a devout Catholic, for she was among those found contributing money in 1845 to the *Archicofradía del Santísimo Sacramento* (Association of the Most Blessed Sacrament) for the purchase of religious artifacts in Barcelona.[74] Being an active and contributing church member probably guaranteed Astarloa support among the members of the church's hierarchy, with whom she would be forced to work closely in presiding over the Junta de Damas. Finally, but not least important, Astarloa's strong ties to San Juan's merchant community guaranteed that she would be an effective fundraiser for the *asilo*.

The junta's vice-president was also a commercially active woman. Doña Consuelo Peralta de Riego Pica was married to Don Luis de Riego Pica, a colonel in the infantry regiment. In 1861, the same year the *asilo* was inaugurated, Peralta was busy purchasing several slaves.[75] In that same year, Peralta appears accepting a payment of 2,300 pesos by Ponce *hacendado* Don José de Jesús Fernández.[76] Fernández had borrowed the money from her a year before. The money Peralta provided Fernández came from her own capital, showing that she was wealthy independently of her husband. Peralta was involved in another incident, concerning one of her housemaids, with Doña Josefa Puig de González (another widow from San Juan).[77] Since the housemaid, Doña Romana Manaras, wanted to move to Spain, Peralta arranged and paid for her trip. It seems that Puig convinced Manaras to stay in Puerto Rico and to work for her. Puig offered to repay Peralta the cost of the tickets, to which Peralta agreed.

Joining Astarloa and Peralta on the Junta de Damas board was Doña Harriet Brewster de Vizcarrondo, elected first secretary. She was a North American married to the abolitionist Don Julio L. Vizcarrondo. Several scholars have credited Vizcarrondo with the idea of creating the *asilo*, due to his liberal beliefs and his special interest in beneficence.[78] Yet, none of the documents I

have seen made any references to Don Julio L. Vizcarrondo. Brewster was a civically oriented woman who shared her husband's abolitionist sentiments. She collaborated in many of Vizcarrondo's liberal campaigns and publications.[79] Brewster's sister-in-law, Doña Aurelia M. de Vizcarrondo, was the *junta's* second secretary. It is probable that they all lived together in the Vizcarrondos' house on Cruz Street. The Vizcarrondos were a well-known San Juan Creole family, and Julio Vizcarrondo and other family members owned significant amounts of property in the municipalities of Carolina and Trujillo.[80] It would have been easy for Brewster and her sister-in-law to pursue fundraising activities in San Juan because of her family connections. They were related, for instance, to Doña Escolástica Astarloa. Astarloa's son, Don José L. Aranzamendi, represented the Vizcarrondos legally.[81] On the other hand, Brewster's North American birth and the well-known anticonservative ideas of her husband might have made her a suspicious character to the Spanish authorities.

I have found less information about the other members of the *junta's* board. Still, several of them were property owners and almost all of them had blood ties with distinguished and powerful families of San Juan. Doña Socorro González de Capetillo, who was born in Venezuela, was married to the merchant Don Casimiro Capetillo. Since Capetillo was very active in the island's slave trade, it was easy to find González purchasing slaves in the city. In 1844, for example, she bought a twenty-six-year-old female slave from Doña Pilar Abad.[82] In the 1846 census, González and Capetillo were listed as having ten slaves at their residence.[83] Later, in 1859, González was listed as owning a house in barrio La Marina.[84] Another house owner in the 1859 listing was Doña Josefa Sevilla de López Pinto. She owned a fine house on San José Street. Doña Nicolasa Cantero de Romero was married to a prominent San Juan physician, Don Calixto Romero. Besides the income from Romero's medical practice, he owned at least three houses in San Juan plus other properties outside the city.[85] Cantero's father, Don Francisco Cantero, also owned a number of houses in the city.

Another *junta* board member from one of San Juan's prestigious families was Doña Julia Skerret de Saldaña. She was probably related to sugar merchant and hacienda owner Don Justo Skerret, a man of Irish descent.[86] Doña Concepción Vidal de Hernaiz was also associated with San Juan's wealthiest families. She was married to Don Manuel Hernaiz, another merchant, and they lived on Tetuán Street.[87] Finally, Doña Demetria Charbonier de Fuertes was married to Don Estevan Fuertes, who worked as a bureaucrat with the colonial government and had risen through the ranks high enough to buy his own house in 1859. In 1846, the couple had rented an apartment from merchant Don Alberto Saleses.[88] Doña Demetria was probably related to Don

Pascasio Charbonier, a landowner in Loíza and the representative of *hacendado* Don H. H. Berg's interests in San Juan.[89] I could not find any information about either Doña Julia Antonia Montilla de Arroyo or Doña Emilia Linares de Lázaro.

Little is known about the women who comprised the board of directors of the Junta de Damas after 1861. By 1866, Doña Clementina Butler de Marchesi, president of the *junta*, informed the governor that they had raised enough funds to pay for the house where the *asilo* was located.[90] By 1873 Doña Encarnación Calderón had become the first secretary of the *junta*, but I have found no personal information about her. By that date, the *asilo*'s management had done extremely well, at least from a financial perspective. By 1873, after having paid all the *asilo* bills, the Junta de Damas had been able to raise 46,825 pesos in capital.[91] It seems that, occasionally, the wife of the governor became the president of the *junta*, although it is not altogether clear whether this was an honorary title or not.[92] In Cuba, for example, the governor's wife was instrumental in creating and running the *Asociación de Beneficencia Domiciliaria de la Habana* (1855), a private charity association.[93] Still, even if the governors' wives took the presidency of the *asilo*'s *junta* seriously, their brief stay on the island probably meant that other members of the board of directors had more influence in the fundraising and management of the institution. The Junta de Damas remained an active group in San Juan's social life until after the United States' 1898 invasion.

The women who organized the *asilo* were not the only ones in Puerto Rico considering similar projects. In 1863, Doña Enriqueta Hirsch de Pratts requested the government's authorization to open a charity asylum in Ponce.[94] Under the name *Damas del Santo Asilo*, Hirsch de Pratts hoped to create a voluntary women's organization that would provide help to the sick and publish a newsletter every six months. The petition was approved, and the *asilo* opened in 1866. Women in Mayaguez got organized a little later, as they petitioned to open the *Asilo de Pobres* in 1886.[95] A local *sociedad de damas* was organized to run the asylum in Mayaguez. Although we lack specific studies about the emergence of beneficence establishments in Puerto Rico during the second half of the nineteenth century, most of the towns on the island had at least one such establishment by the 1880s.[96]

From the brief profile of the social status and personal history of the members of the first Junta de Damas, it is clear that women from San Juan's elite dominated the group. Many of the members had been active managers in the past, either taking care of their own personal wealth or participating in the business life of their spouses and families. Others were tied to some of the most outspoken liberal minds in the city—like the Vizcarrondos and the Romeros—which means that they probably embraced the individualistic, ef-

ficiency-minded, and pro-education orientation of beneficence. The emphasis beneficence ideology placed on self-discipline, order, and subjection to authority probably catered to the interests of the most conservative members of the board of directors. Beneficence, it must be remembered, still carried the hierarchical legacy of charity. The Junta de Damas wanted to improve the lot of the destitute and the underprivileged, but clearly within an institutional setup that embodied the structural inequities of society at large. This notion of *beneficencia* was very different from the one that artisan and ethnic groups on the island were beginning to practice. By the late 1860s, artisans and ethnic groups began to institutionalize their networks of solidarity, not from a hierarchical perspective but from a communitarian one.[97] The mutual aid societies, the artisan casinos, and the cooperatives provided a contrasting perspective to the liberal, bourgeois notions of beneficence sponsored by the colonial state, San Juan's elite, and the church in the late nineteenth century.

Beneficence and Social Control in the City

Beneficence allowed the women of San Juan's elite to push for a double agenda. Not only were they expanding the realm of public action open to women by venturing out into philanthropy as organizers, managers, educators, and partners; these *sanjuaneras* also pressed for their own class agenda. In doing so, they were staunch allies of men in their own social class. Beneficence was an ally of social and labor control, and it was also an ally in the struggle to sanitize and rationalize inequality.[98] In the particular context of San Juan, the elite was facing the coming implementation of abolition, the crisis in the sugar economy, the changing political regime in Spain, the growing pains of a medievally constructed city hoping to modernize, and the growth in influence and consciousness of popular sectors of the population. These challenges had to be met, and beneficence provided one of the fronts on which San Juan's elite decided to concentrate. Abundant and well-trained domestics were extremely important for elite women who wanted and needed time to pursue other intellectual and economic projects. There is a correlation between the presence of domestic workers and the rate of participation of women in professional occupations in Latin America.[99] The case of nineteenth-century San Juan is another example of this trend.

Caring for poor children, for instance, either at the Casa de Párvulos or at the *asilo* was a convenient way of taking care of the children of women who probably worked as domestics in the very homes of many of the elite *sanjuaneras* who helped to organize and fund these establishments. Thus, not only were elite women able to expose poor children to a work ethic, to discipline, and to vocational jobs, but they were able to obtain more efficient services from the domestic women who took care of their households.

Caring for indigent children also had a parallel in the case of education in San Juan. Using teaching as a vehicle to participate in public life was an experience that *sanjuaneras* shared with other Latin American women and women of the United States. The proliferation of teaching jobs for women and the increased importance of educating women also went hand-in-hand with secular modernization efforts in Latin American society.[100] In Brazil's case, for example, June Hahner has documented how teaching was "accepted as an extension of the traditional nurturing role of women—motherhood on a larger scale."[101] Also, there was a clear connection in Latin American cities among primary education, female education, and beneficence. Usually, these three functions were combined in a single establishment. In Buenos Aires, for example, the Society of Beneficence was responsible for all public education of girls.[102] San Juan seemed to have shared in the Latin American experience of increased female participation in the areas of education and beneficence during the second half of the nineteenth century.

Although one must be careful not to generalize based on the experience of the women from the Junta de Damas, the process by which women's organizations emerged out of the involvement of elite women in beneficence and education in San Juan seems to have been part of the broader Latin American experience. In Argentina, Mexico, Cuba, Uruguay, and Chile, elite women who had been actively engaged in managing businesses, haciendas, or real estate found an outlet for their experiences as the liberal currents of the end of the nineteenth century made their presence felt in Latin America.[103] Although the time frames were different, there also seem to be parallels between the experiences of U.S. women and *sanjuaneras*. In the United States over the first two decades of the nineteenth century, women's voluntary associations appeared all over the country.[104] These associations allowed women to participate in public life without having their domesticity or womanhood questioned.

Conclusion

As members of the city's elite, *sanjuaneras* active in women's organizations were helping to ameliorate some of the effects that the island's entry into full agrarian capitalism was causing. They were also trying to survive the painful economic times that the city had been facing since the 1850s. In this sense these elite women were important allies of their male partners and family members in protecting their common class and race interests. Philanthropy has always been an effective mechanism to downplay and alleviate some of the most visible inequalities produced by capitalism. By having women lead beneficence efforts, members of San Juan's elite were using gender to defuse potential doubts or criticisms about the class-oriented intentions of their ef-

forts. Since part of women's nature was to be comforting and nurturing, the reasoning went, elite women's efforts in philanthropy did not raise suspicions. Elite women were, at the same time, active participants in the attempts to preserve the inequalities and privileges of the class system while trying to break through constricting gender roles.

The women who organized and managed the Asilo San Ildefonso have been identified as some of the first women who decided to form a group that would advocate the concerns of women. In this sense, the women from the Junta de Damas were clearly leading the way for the turn-of-the-century efforts by bourgeois feminists. Yet, as I have shown in this chapter, the advancement of these elite women's agenda was more a victory for a very particular class- and race-based gender agenda. The *sanjuaneras* who donated their time to serve in the Junta de Damas and other such establishments were protecting and securing their class interests within the new contours that allowed women some access to the public arena. The development of a growing notion of consciousness among elite *sanjuaneras*—the development of a sense of sisterhood, if you wish—was dependent on creating concrete barriers between them and other women.[105] In San Juan some of these other women were the recipients of beneficence: poor women, widows, and women of color. Some scholars have pointed out that lower-class women participated in beneficence institutions in San Juan, such as the Casa de Beneficencia, thus reinforcing the ideological constructs created by the elite.[106] Still, the historical record on nonelite women's perspectives about beneficence remains mostly hidden. The available data make it difficult to recover the voices and the vision of those who were at the receiving end of beneficence. The ideology that pushed for a respectable, modern city in San Juan tried to marginalize lower-class women. The organizational and social victories of the elite *sanjuaneras* did not have the same meaning for the female domestics of the city, for example, or for other nonelite women in San Juan.

Conclusion

On July 24, 1871, Governor Baldrich was forced to impose a state of siege on San Juan. Meetings of more than three people were forbidden, as was carrying any type of weapon or publishing any kind of newspaper article or pamphlet that would incite violence.[1] The governor was reacting to several skirmishes, attacks, and fights initiated by pro-Spanish, conservative elements in the city. Members of the Conservative Party were attempting to destabilize the government, halt some of the gains of the opposing Liberal Party, and protest political reforms being discussed in Spain regarding the abolition of slavery and the possibility of some measures of home rule for the island. From the late 1860s onward, San Juan and Puerto Rico faced tumultuous social, political, and economic times.

The *Boletín Mercantil,* official newspaper of the Conservative Party, had published a curious commentary on the level of political debate in San Juan in 1871. "It is really repugnant," the article read, "to see the kind of people in our city streets who engage in politicking today. We have even heard laundresses— it is a shame to admit it!—commenting about heated political problems."[2] For this conservative author, it was inconceivable that women of color should and could comment about politics in a respectable city such as San Juan.

The fact of the matter was that members of San Juan's elite and Spanish colonial officials tried for decades to make the city a place where people of the same race, class, and gender as the laundresses would be silenced and placed physically out of sight. Again and again, the reality of daily life clashed with the concerted efforts of the city's upper and middle classes. Throughout the mid-nineteenth century, San Juan's lower class and colored population refused to be marginalized and completely removed from the city they called home.

Laundresses in San Juan seem to have symbolized the unruly women that needed to be watched, silenced, disciplined, and controlled. Pushed by city authorities into extramural barrios, tabulated in recurring lists since the 1850s, needed for their work in an urban environment that faced the extinction of

slavery as a form of guaranteed labor, expelled from the wells in the city plazas for their boisterous behavior, suspected of spreading diseases and having unsanitary working practices, and distrusted by the elite and middle classes for their capacity to move from the public streets into the sanctity and privacy of the home, laundresses in San Juan exemplified the type of poor and colored women that needed to be controlled and reformed in order for San Juan to become a safe, progressive, and respectable capital. The laundresses' individual feistiness and collective solidarity, of course, did nothing to improve relations with Spanish colonial authorities or with the city's elite.

The laundresses in San Juan were not an exceptional case in Puerto Rico. In Ponce during the last three decades of the nineteenth century, prostitutes became the symbol of women who needed to be demonized in order to justify the moral, social, and economic regenerative intervention led by the city's respectable male and female citizens.[3] In other towns, government officials, members of the elite, and professionals joined efforts in trying to keep poor and colored women "in their place." The burden of many of the economic and social reforms proposed on the island in the second half of the nineteenth century rested on the shoulders of these women.

The city of San Juan changed considerably during the period covered in this book. Migration and Spanish public policy helped to alter the demographic profile of the city and the spatial composition of several neighborhoods, such as Ballajá. The city became more gentrified and congested. Imports emerged as San Juan's main focus of economic activity at the same time that other cities, such as Ponce and Mayaguez, developed as the key urban nodes from which most of Puerto Rico's agricultural goods were shipped off to Europe and the United States. Women played an important role in all of these changes affecting San Juan in the nineteenth century.

The city's commercial stagnation, which started in the 1840s, was felt by all sectors of San Juan's urban economy. Women, from all races and class backgrounds, seem to have been affected in a disproportionate way. Elite women found preserving their privileged lifestyle more expensive during the second half of the nineteenth century. As the city's housing and financial crises continued, many of the upper- and middle-class women who depended on the revenues from the rents they collected faced increasingly tougher times getting paid on time, or at all. For many "landladies" the courts became the only vehicle to obtain some or all of their uncollected rent monies. Many of the small- and medium-sized retail establishments owned by women in San Juan disappeared from the city's landscape after the 1850s.

San Juan's economic malaise forced lower-class women to become more aggressive in attempting to secure a livelihood. Domestics worked longer hours for their employers as fewer women became available for domestic

labor. Domestics often needed to supplement their incomes by selling items on the city streets or by hiring out their services to more than one employer. Slaves, until 1870, faced a similar scenario, as most of them performed domestic chores for their masters. After the 1850s, the state increased its control mechanisms over domestic workers in San Juan, so these women were forced to face additional bureaucratic hassles mandated by the governor and the town council. At home, as the economic crisis depleted family resources, poor and colored women faced more domestic violence and increased friction with their spouses or partners.

The modernizing ideals and vision shaped by the city's elite and Spanish colonial officials in the early nineteenth century changed during the last third of that century. If building infrastructure; expanding commerce; guaranteeing safety, order, and labor; and focusing on hygiene and recreation were the foundational aspects of the hegemonic project pursued by San Juan's upper classes, new elements were added in the late 1860s.[4] Political debate and participation, freedom of expression in the newly emerging press, the abolition of slavery, enhanced educational opportunities, and space for literary creativity also became important projects for the city's elite and for the emerging professional and middle class in the city. Furthermore, the configuration of social actors changed.[5] After the 1870s, it would not suffice to talk about the aspirations and the modernizing vision of the Spanish colonial state and the city's elite alone. One needed to include artisan groups, freedmen and -women, urban professionals, and elite women, since these groups were injecting their vision more assertively and more frequently into the collective arena.

Women were part of the expanding cast of characters pushing for change after the 1870s. As a result, elite women ventured further into the fields of education and philanthropy. They were also more active in the growing number of literary *tertulias* (discussion groups) and the publishing of articles intended for both the general public or specifically for women. Examples of these literary gatherings were the ones convened in the house of poets Alejandrina Bénitez de Gautier and her aunt María Bibiana Bénitez from the late 1850s.[6] The number of magazines and publications published and distributed by, about, and for elite and professional women increased in San Juan and in other towns such as Ponce. Among such publications, some of the most important ones include *La Guirnalda Puertorriqueña* (founded in 1856), *Las Brisas de Borinquén* (1864), and *La Azucena* (1870).[7] These publications were the origin of the relationship between elite women, bourgeois feminism, and journalism, which played such an important role in the feminist struggles of the first decades of the twentieth century.

The efforts by elite women to expand the educational opportunities and teaching positions available to other women were as much a sign of the new

energy in the city as they were a sign of how women were affected by the economic crisis in San Juan. Education was seen by women as a potential equalizer in the opportunities available for women and men. By fighting to increase the access girls had to education, elite and middle-class women were struggling against the public structures that had guaranteed their subordination for centuries. In this way they challenged certain aspects of their inferior status in order to face the economic hard times and the social uncertainty that Puerto Rican society experienced after midcentury. In pushing for their educational agenda, elite women in San Juan were also attempting to help the next generation of *sanjuaneras* prepare to assist their families in the future. Young elite girls could also become the educated, cultured *damas* who would continue the beneficence and educational work initiated by their foremothers.

After the 1860s, elite women continued their advances in the areas of beneficence and education. After the creation of the Asilo San Ildefonso, many more beneficence establishments were formed in the city and in surrounding neighborhoods. Among some of the newly opened institutions were the Asociación de Damas para la Instrucción de la Mujer, the Sociedad de Auxilio Mutuo y Beneficencia, Asociación Para la Protección de la Niñez, and the Asilo Municipal de Caridad.[8] Becoming involved in the management or fundraising for any of these institutions became an important source of status for elite *sanjuaneras* in the late nineteenth century.

The partnership between the Catholic Church and female elite members continued in the period after 1868. The best example of this collaboration was the foundation of the Colegio del Sagrado Corazón in the suburbs of San Juan in 1880. The school was founded to provide an education to the daughters of elite *sanjuaneros(as)*.[9] Again, the dismal record of the Spanish colonial estate in providing real educational opportunities to girls in the city provided the context for the church moving in to fill the void. The Colegio was also supported, financially and intellectually, by San Juan's conservative elite, who hoped both to provide their daughters with a better education and to counter the secularization of education promoted by the Spanish government. In the last decades of the century, elite *sanjuaneras* continued what they had started in the 1850s: gender empowerment within the confines of their own socioeconomic class.

In the 1870s, lower-class and plebeian women were becoming more vocal in demanding their rights, particularly those related to work. In 1876 a group of women formed a laundresses' guild (*gremio*).[10] Although they never constituted a powerful force, women were also increasing their influence among artisan groups in the city. Also, the end of slavery in 1873 initiated a process of labor rearrangement among the former slaves. As a result, more women

moved into urban areas seeking economic opportunities and leaving behind the plantation world.[11] *Libertas,* ready to test the limits of the freedom the abolition of slavery provided, came into San Juan and its extramural barrios with high expectations and little tolerance for direct and indirect mechanisms of social and labor control.

In Puerto Rico's historiography, where military fortifications, bureaucratic legislation, and deals by Spanish merchants have defined the essence of San Juan, social history calls for a reassessment of who the historical agents were in the city and what the foci of their actions were. San Juan in the 1870s was far from being the Spanish city usually alluded to in the historical literature. It was a city bursting with the energy of change even as it remained confined by the legacy of its colonial past. It was a city where social groups of uneven power and resources were rearticulating their visions of modernity to adjust to the approaching end of the century. In this panorama of competing discourses, women were among those working to create a city that responded to their view of the future. The roots of the intellectual, spatial, and power discourses being used by these new, old, or reconfigured social groups were developed in the period between 1820 and 1868. Women, elite and plebeian, formed an important part of the process by which these roots were planted in San Juan, and they continued to play a fundamental role in the changes that came after the 1860s.

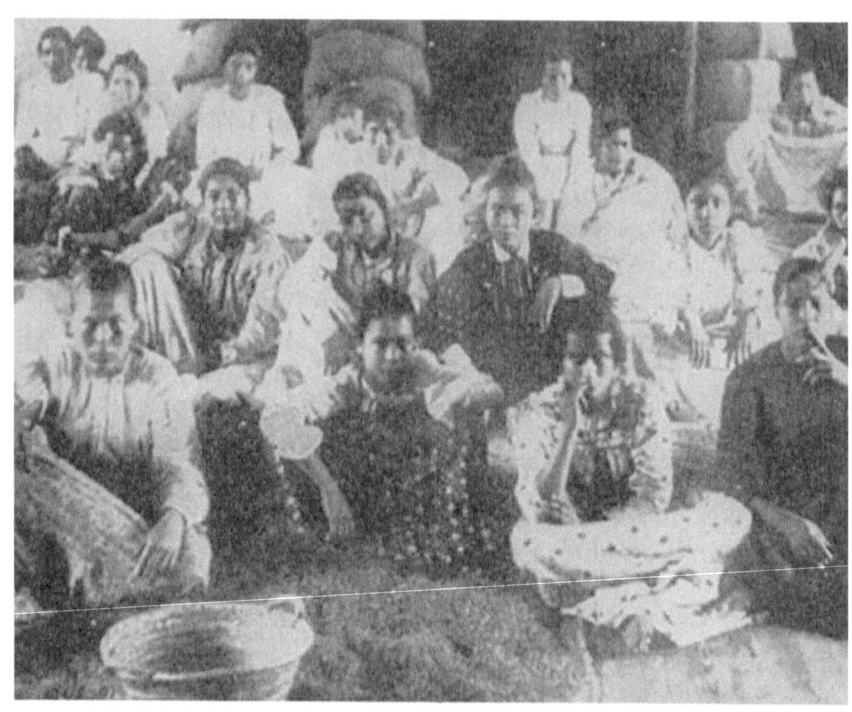

Girls Assorting Coffee at Yauco

Manufacturing Chewing Tobacco at Sabana Grande

Glossary

Agregado(a): Farmhand living on another's farm or ranch; nonfamily member living in a household
Aguador: Water carrier
Alcalde: Town official
Aljibe: Water cistern or reservoir
Amancebado(a): One who lives in concubinage
Apoderado(a): Proxy legal representative
Arrabales: Slums
Barrio: District or quarter
Bodeguero(a): Retail grocer
Bohío: Hut
Bótica: Small drug store
Cabildo: Town council
Capellanía: Agreement for settling an annuity on a property to pay for masses, entrance fee to a convent, or any other religious activity
Censos: Agreement for settling an annuity on a person or a property
Chocolatería: Chocolate store
Coartación: Process by which slaves could purchase their freedom in installments
Condición: Quality or state in reference to one's legal, social, or racial standing
Confitería: Confectionery
Cordonería: Lace maker's shop
Costurero(a): Seamstress
Criado(a): Servant or valet
Criollo(a): Creole or native-born
Cuerda: Agrarian unit in Puerto Rico equivalent to .97 acre
Dependiente: Clerk or salesperson
Derrama: Temporary or emergency tax
Despalillador(a): Tobacco-leaf stripper

Dulcero(a): Sweet maker
Estancia: Small farm
Faldera: Skirtmaker
Finca: Country estate or farm
Fonda: Inn or eating house
Fumacería: Cigar-making shop
Gallera: Cockpit
Hatos: Cattle ranch
Hospedaje: Lodging or hostel
Inquilino(a): Tenant or renter
Jefe: Head of household
Jornalero(a): Day laborer
Labrador(a): Farmer or tiller
Lencería: Linen draper's shop
Liberto(a): Freedman/woman
Loquero(a): Insane asylum attendant
Mampostereria: Masonry
Mercería: Haberdashery or dry-goods store
Modista: Dressmaker
Mondongo: Tripe stew
Moreno(a): A dark-skinned mulatto
Pardo(a): A light-skinned mulatto
Peninsular: Person born in Spain
Pulpería: Retail grocery or general store
Quincallero(a): Small wares store
Quintal: 100 lbs., or nearly 46 kg.
Revendón(a): Reseller
Sanjuanero(a): Person living in San Juan
Sociedad Mercantil: Commercial partnership
Taberna: Tavern or saloon
Vendedor(a): Salesperson
Ventorillo: Small store or inn

Notes

Introduction

1. In the absence of a presiding bishop, the Cathedral Chapter ran the diocese of Puerto Rico. Baez's petition is found in AHD, Actas del Cabildo Eclesiástico, July 14, 1840. References to the public scandal are found in a letter to Cathedral Chapter by the cathedral's sacristan, Don José Antonio de Córdova. See AHD, Correspondencia Cabildo, C-4.

2. Baez and Méxias were listed as married in an 1828 San Juan barrio census. If their ages were reported correctly, Méxias would have been fifty-four years old at the time of his death in 1840, and Baez would have been forty-six. In 1828 the couple was listed as having four children, ages three through fourteen. There is no way to know if the couple had any additional children between 1828 and 1840, or how many of the children listed in 1828 were alive in 1840. For the census data, see AGPR, Censos San Juan, Cuartel de San Juan, 1828, 23f.

3. The best study of modern ideology—"the eagerness of modernity" as she calls it—in Puerto Rico is Silvia Alvarez Curbelo, "El afán de modernidad." See also Angel G. Quintero Rivera, *Patricios y plebeyos*, 23–98; Aníbal Sepúlveda Rivera, *San Juan*; Julio Ramos, *Desencuentros de la modernidad en América Latina*; and Teresita Martínez Vergne, *Shaping the Discourse on Space*. I want to thank this last author for allowing me to read and quote from her book while it was still in manuscript form.

4. For my usage of the term "hegemony," see Antonio Gramsci, *Selections from the Prison Notebooks*.

5. Fernardo Picó, *Historia general de Puerto Rico*, 161–74, 200–206.

6. María Odila Silva Dias has shown how important it was for street vendors to loudly promote their merchandise in the city. See *Power and Everyday Life*, 6–10, 74.

7. Although Fernando Picó tends to overemphasize the dichotomy between order and freedom as marked by San Juan's walls, it is true that life outside the city followed a different tempo. See "Nociones de orden y desórden," 48–54.

8. Aníbal Sepúlveda Rivera, *San Juan*, 248–300.

9. For the usage of the term "beneficence" in this book, refer to the notes in chapter 5. My usage, in Puerto Rico's context, is partially derived from Teresita Martínez Vergne, "The Liberal Concept of Charity."

10. For a review of this literature in Latin America, see Francesca Miller, *Latin American Women*, 68–100; and K. Lynn Stoner, *Latinas of the Americas*, 130–34, 248–49. Excellent examples of the vast literature in the United States are Lori Ginzberg, *Women and the Work of Benevolence*; and Linda Gordon, *Heroes of Their Own Lives*.

11. Teresita Martínez Vergne, *Shaping the Discourse.*

12. I define a "women's organization or group" as one that is organized exclusively or primarily by women, with a particular agenda of enhancing the overall political, economic, and social condition of women. I do not use "feminist" for any of the nineteenth-century groups because the term is properly a twentieth-century product. On the appearance of the term "feminism," see Nancy F. Cott, *The Grounding of Modern Feminism*, 3–50. For a different view on applying the term to groups that opposed gender inequality in the nineteenth century, see June E. Hahner, *Emancipating the Female Sex*, xiii. Also, Steve Stern has recently commented on the connection between protofeminist thinking and struggles over gender ideology in *The Secret History of Gender,* 297–301.

13. The emergence and development of women's and feminist organizations in Puerto Rico has been studied by Yamila Azize, *La mujer en la lucha*, 61–163; Yamila Azize Vargas, "Mujeres en la lucha," 9–25; Yamila Azize Vargas, "The Roots of Puerto Rican Feminism," 71–80; Edna Acosta-Belén, "The Puerto Rican Woman," 1–29; Isabel Picó, "The History of Women's Struggle," 46–58; Norma Valle Ferrer, "Feminism and Its Influence," 75–87; Norma Valle Ferrer, *Luisa Capetillo*, 23–37, 75–102; Alice Colón, et al., *Participación de la mujer;* Norma Valle Ferrer, "Primeros fermentos," 15–19; and Barceló Miller, María T., *La lucha por el sufragio.*

14. On the differences between working-class and bourgeois feminists in Puerto Rico, see Acosta-Belén, "Puerto Rican Women," 6–10; Azize Vargas, "Mujeres en la lucha," 19–21; Barceló Miller, *La lucha por el sufragio*, 73–113; Colón et al., *Participación*, 6–35; and Valle Ferrer, *Luisa Capetillo*, 29–37. Eileen Findlay is particularly perceptive about how race and class prevented alliances based on gender subordination to emerge; see "Domination, Decency, and Desire."

15. See, among others, Doris Sommer, *Foundational Fictions*, 1–30; Sandra McGee Deutsch, "Gender and Sociopolitical Change," 259–306; Sueann Caulfield, "Women of Vice," 164–66; and Ana María Alonso, *Thread of Blood*, 72–104.

16. Silvia M. Arrom, *Las mujeres*, 28–69, 322–24; and Jean Franco, *Plotting Women*, xvii–xx.

17. Susan E. Besse has probably best argued this case; see *The Modernization of Gender,* 1–37.

18. Matt Childs, "Sewing Civilization," 83–108.

19. Sandra McGee Deutsch, "The Catholic Church," 127–51. On the rest of Latin America, see Miller, *Latin American Women*, 36–42.

20. See Findlay, "Domination, Decency, and Desire." The works of María F. Barceló Miller and Gladys Jimenez-Muñoz on the suffragist movement are also examples of twentieth-century historical research using gender methodology. See Barceló Miller, *La lucha por el sufragio*; and Jimenez-Muñoz, "A Storm Dressed in Skirts." On using sexuality to construct national identity, from a literary perspective, see Yolanda Martínez-San Miguel, "Deconstructing Puerto Ricanness," 127–39.

21. Alvarez Curbelo, "El afán de modernidad."

22. Carlos J. Alonso, "The Burden of Modernity," 228. Also, see his *Modernity and Autochthony.*

23. Alvarez Curbelo shows how the association of Spain with backwardness was exploited by the abolitionists in Puerto Rico; see "El afán de modernidad," 102–73.

24. See, for example, Stern, *The Secret History of Gender,* 297. A similar argument, for Puerto Rico, is made by Findlay, "Domination, Decency, and Desire," 14.

25. The story of Barbudo's life can be found in Raquel Rosario Rivera, *María de las Mercedes Barbudo.*

26. Arrom, *Las mujeres,* 28–32.

27. Some of the authors who have traced this modernizing "moment" include Alvarez Curbelo, "El afán de modernidad"; Silvia Alvarez Curbelo, "El motín de los faroles," 120–47; María Elena Rodríguez Castro, "Tradición y modernidad," 45–56; and Arcadio Díaz-Quiñones, *La memoria rota.*

28. An example of this would be the visions and projects espoused by suffragists in the early twentieth century. See Barceló Miller, *La lucha por el sufragio,* 19–72.

29. For a comprehensive bibliographic review of the literature on Latin American and Caribbean women, see K. Lynn Stoner, *Latinas of the Americas;* and Meri Knaster, *Women in Spanish America.* For examples of current research trends, see Asunción Lavrin, "Women in Latin America"; Bridget Brereton, "General Problems and Issues," Verene Shepherd, Bridget Brereton, and Barbara Bailey, eds., *Engendering History;* and Félix V. Matos Rodríguez, "Women's History in Puerto Rican Historiography," 9–37.

30. The only works that deal exclusively with Puerto Rican women's history prior to the twentieth century are Jalil Sued Badillo, *La mujer indígena;* Rosa Santiago Marazzi, "La inmigración de mujeres," 154–65; María F. Barceló Miller, "De la polilla a la virtud," 49–88; Ivette Pérez Vega, "Juana María Escobales," 397–402; Olga Jimenéz de Wagenheim, "Puerto Rican Women," 196–203; Valle Ferrer, "Primeros fermentos," 15–19; and Rosario Rivera, *María de las Mercedes Barbudo.* Other works, although primarily concerned with twentieth-century developments, have chapters or sections about nineteenth-century women. See, for example, Azize Vargas, *La mujer en la lucha;* Federico Ribes Tovar, *La mujer puertorriqueña;* Colón et al., *Participación de la mujer;* Findlay, "Domination, Decency, and Desire"; and several of the essays found in Acosta-Belén, ed., *The Puerto Rican Woman.*

31. Most of the scholarship produced in Puerto Rico from the "new history" onward has not really addressed urban concerns. The studies about regions that included important urban clusters, like Ponce or Utuado, dealt more with sugar and coffee haciendas than with urban life per se (although both were intimately intertwined). See, for example, Francisco Scarano, *Sugar and Slavery in Puerto Rico;* and Fernando Picó, *Libertad y servidumbre.* One exception has been the work of María de los Angeles Castro, which dealt mostly with urban architecture; see *Arquitectura en San Juan.*

32. Fortunately, there has been a recent trend to pay more attention to nineteenth-century urban issues on the island. Some examples of this trend include Quintero Rivera, "La capital alterna," 23–98; Sepúlveda Rivera, *San Juan: Historia ilustrada;* Jay Kinsbruner, "Caste and Capitalism," 433–62; Jay Kinsbruner, *Not of Pure Blood;* Jorge Rigau, *Puerto Rico 1900;* Mariano Negrón Portillo and Raúl Mayo Santana, *La esclavitud urbana;* Raúl Mayo Santana, Mariano Negrón Portillo, and Manuel Mayo López, *Cadenas de la esclavitud;*

Martínez Vergne, *Shaping the Discourse;* George Edward Stetson, "San Juan, Puerto Rico"; and Luis Aponte-Parés, "Casas y Bohios."

33. In 1868 Puerto Rico experienced its most significant—although ultimately unsuccessful—pro-independence revolt in the town of Lares. In that same year, the first war for independence started in Cuba, and a military uprising in Spain toppled the monarchy. See Luis Martínez-Fernández, *Torn between Empires,* 205–8.

Chapter 1

1. AGPR, FMSJ, Actas Cabildo, February 14, 1853, 20–22v.
2. From Federico Asenjo, *Las fiestas de San Juan,* 43–46.
3. Albert Manucy and Ricardo Torres Reyes, *Puerto Rico,* 7.
4. Kinsbruner, "Caste and Capitalism," 442.
5. Castro, *Arquitectura,* 94.
6. Aponte-Parés, "Casas y Bohios," 143.
7. On the symbolic importance of this event, see Rubén Dávila Santiago, *El derribo de las murallas,* 17–39.
8. Sepúlveda Rivera, *San Juan,* 4–51; and Castro, *Arquitectura,* 20–26.
9. By "civil infrastructure" I mean all the buildings, offices, and quarters that the Spanish authorities had to construct and maintain to run the local colonial bureaucracy. As any regional economy needs roads, ports, and bridges to function, a government needs offices and quarters to provide services and to house its officials.
10. These markers were changed in the second half of the nineteenth century. San Justo Street became the new east/west boundary. See Castro, *Arquitectura,* 134–36.
11. Although this barrio's most common name was San Juan, in order to avoid confusion with the city of San Juan, I will refer to this barrio as Fortaleza throughout the book.
12. Adolfo De Hostos, *Historia de San Juan,* 219.
13. The measurement was 142 hectares. See Antonio Nuñez Jiménez and Carlos Venegas Fournias, *La Habana,* 38.
14. David Watts, *The West Indies,* 378–79.
15. Aponte-Parés, "Casas y Bohios," 278.
16. María de los Angeles Castro has suggested that the *arrabal* from which Ballajá emerged was formed at least by 1800. She suggests that the barrio's name came from Santo Domingo (the colony, not the barrio) migrants, who left a town in Hispaniola with the same name in about 1795 after continuous territorial struggles with the French. Following that lead, I started to look for a Hispaniola connection in the documents related to that barrio. Marta Villaizán, formerly at San Juan's Diocesan archive, discovered correspondence between Dominican friars from San Juan and the clergy from Ballajá (in Hispaniola). Most of the lots in the Ballajá sector were owned by the Dominican order and rented to local residents. Maybe the name Ballajá came as a result of the Dominican connection. For Castro's suggestion, see *Arquitectura,* 137.
17. Fray Iñigo Abbad y Lasierra, *Historia geográfica,* 100.
18. Castro, *Arquitectura,* 383.
19. Alejandro Tapia y Rivera, *Mis memorias o Puerto Rico,* 151.

20. Ibid., 51.

21. On the provisions made for the 1842 drought, see AGPR, FOP, Edificios Públicos, San Juan, C-693, L-119.

22. De Hostos, *Historia*, 477–79.

23. Ibid., 479.

24. José M. Eizaguirre, "Los sistemas," 54–89.

25. Castro, *Arquitectura*, 141, 197–99.

26. See Félix V. Matos Rodríguez, "Diario de Edward Bliss Emerson," 174–75.

27. Castro, *Arquitectura*, 199–200.

28. Oscar L. Bunker, *Historia de Caguas*, 277.

29. De Hostos, *Historia*, 74.

30. See, for example, Pierre Ledrú, *Viaje a la Isla de Puerto Rico*, 57–60; and Abbad y Lasierra, *Historia geográfica*, 99–101.

31. Picó, "Nociones de orden," 50; and Adam Szászdi, "Credit without Banking," 160–61.

32. Picó, *Historia general*, 142–43; and Szászdi, "Credit without Banking," 162.

33. Szászdi, "Credit without Banking," 163–65. Zeballos was San Juan's *alcalde*; Mascaró was a military hero during the British attack on San Juan in 1797; and Andrade was the Prebendary of the Cathedral and subsequent Dean of the Cathedral Chapter.

34. Picó, "Nociones de orden," 48–49; and Fernando Picó, "Esclavos, cimarrones," 26–29.

35. See Adam Szászdi, "Apuntes sobre," 1433–77; and Birgit Sonesson, "Puerto Rico's Commerce," 47–48. For a general discussion of the nineteenth-century slave trade in Puerto Rico, consult Arturo Morales Carrión, *Auge y decadencia*, 33–45.

36. Ruth Pike, "Penal Servitude," 21–40.

37. Elizabeth Kuznesof, "A History of Domestic Service," 24–26.

38. Picó, *Historia general*, 52.

39. Iñigo Abbad, *Historia geográfica*, 107.

40. AGPR, Censos San Juan, Barrio Puerta de Tierra, 1845 and 1846.

41. On fishing in the Cangrejos area, see Gilberto Aponte, *San Mateo de Cangrejos*, 17–18.

42. AGPR, FMSJ, Actas del Cabildo, 1855, March 20, 1855, 41v.

43. See AGPR, FMSJ, Actas del Cabildo, 1843, June 1, 1843, 116v.

44. Tapia y Rivera, *Mis memorias*, 56. See also Herminio Rodríguez Morales, "Canal de transporte," 130–39.

45. See Matos Rodríguez, "Diario de Edward B. Emerson," 174–80.

46. See, for example, *Actas del Cabildo*, March 13, 1809, 12, and September 19, 1814, 125.

47. Nilda Martínez Ortiz, "Las sociedades mercantiles," 80–81.

48. See Scarano, *Sugar and Slavery*, 3, 9–12; and Teresita Martínez Vergne, *Capitalism in Colonial Puerto Rico*, 7–8. Fernando Picó has stressed San Juan's economic stagnation beginning in the 1820s; see "Nociones de orden," 59–60, and *Vivir en Caimito*, 28–34.

49. Scarano, *Sugar and Slavery*, 14; Andrés Ramos Mattei, *La hacienda azucarera*, 20–24; and Laird W. Bergad, *Coffee*, 68–73.

50. Doña Simona Peralta was one of the teachers asking for and receiving a salary increase in 1846. For sixteen years she had been earning 96 pesos a year; the *cabildo* gave her 150 pesos a year. See AGPR, FMSJ, Actas Cabildo, C-17, October 21, 1846, 291v–f, and December 2, 1846, 329f. For the city's doctors' story, see ibid., C-21, March 10, 1856, 40f–v, and March 27, 1856, 47f–v. In his memoirs, Governor Norzagaray comments on the demands of public employees for salary increases; see "Diario del gobernador," 72–73.

51. Asenjo, a *sanjuanero,* believed that the combination of hurricanes, earthquakes, and economic crises "had produced the most complete disturbance to the economic life of this city and of this entire island" (my translation). See *Las fiestas,* 43–46.

52. Sepúlveda Rivera, *San Juan,* 222–24.

53. Ibid.

54. Tapia y Rivera, *Mis memorias,* 32–33.

55. Sepúlveda Rivera, *San Juan,* 171–81.

56. Kinsbruner, for example, argues that "unfortunately, the dearth of socioeconomic data in the San Juan censuses makes it impossible to situate the population within even such crude categories as upper, middle, and lower strata. Much less is it possible to correlate race and income or race, income, and occupation. Nor, therefore, is it possible to apply class analysis in this investigation." Kinsbruner does argue for employing race as the key factor in determining social status in nineteenth-century San Juan. See his "Caste and Capitalism," 434–35.

57. Martínez Vergne, *Shaping the Discourse,* chap. I, 5–12.

58. An excellent synthesis of the literature on class and social structure in urban colonial Latin America can be found in Susan Socolow, "Introduction," 3–18. For an analysis of the class structure of nineteenth-century Puerto Rican society, see Angel G. Quintero Rivera, *Conflictos de clase,* 117–26; and James L. Dietz, *Economic History,* 57–61. On Ponce's merchants, see Scarano, *Sugar and Slavery,* 79–99, 144–60; and Ivette Pérez Vega, "Las sociedades mercantiles," 52–112. About Arecibo's merchants, consult Astrid Cubano Iguina, *El hilo en el laberinto,* 13–76. On San Juan's merchants, see Birgit Sonesson, "Puerto Rico's Commerce," 48–66, 292–433; Carmen Campos Esteve, "La política del comercio"; Jay Kinsbruner, "The Pulperos," 65–85; and Martínez Ortíz, "Las sociedades mercantiles," 74–104.

59. Dietz, *Economic History,* 57–58; and Socolow, "Introduction," 8–9.

60. I use the term "Creole" as a translation of the Spanish term *criollo,* which means "native-born." In the Spanish-speaking Caribbean, the term *criollo* was applied to people of all races. In the English-speaking Caribbean the term is currently used to describe native-born black people. See Richard Allsop, *Dictionary,* 176–77.

61. Socolow, "Introduction," 9; and Kinsbruner, "Caste and Capitalism," 434–38.

62. Martínez Vergne, *Shaping the Discourse,* chap. I, 8–10.

63. The question as to whether the cities that were used as models really attained all these attributes is obviously a pressing one here. For an excellent analysis of "the eagerness of modernity," see Alvarez Curbelo, "El afán de la modernidad," 9–49, 269–320.

64. For an analysis of the activities of the church in nineteenth-century Puerto Rico, see José M. García Leduc, "La Iglesia"; Almudena Hernández Ruigómez, *La desamortización;* Jorge David Diaz, "Estudio sobre," 67–138; Arturo V. Dávila, "Aspectos," 39–102; and Barceló Miller, "De la polilla."

65. Alejandro Tapia y Rivera was one of the leading romantic literary figures in Puerto Rico. For a description of his vision of modernity and that of other literary figures and abolitionists, see Alvarez Curbelo, "El afán de modernidad," 175–318.

66. On the composition and agendas of San Juan's town council, see Picó, *Historia general*, 119–20, 126–27.

67. AGPR, FMSJ, Actas Cabildo, January 26 [56v–57f] and March 15 [74f–74v], 1824.

68. AGPR, FMSJ, Actas Cabildo, May 21 [55v], September 14 [83f–84f], and December 11 [103v], 1829.

69. See, for example, the complaint on AGPR, FMSJ, Actas del Cabildo, 1829, September 14, 1829, 83f–84v. In 1836 the *cabildo* imposed a 10-peso fine on anyone caught in this type of activity. See ibid., 1836, May 25, 1836, 51f–v. In 1846, faced with more complaints, the *cabildo* reissued the 10-peso fine. See ibid., 1846, March 30, 1846, 88f–v.

70. AGPR, FMSJ, Actas Cabildo, February 29, 1836, 14v.

71. AGPR, FMSJ, Actas Cabildo, May 25 [51f–v], June 21 [63v–64f], July 19 [80f–v], and August 9 [81f], 1836. The *cabildo*'s logic for supporting the school is interesting. They thought that by providing financial support they would be in a better position to closely monitor the school.

72. AGPR, FMSJ, Actas Cabildo, June 10, 1840, 137v.

73. AGPR, FMSJ, Actas Cabildo, May 5 [102v/103f] and October 6 [329f–v], 1847.

74. AGPR, FMSJ, Actas Cabildo, June 15, 1847, 259f–v.

75. AGPR, FMSJ, Actas Cabildo, August 17, 1842, 152v.

76. AGPR, FMSJ, Actas Cabildo, June 13, 1847 [143f] and October 10, 1849 [227f].

77. AGPR, FMSJ, Actas Cabildo, May 15, 1862, 69f–v.

78. AGPR, FMSJ, Actas del Cabildo, August 8, 1849, 193f–193v (my translation).

79. AGPR, FMSJ, Actas Cabildo, March 3, 1865, 37f–38v.

80. See, for example, AGPR, FMSJ, Actas Cabildo, September 10, 1861, 142f.

81. AGPR, FMSJ, Actas Cabildo, August 13, 1850, 137v.

82. GPR, FMSJ, Actas Cabildo, February 14, 1853, 20f–22v. The new marketplace also provided the opportunity, according to the *cabildo* and the governor, of relocating poor families from the Santo Domingo barrio into the extramural neighborhoods.

83. AGPR, FMSJ, Actas Cabildo, October 1, 1855, 120f–v.

84. AGPR, FMSJ, Actas Cabildo, June 3, 1862, 76f–v.

85. AGPR, FMSJ, Actas Cabildo, March 3, 1865, 38f.

86. Delfín Vecilla de las Heras, *El Obispo*, 246–47.

87. Barceló Miller, "De la polilla," 82–86; and Picó, *Libertad y servidumbre*, 152.

88. "La sociedad civil descansa sobre la sociedad doméstica," *Boletín Eclesiástico* 4, no. 22 (November 1862): 269.

89. "Así se ve que el bien público esta identificado con las más íntimas relaciones de la familia," *Boletín Eclesiástico* 4, no. 22 (November 1862): 269.

90. "En toda grande empresa interviene una mujer," *Boletín Eclesiástico* 4, no. 18 (September 1862): 221. See Barceló Miller's reading of this and other *Boletín* articles in "De la polilla," 76–88.

91. "La muger, colocada al lado del hombre, siempre . . . le fortalece ó debilita," *Boletín Eclesiástico* 4, no. 18 (September 1862): 221.

92. Barceló Miller, "De la polilla," 80–81; and Vecilla de las Heras, *El Obispo*, 84.

93. For a list of the association's goals and the requirements for membership, see the *Reglamento de las Hijas de María* (1875), in AHD, S-Asociaciones, C-G114.

94. *Boletín Eclesiástico* 6, no. 1 (January 1864): 1–3.

95. "Este bello e interesante modelo" and "suave poder de la pobre doncella," *Boletín Eclesiástico* 6, no. 10 (May 1864): 110.

96. "Pudiese tomar al hombre pecador por la mano" and "Por medio de ella el hombre mas pecador puede salvarse," *Boletín Eclesiástico* 6, no. 11 (June 1864): 122–23.

97. This sermon or conference has no author. "Deberes de los esposos [San Fco?], [March?] 20, 1865," AHD, F-Diocesano, S-Gobierno, Se-Doctrina, C-G134, 1f.

98. Ibid., 6v.

99. Ibid., 8v.

100. Ibid., 1f.

101. Ibid., 3f.

102. Ibid., 3v.

103. Ibid., 7f.

104. Picó, *Libertad y servidumbre*, 131–32.

105. *Boletín Eclesiástico* 6, no. 13 (July 1864): 147.

106. *Boletín Eclesiástico* 6, no. 12 (June 1864): 135.

107. *Boletín Eclesiástico* 6, no. 10 (May 1864): 113. On the cult of Mary in Puerto Rico's countryside, see Picó, *Libertad y servidumbre*, 144.

108. *Boletín Eclesiástico* 6, no. 13 (June 1864): 148.

109. On the island's entrance into the world's sugar market and the subsequent growth and development of this sector, see Scarano, *Sugar and Slavery*, chaps. 1 and 2. Consult also Ramos Mattei, *La hacienda azucarera*; and Pedro San Miguel, *El mundo*.

110. The classic study of the life and labor conditions in Puerto Rico's interior municipalities before the expansion of coffee cultivation is Picó, *Libertad y servidumbre*. Other important studies are Carlos Buitrago Ortiz, *Haciendas cafetaleras*, 1–61; and Bergad, *Coffee*, 3–68.

111. See the essays about Puerto Rico in Manuel Moreno Fraginal et al., eds., *Between Slavery and Free Labor*, 117–80. Consult also Francisco Scarano, "Slavery and Free Labor," 553–63; Andrés Ramos Mattei, "El liberto," 99–124; Quintero Rivera, *Conflictos de clase*; Martínez Vergne, *Capitalism*, 1–37, 102–35; and Luis Figueroa, "Facing Freedom."

112. See Fernando Picó, *Amargo café*; Bergad, *Coffee*, chaps. 3 through 5; and Buitrago Ortiz, *Haciendas cafetaleras*, chaps. 3 through 8.

113. For various interpretations of the "Gloriosa" revolt in Spain in 1868, consult Emile Témime et al., eds., 111–64; Jordi Nadal, *El fracaso*; and Miguel Artola, *La burguesía*. The Cuban situation is discussed in Ramiro Guerra y Sánchez, *Historia de la guerra*; Rebecca Scott, *Slave Emancipation*, 3–128; Raúl Cepero Bonilla, *Azucar y abolición*; and Louis A. Pérez Jr., *Cuba*, 104–55.

114. Much has been written about the Grito de Lares in 1868. An excellent study of the economic and political situation of the period is given by Cubano Iguina, *El hilo*. More specific studies about the Lares revolt include José Pérez Moris, *Historia de la Insurreccion*; Olga Jiménez de Wagenheim, *El Grito de Lares*; Luis de la Rosa Martínez, *La periferia*; and Laird W. Bergad, "Towards Puerto Rico's Grito de Lares," 617–42.

115. Political parties had been loosely organized since 1865. See Bolivar Pagán, *Historia de los partidos*, vol. I, 11. For an explanation of the elites' alliances to the different sectors of the original Conservative and Liberal parties, see Cubano Iguina, *El hilo*, 23–77; and Quintero Rivera, *Conflictos de clase*, 13–27.

116. Gervasio García and Angel G. Quintero Rivera, *Desafío y solidaridad*, 18–25.

117. On the origins and growth of women's organizations in the late nineteenth century, see Azize, *La mujer en la lucha*, chap. 1; and Valle Ferrer, "Primeros fermentos," 15–19. On the participation and importance of nineteenth-century Puerto Rican women in literature, see Carmen Elisa Colberg, "Esquema histórico-biográfico."

118. Martínez Vergne discusses some of the elements of that counter-hegemonic perspective but emphasizes how women reproduced the social order that oppressed them. See *Shaping the Discourse*, chap. 4, 9–12.

Chapter 2

1. An example of the literature associating San Juan with Spanish, white, conservative elements can be found in Quintero Rivera, "La capital alterna," 45–46. It is interesting that writers and literary critics, but not historians, have been the ones who have chosen to highlight the cultural and numeric importance of nonwhites in eighteenth-century Puerto Rico. See José L. González, "El país de cuatro pisos," 20–23; and Edgardo Rodríguez Juliá, *Campeche o los diablejos*, 8, 153–55. One of the few historical works addressing the black and colored population prior to the nineteenth century is Jalil Sued Badillo and Angel López Cantos, *Puerto Rico negro*.

2. See Nicolás Sánchez-Albornoz, *The Population of Latin America*, 86–145; and Watts, *The West Indies*, 307–8, 378–81, 456–65.

3. See Picó, *Historia general*, 136–39; and Juan R. González-Mendoza. "The Parish," 141–42.

4. Picó, *Historia general*, 140–44.

5. See Quintero Rivera, "La capital alterna," 39–41.

6. The extramural barrios also received people directly from San Juan's hinterland. On the growth of San Juan's extramural barrios during the nineteenth century, see Sepúlveda Rivera, *San Juan*, chap. 7.

7. See Leví Marrero, *Cuba*, vol. 14, 133–48; and Julio Le Riverend, *Historia económica*, 325–26.

8. The eighteenth-century census totals, running from 1776 to 1803, come from AGPR, Colección Scarano, CP-3.

9. For Abbad y Lasierra's demographic profile, see *Historia geográfica*, 181–84. For Pierre Ledrú's comments, see *Viaje a la Isla*, 109–15.

10. In the nonwhite category, I include blacks, mulattoes, pardos, and morenos. Although "female" is an awkward adjective to describe a population, I am using the term here to state the numeric superiority of women over men in the overall civil population.

11. It is important to remember that the military was not included in the general population tallies. The data about the numbers of military personnel in San Juan have been difficult to collect. Some authors list the number of slots authorized by Spanish officials, while cautioning that the actual numbers were probably smaller. See, for ex-

ample, Héctor A. Negroni, *Historia militar,* 133–34. Negroni says that there were 2,046 soldiers in 1818. Pedro Tomás de Córdova lists 1,593 men in 1825. See his *Memorias geográficas,* vol. 5, 27. Darío de Ormaechea quotes 1,750 military men in 1847. See his "Memoria acerca," 394. One more aspect to consider in assessing San Juan's military population was its transient nature. Even if one accepts a figure of about 1,500–2,000 members of the military, that would about level the sex ratios in San Juan by the 1840s.

12. See Picó, *Historia general,* 180–81.

13. On the end of the slave trade in Puerto Rico, see Morales Carrión, *Auge y decadencia,* 213, 229–31; and Francisco Scarano, "Población esclava," 20–21.

14. See Scarano, "Población esclava," 17–21.

15. On the cholera epidemic and its effects, see Picó, *Historia general,* 175, 180–81; and Kenneth Kiple, "Cholera and Race," 169–72.

16. Ramonita Vega Lugo, "Epidemia y sociedad," 78–79.

17. Sepúlveda Rivera, *San Juan,* chap. 7; Aponte, *Cangrejos,* 17–18; and Arlene J. Díaz Caballero, "Las trabajadoras," 5–7.

18. Ruben Carbonell Fernández, "Las compra-ventas," 29, 61–62; and Szászdi, "Apuntes sobre la esclavitud," 17–19.

19. See Estela Cifre de Loubriel, *La inmigración,* 44–93. See also Rosa Santiago Marazzi, "El impacto," 1–44.

20. Sepúlveda Rivera, *San Juan,* 254–56.

21. AHN, Se-Ultramar, S-Gobierno de Puerto Rico, L-5074, E-19, December 28, 1854.

22. This was the case for those forced to relocate to make room for the Casa de Beneficencia building. AHN, Se-Ultramar, S-Gobierno de Puerto Rico, L-5077, E-40, February 21, 1848.

23. Sepúlveda Rivera, *San Juan,* 224.

24. See his "Diario del Gobernador," 108.

25. Ibid., 122.

26. This law code severely restricted the civil rights of people of "African" descent. See Jorge L. Chinea, "Race, Colonial Exploitation," 510–13.

27. For the Santa Bárbara barrio, there are manuscript censuses for the years 1808, 1818, 1823, 1833, 1838, 1840, and 1846. Kinsbruner has worked with some of these censuses; see "Caste and Capitalism."

28. Since there are a few gaps—torn pages or ink blotches—in the censuses, data were missing about some individuals. There were only a few instances of these gaps, so their effects on the total data are insignificant. Although it seems that municipal officials were in charge of collecting the census data, I have been unable to locate any census totals for the city in 1833 and 1846. All the census data were checked for age "heaping"—the tendency to round one's age to numbers ending in 0 or 5. The Whipple Index was used, and, unfortunately, it indicated that the accuracy of the data was very rough. About the Whipple Index and age heaping, in general, see Colin Newell, *Methods and Models,* 24–25.

29. Lack of time prevented me from doing a systematic review of the baptismal and burial records at the AHD. I want to add that the likelihood of "discovering" other manuscript censuses for nineteenth-century San Juan at the AGPR is not small. After being told for several months that there were only a few manuscript censuses available for nineteenth-century San Juan, I found many of the manuscript censuses I am using for this study.

30. I am assuming that the Fortaleza barrio followed, in general terms, the broader demographic trends exhibited by the other barrios in 1833. It is important to acknowledge the tentative nature of the propositions of this chapter based on the missing data from the Fortaleza barrio. Still, given that the Fortaleza barrio did not seem to be demographically too distinct from the other three barrios and that the data from the other barrios account for close to 75 percent of the city's population in 1833 and 1846, I believe that the conclusions from my demographic analysis are representative of the city.

31. Carlos Rodríguez Villanueva, "Guaynabo en 1860," 132.

32. For Ponce's figures, see Guillermo Baralt, *La Buena Vista*, 15. For Vega Baja's figures, see San Miguel, *El mundo*, 218.

33. The high numbers of widows produced by the constant warfare with Haiti must have influenced the sex ratios in Santo Domingo. See Roberto Marte, *Cuba*, 104–5.

34. Welch, however, does not provide the specific percentages or figures; see "The Urban Context," 120–26.

35. Unfortunately, I could not find any figures for the 1840s and 1850s. It is not clear whether these figures refer only to the intramural part of Havana or to the whole city. By the total, I suspect the numbers correspond to the intramural sector. Marte, *Cuba*, 108.

36. On the relationship between domestic work, low wages, high inner-city rents, and residential segregation patterns, see the incisive work by Tera Hunter, "Household Workers," 61–74.

37. AGPR, FGEPR, C-163, Policía, March 21, 1832.

38. Racial classifications in Puerto Rico, and in the Americas, for that matter, can be quite confusing. The term "mulatto," for example, meant different things in Sao Paulo, Havana, and New Orleans. In the Puerto Rican case, I believe Jay Kinsbruner has provided a brief but accurate description of the racial spectrum: "Puerto Ricans recognized degrees of blackness, generally descending from white to *pardo*, to *moreno*, to *negro*. *Pardos* almost always were the free people of color of lightest skin color; *morenos* were darker skinned, and *negros* the darkest of all. These, nevertheless, were flexible terms, variously used." See his "Caste and Capitalism," 438.

39. One should take the mulatto and pardo figures with caution. Changes in their figures could have been caused by changing taxonomical criteria and not by any actual difference in their numbers.

40. Ponce's figure is an estimate made by Scarano based on 1828 census figures; see *Sugar and Slavery*, 135. For Guayama, see Figueroa, "Facing Freedom," 106; for Vega Baja, see San Miguel, *El mundo*, 96; and for Arecibo, see Cubano Iguina, *El hilo*, 28.

41. Le Riverend, *Historia*, 180.

42. See Sepúlveda Rivera, *San Juan*, 253–54. The families were moved due to the construction of the Casa de Beneficencia. Ballajá's 1833 racial distribution was: 45 percent pardo, 31 percent mulatto, 20 percent white, and 4 percent black. The data come from AGPR, Censos San Juan, Santo Domingo, 1833.

43. For the island's total figures, see Figueroa, "Facing Freedom," 54. Guayama was one of the *municipios* where the percentage of slaves as part of the total population increased in the 1840s.

44. Since the demand for slaves became higher as the slave trade came to a close, it was very profitable for *sanjuaneros(as)* to sell their slaves to plantation owners in desperate

need of labor. Indeed, San Juan was a busy slave export center after 1850. See Carbonell Fernández, "Las compra-ventas de esclavos," 29.

45. Félix V. Matos Rodríguez, "Economy, Society," 108–12.

46. See James E. Vance Jr., *The Continuing City,* 357.

47. On the number of immigrants who had San Juan as their destiny, see Santiago Marazzi, "El impacto de la inmigración," 33–34.

48. On Vives' entrepreneurial and bureaucratic career in Ponce, see Baralt, *La Buena Vista,* 21–24. The census information comes from AGPR, FGEPR, C-563, Padrón de Almas Santa Bárbara 1823, house no. 79.

49. See the previously mentioned studies by Santiago Marazzi ("El impacto de la inmigración") and Cifre de Loubriel (*La inmigración a Puerto Rico*). See also Chinea, "Race, Colonial," 495–520. Although not limited exclusively to the nineteenth century, consult also Santiago Marazzi, "La inmigración de mujeres," 154–65.

50. Costa Firme is the listing given in the manuscript censuses to those born in the Viceroyalty of New Granada and the Captaincy-General of Venezuela.

51. Of all the known women immigrants during the first thirty years of the nineteenth century, around 22 percent came from Santo Domingo. See Santiago Marazzi, "La inmigración de mujeres," 163–64. Also see Cifre de Loubriel, *La inmigración a Puerto Rico,* 49–50.

52. AGPR, FPNSJ, Juan B. Nuñez, C-462, November 16, 1807, 102 f.

53. Cuba received a substantial number of French immigrants fron Haiti. See Leví Marrero, *Cuba,* vol. 9, 141–50.

54. Le Riverend, *Historia,* 181.

55. For details about Puerto Rico's commercial ties with the rest of the Caribbean, see Sonesson, "Puerto Rico's Commerce," 17–48.

56. Santiago in Hispaniola received many *libertos* from the neighboring British and French Caribbean colonies. See Marte, *Cuba,* 147; and Chinea, "Race, Colonial," 499–506.

57. The list goes to show the detailed policing that city authorities did of foreigners and people of color. The list can be found in FMSJ, L-49 (P.I.), E-49, September 1, 1842.

58. This is a list of naturalized foreigners with temporary residence licenses from the Spanish government in all of San Juan's barrios. See FGEPR, C-570, San Juan, October 13, 1856.

59. On the propensity of urban slaves to acquire or receive manumission in higher rates than their rural or plantation counterparts, see Herbert S. Klein, *African Slavery,* 229.

60. FMSJ, L-49 (P.I.), E-45, September 1, 1842.

61. Chinea's work is a recent attempt at understanding this migration; see "Race, Colonial," 495–520. On intra-Caribbean migration in the nineteenth century, see Bonham C. Richardson, *The Caribbean,* 131–38; and Watts, *The West Indies,* 481–84. On the migration of West Indians to work on Puerto Rican sugar plantations during the 1860s and 1870s, see Andrés Ramos Mattei, "La importación," 125–41.

62. Picó, *Historia general,* 180–81.

63. The number of people coming from Costa Firme might have been even higher,

because the census data give the individual's place of birth and not the last place of residence. The censuses would, therefore, list a person born in Cataluña as a Catalan, even when he or she might have migrated into San Juan from Costa Firme. On the overall number of women migrating from Costa Firme, see Santiago Marazzi, "La inmigración de mujeres," 164–65.

64. Raquel Rosario Rivera, Los emigrantes, 59–77.
65. See, AGPR, FGSPR, Policía, C-163, August 1, 1830.
66. Le Riverend, Historia, 182.
67. Santiago Marazzi, "La inmigración de mujeres," 163–65; and Cifre de Loubriel, La inmigración a Puerto Rico, 94.
68. On the Catalan merchants, see Santiago Marazzi, "El impacto," 19–26; and Estela Cifre de Loubriel, La formación, 23–25, 47–49, 52–54. Also, Jordi Maluquer de Motes, "Inmigración y comercio," 161–82.
69. Santiago Marazzi, "El impacto de la inmigración," 26.
70. Campos Esteve found that 48 percent of the merchants included in her study, half of which were Catalans, married Creole women; see "La política del comercio," 65. For the Cuban experience, consult Pablo Tornero, "Inmigración, población," 266–71.
71. Campos Esteve, "La política del comercio," 63.
72. See Kinsbruner, "The Pulperos," 80–81.
73. Cifre de Loubriel, La inmigración a Puerto Rico, 51–52.
74. Puerta de Tierra had 232 residents in 1845. AGPR, Censos San Juan, Barrio Puerta de Tierra, 1845. There were only ten Canarios, out of around 155 people, in Puerta de Tierra in 1838. See AGPR, FMSJ, L-49 (P.I.), E-4.
75. Based on the census data from the AGPR, Censos San Juan, 1833 and 1846.
76. See Klein, African Slavery, 247; and Picó, Historia general, 167.
77. See Carbonell Fernández, "Las compra-ventas de esclavos," 29.
78. See, among others, Philip D. Curtin, The Atlantic Slave Trade, 19, 28; Klein, African Slavery, 147–49, 155–56; Herbert S. Klein, The Middle Passage; Kenneth F. Kiple, The Caribbean Slave, 104–19; and B. W. Higman, Slave Populations, 72–78, 115–20, 303–78.
79. On urban and domestic slavery in San Juan, see Negrón Portillo and Mayo Santana, La esclavitud urbana; Mayo Santana, Negrón Portillo, and Mayo López, Cadenas de la esclavitud; Carbonell Fernández, "Las compra-ventas de esclavos," 32, 61–69; and Szászdi, "Apuntes sobre la esclavitud," 1449–51.
80. See Tornero, "Inmigración, población y esclavitud," 256–64.
81. For the early-nineteenth-century sex ratios in some of the major towns and cities in the British Caribbean, see Higman, Slave Populations, 117–19.
82. The census data did not provide the place (town/city) of origin of those classified as born in Puerto Rico. Without this information, it is impossible to determine the precise role of migration from other areas of the island into San Juan.
83. See Arrom, Las mujeres, 225–27; and Elizabeth Kuznesof, "Household Composition," 82–83.
84. See Sherry Johnson, "La Guerra Contra," 181–209.

Chapter 3

1. The five merchants filing the lawsuit were: Don José Viñals (1,853 pesos), Don Benito Carreras (585 pesos), Don Francisco Barnes (375 pesos), Don Pedro Prado (362 pesos), and Don Francisco Bas (320 pesos). See AGPR, FMSJ, L-73E (P.I.), E-3, November 11, 1823.

2. See, for example, Susan Socolow, *The Merchants;* David A. Brading, *Miners and Merchants;* and Ann Twinam, *Miners, Merchants.*

3. Sonesson, "Puerto Rico's Commerce," 28, 52–53; and Campos Esteve, "La política del comercio," 63–71.

4. The breakdown of San Juan merchants' nationalities comes from Campos Esteve, "La política del comercio," 63–65.

5. For some of Mason's activities, see the account by his guest and employee, Edward B. Emerson, found in Matos Rodríguez, "Diario de Edward," 167–86.

6. Sonesson, "Puerto Rico's Commerce," 53, 387.

7. Campos Esteve, "La política del comercio," 55–90.

8. Elzaburu y Compañía's reorganization papers are found in AGPR, FPN, SJ, Manuel Camuñas, 1861, C-29, 606v–608f.

9. They had been associated since 1844, but in 1856 the three partners filed for reorganization. See AGPR, FPN, SJ, Agustín Rosario, 1856, C-550, 63v–65v.

10. AGPR, FPN, SJ, Manuel Camuñas, C-29, April 12, 1861, 210v–212f.

11. AGPR, FPN, SJ, José Ma. León Urbina, C-442, February 5, 1827, 63v–64f.

12. AGPR, FPN, SJ, Juan B. Nuñez, C-502, April 23, 1844, 116f–116v.

13. AGPR, FPN, SJ, Juan B. Nuñez, C-473, November 24, 1823, 690v–691f.

14. AGPR, FPN, SJ, Manuel Camuñas, C-29, March 2, 1861, 153v–155f and September 30, 1861, 456v–458v.

15. For a solid review of the abundant literature on marriage and kinship relations patterns among Latin American merchants, see Catherine Lugar, "Merchants," 63–67.

16. Manuel Moreno Fraginals, *El ingenio,* vol. 1, 265–69.

17. Lugar, "Merchants," 65–67. A study of Corsican immigrants, many of them merchants, in early nineteenth-century Yauco, showed that they also married members of the local Creole elite. See María D. Luque de Sánchez, "Matrimonios y compadrazgos," 43–55.

18. Campos Esteve, "La política del comercio," 60.

19. AGPR, Censos San Juan, Barrio San Francisco, 1833, 96f.

20. AGPR, Censos San Juan, Barrio San Francisco, 1833, 97 (Viñas-Bufarres) and 137v (Sola-Flores).

21. Cubano Iguina, *El hilo,* 55–59; and Scarano, *Sugar and Slavery,* 91–93.

22. Guillermo Baralt, "Los estadounidenses," 8–10. I want to thank the author for sharing with me some of the findings of his ongoing research about José Ramón Fernández.

23. Sonesson, "Puerto Rico's Commerce," 48–66.

24. Ibid., 53.

25. See Suzanne Lebsock's analysis in *The Free Women,* 15–86. For an example of promoting women's protection with ulterior motives, see K. Lynn Stoner, *From the House,* 40–41.

26. AGPR, FMSJ, PN, Juan B. Nuñez, C-473, 1823, 452v–454v.

27. On the performance of women plaintiffs and defendants in lower court cases in San Juan, see Félix V. Matos Rodríguez, "La mujer, 227–64.

28. AGPR, FPN, SJ, Juan B. Nuñez, C-462, August 9, 1808, 78v–81v.

29. AGPR, FPN, SJ, Manuel Camuñas, C-29, February 13, 1861, 116v.

30. Dávila Ramirez's *estancia* was located on the Juan Domingo barrio of Pueblo Viejo. She had bought the *estancia* in 1852 from Don Manuel Monieu. Pizarro agreed to divide his payments into three parts, making the last payment in August 1858. See AGPR, FPN, SJ, Agustín Rosario, 1856, C-550, July 29, 1856, 459f.

31. Ibid., June 4, 1856, 289f.

32. De los Reyes' land was located within the Juan Sánchez and Cataño barrios of Bayamón. The sale's documents are found in AGPR, FPN, SJ, Manuel Camuñas, 1861, C-29, April 10, 1861, 206f–207f.

33. Sonesson, "Puerto Rico's Commerce," 46–48. See also Carbonell, "Las compraventas," 55–60.

34. AGPR, FPN, SJ, Juan B. Nuñez, 1844, C-502, July 8, 1844, 187f–187v. In Juan B. Nuñez's 1844 notary book, of the 397 slave transactions recorded, 192 included women as either buyers or sellers.

35. AGPR, FPN, SJ, Juan B. Nuñez, 1844, C-502, October 15, 1844, 289v.

36. See AGPR, FPN, SJ, Juan B. Nuñez, 1829, C-478, January 22 and April 8, 1829. Fragoso did not know how to sign her name, and her brother signed for her. In Nuñez's 1829 notary book, of 237 slave transactions, 100 involved women as either buyers or sellers.

37. AGPR, FPN, SJ, Juan B. Nuñez, 1829, C-478, November 20, 1829. Fragoso was single at the time of this transaction.

38. AGPR, FPN, SJ, José Ma. León Urbina, 1827, C-442, July 2, 1827, 290f–290v.

39. AGPR, FPN, SJ, Manuel Camuñas, C-29, May 11, 1861, 264v–265v.

40. AGPR, FPN, SJ, Manuel Camuñas, C-29, January 10, 1861, 23v–24f.

41. Higman, *Slave Populations*, 119.

42. On the effect that inheritance laws had on women, see Arrom, *Las mujeres,* 80–100. See also Alida Metcalf, "Women and Means," 277–98.

43. Jay Kinsbruner, "Real Property Ownership in San Juan, Puerto Rico during the Early Nineteenth Century: An Analysis of the Census of 1820." Unpublished manuscript, AGPR, 4.

44. AGPR, FGEPR, C-163, Policía, August 1, 1830.

45. AGPR, FGEPR, C-163, Policía, February 23, 1831.

46. AGPR, FMSJ, Actas del Cabildo, September 30, 1847, 319v–320f.

47. See Sepúlveda Rivera, *San Juan,* 222–24, 250.

48. The 1820 data come from Kinsbruner, "Real Property," 5. The 1859 data come from my analysis of the property census found in AGPR, FMSJ, L-123A, E-25.

49. Kinsbruner, "Caste and Capitalism," 452–53.

50. The data come from Kinsbruner, "Real Property," table 5. The units included here do not count those owned by the church or the Spanish state. The number of such units in San Juan was very small.

51. Women owned 288 houses out of 834. This does not include, again, church and state properties. It does not include, also, forty-six units that were owned by *sucesiones* (a dead person's estate), since I was not able to assign a gender category to these *sucesiones*. The data came from AGPR, FMSJ, L-123A, E-25.

52. Kinsbruner, "Caste and Capitalism," 452.

53. AGPR, FMSJ, Juicios de Conciliación, L-73E (P. II), E-18, August 9, 1844.

54. AGPR, FMSJ, Juicios de Conciliación, L-73E (P. III.), E-67, March 25, 1860, and L-73E (P. IV.), E-68, December 11, 1860.

55. The 1844–45 cases are found in AGPR, FMSJ, L-73E (P.II.), E-18, August 27, 1844, and the 1852 case is found in ibid., L-73E (P. III.), E-34, November 13, 1852.

56. See Matos Rodríguez, "La mujer y el derecho."

57. AGPR, FPN, SJ, Juan B. Nuñez, C-478, January 3, 1829, 5f–7v.

58. AGPR, FPN, SJ, Manuel Camuñas, C-29, February 13, 1861, 116v.

59. Metcalf, "Women and Means," 279–82, 289–92.

60. AGPR, FMSJ, L-73E, P-I, E-3, July 24, 1823.

61. See Matos Rodríguez, "Economy, Society," 161–82.

62. Kinsbruner, "The Pulperos," 75. Kinsbruner distinguished between *bodegas,* which were establishments where retail merchants sold mostly imported goods bought from wholesale merchants, and *pulperías,* which basically provided retail food items and spirits that were domestically produced.

63. Ibid., 69–70.

64. AGPR, FGEPR, San Juan 1820, C-564.

65. AGPR, FGEPR, San Juan 1816–1820, C-561.

66. AGPR, FMSJ, L-76, E-2, September 30, 1841, and March 14, 1843.

67. AGPR, FMSJ, L-123A, E-25.

68. "Relación de Establecimientos Mercantiles," AGPR, FGEPR, San Juan 1830–50, C-567.

69. Kinsbruner, "The Pulperos," 72, 79.

70. Ibid., 67–68.

71. Méndez paid 25 pesos a month for the locale on Luna Street. See AGPR, FMSJ, PN, Agustín Rosario, C-550, August 26, 1856, 543v.

72. Kinsbruner, "The Pulperos," 80.

73. Ibid., 80–82.

74. AGPR, Censos San Juan, Barrio San Francisco, 1833, 17f. Fragoso was the same women I mentioned earlier who bought many slaves between 1827 and 1829. She was single when she bought those slaves.

75. AGPR, Censos San Juan, Barrio San Francisco, 1833, 61v.

76. AGPR, Censos San Juan, Barrio Santa Bárbara, 1846, 118f.

77. On the Jamaican case, see Paulette Kerr, "Jamaican Female," 7–17.

78. The innkeeper had lived in the United States and worked as a cook. See Matos Rodríguez, "Diario de Edward Bliss Emerson," 175.

79. AGPR, FPN, SJ, Manuel Camuñas, 1861, C-29, 324.

80. AGPR, FPN, SJ, Agustín Rosario, 1856, C-550, 40v–41f.

81. AGPR, FGEPR, San Juan 1820, C-564.

82. See AGPR, Censos San Juan, Barrio Santa Bárbara, 1846, 5v. Pio and Josefa's entries are found in ibid., Barrio Santo Domingo, 1846.
83. AGPR, Censos San Juan, Barrio Santa Bárbara, 1846, 18v.
84. See Lyman Johnson, "Artisans," 236–44. Johnson also makes reference to the participation of women among the urban artisan industries.
85. See José G. Rigau-Pérez, "The Introduction," 418–23.
86. On the general, local secondary and professional education conditions during the nineteenth century, see Juan José Osuna, A History, 103–24; and Antonio Cuesta Mendoza, Historia de la educación, 107–90.
87. Osuna, A History, 19–20.
88. De Hostos, Historia de San Juan, 377.
89. Jesús Raúl Navarro García, Control social, 140.
90. AGPR, FMSJ, Actas del Cabildo, 1832, November 26, 1832, 99v.
91. For the accusations against Cordero, see AGPR, FMSJ, Actas del Cabildo, 1832, January 28, 1832, 123v–124f. The town council, though, increased Cordero's salary in 1847 from 100 pesos to 150 pesos a year (ibid., 1847, March 3, 1847, 54f). It seems that Cordero finally left her job around 1853. For Antoñaura de Gallardo comments, see ibid., 1853, December 5, 1853, 174f.
92. Osuna, A History, 46.
93. Cuesta Mendoza, Historia, vol. 2, 60–61.
94. Fernando Picó, Educación y sociedad, 6.
95. Osuna, A History, 41–42.
96. Ibid., 19.
97. AGPR, FMSJ, Actas del Cabildo, 1836, July 19, 1836, 80f–v.
98. AGPR, FMSJ, Actas del Cabildo, 1846, December 2, 1846, 329f; and ibid., 1847, March 3, 1847, 54f.
99. AGPR, FGEPR, Comercio y Contribución, C-194, "Copia certificada de las noticias," 12v.
100. The salary scale is reproduced in Osuna, A History, 56.
101. In this 1843 competition, sixty-four island schools sent entries. Out of these sixty-four schools, eight were girls' schools and two were coeducational. From the Mayaguez region, three out of the five schools that participated were for women. In the Aguadilla region, there were two girls' schools out of eight participating in the competition. For the listing, see AGPR, FGEPR, S-Instrucción, C-328, "Acta de la Junta pública celebrada," 1843.
102. The two female teachers who had to purchase their own materials and furniture were Doña Nicolasa Peralta and Doña Juana Canals. AGPR, FMSJ, Instrucción Pública, L-67, E-17.
103. The title Riera wanted was *comadrona titular*. The town council did not act on her request. AGPR, FMSJ, Actas del Cabildo, 1855, June 11, 1855, 76f.
104. Lydia Pérez González, Enfermería en Puerto Rico, 40.
105. AGPR, FMSJ, Actas del Cabildo, 1846, October 21, 1846, 288v. Also, Pérez González, Enfermería en Puerto Rico, 40.
106. Cipres' husband was also a *loquero* at the Casa de Beneficencia. The notice of Cipres' death is found in AGPR, FGEPR, Beneficencia, C-2, March 28, 1845.

107. AHN, Se-Ultramar, S-Gobierno de Puerto Rico, L-5077, E-40, December 9, 1851.

108. Ibid.

109. AGPR, FMSJ, Actas del Cabildo, 1865, February 10, 1865, 27v.

110. Guerra's husband was Don Marcos Sosa. AGPR, FMSJ, Actas del Cabildo, 1859, October 29, 1859, 179v.

111. AGPR, FMSJ, Actas del Cabildo, 1855, May 14, 1855, 64v–65f. If the *cabildo* did act on Requena's request, I was unable to find their response in their minutes.

112. De Córdova, *Memorias geográficas*, vol. 4, 423–27. The *manda-pía forzosa* was established in 1811 to raise funds for the crown's European wars. The tax was paid by all those declared as "inheritors" in a will. See Luis De la Rosa Martínez, *Lexicón Histórico*, 79. About the support given for the widows and children of South American soldiers during the struggle for independence, see Rosario Rivera, *Los emigrantes llegados*.

113. AGPR, FMSJ, Actas del Cabildo, 1856, June 26, 1856, 86v–87f.

114. AGPR, FGEPR, Hacienda (1821–25), C-202, December 13, 1820.

115. Arrom, *Las mujeres*, 79–80.

116. There is no indication as to whether she was involved in hatmaking herself or whether she was just selling the hats. See Matos Rodríguez, "Diario de Edward Bliss Emerson," 177.

117. Kinsbruner, "The Pulperos," 72.

118. I will use the term "working women" to refer to those women whose occupations were listed on the 1846 census and who worked on either domestic or dressmaking activities. Almost all the women for whom occupations were listed in the 1846 census were either domestics or dressmakers. The number of women listed as teachers, merchants, artisans, shop owners, etc., was very small. The Spanish census takers, of course, did not consider any noncontractual household work as an occupation.

119. This assumption is based on the census criteria for *jefatura* (head) of family status. Usually, home owners or room renters were designated heads of families by census takers.

120. On women and the nineteenth-century Cuban cigar industry, see Olga Cabrera, "Cuba," 227–33.

121. AGPR, Censos San Juan, Barrio San Francisco, 1846, 72f (Más) and 90f (Fauco).

122. AGPR, FGEPR, C-1, Beneficencia, July 8, 1821.

123. The *cabildo* records did not register their complete names. See AGPR, FMSJ, Actas Cabildo, August 31, 1868, 395f (Gonzalez) and September 1, 1868, 396v (Ferrer).

124. Barceló Miller, "De la polilla," 86.

125. On women's use of San Juan lower courts to advance their interests, see Matos Rodríguez, "La mujer y el derecho."

Chapter 4

1. She also required the services of an *apoderado* to handle her affairs in 1856. See FMSJ, PN, Agustín Rosario, C-550, July 14, 1856, 395f. I have not been able to find out whether she owned any of the houses prior to being fired in 1846.

2. I have provided a more comprehensive perspective on the role domestic labor and urban slavery played in the city's preparation for the abolition of slavery in "¿Quién trabajará?," 62–82.

3. AGPR, Censos San Juan, Barrio Santa Bárbara, 1846, 14v (Tanco) and 34f (De los Santos).
4. See Matos Rodríguez, "Diario de Edward Bliss Emerson," 168–69, 174–81.
5. AGPR, FMSJ, Actas Cabildo, April 1, 1862, 48f–v.
6. The information on the three *fonderas* comes from AGPR, Censos San Juan, Barrio San Francisco, 1846.
7. On the slaughterhouse's location, see Sepúlveda Rivera, *San Juan*, 292.
8. AGPR, FMSJ, Actas del Cabildo, November 15, 1843, 231f and June 15, 1846, 160f.
9. "La Calle del Mondongo," Alejandro Tapia y Rivera recalled; see *Mis memorias*, 51.
10. AGPR, FGEPR, Policía, C-163.
11. Ibid.
12. Diaz Caballero, "Las trabajadoras asalariadas," 8–9.
13. AGPR, FPN, SJ, Manuel Camuñas, C-29, 1861, 324f.
14. Sidney W. Mintz, "Men, Women," 247–69.
15. See the brief but suggestive piece by Mary Karasch, "Suppliers, Sellers," 267–69.
16. AGPR, FMSJ, Juicios Verbales, L-49E (P. IV.), E-67, October 10, 1860.
17. See Frank Otto Gatell, "Puerto Rico," 69.
18. Christine Hünefeldt, *Paying the Price*, 107–16.
19. AGPR, FMSJ, Actas Cabildo, June 21, 1836, 63v–64f.
20. AGPR, Censos San Juan, Barrio Santa Bárbara, 1846, 39f. (Gabiel) and 40f. (Dorado).
21. The data from Guzmán and the other street vendors come from AGPR, Censos San Juan, Barrio Santo Domingo, 1846, 27f.
22. Boa, "Urban Free Black," 4.
23. AGPR, FMSJ, Actas Cabildo, July 26, 1846, 210v.
24. AGPR, FMSJ, Actas Cabildo, September 14, 1829, 83f–84v.
25. AGPR, FMSJ, Actas Cabildo, November 15, 1843, 231f.
26. AGPR, FMSJ, Actas Cabildo, May 18, 1853, 76v.
27. AGPR, FMSJ, Actas Cabildo, May 3, 1853, 81–81v, and June 27, 1853, 97f.
28. AGPR, FMSJ, Actas Cabildo, June 3, 1859, 113f.
29. De Hostos, *Historia de San Juan*, 504.
30. Ibid.
31. For a comparison with slave prostitution in Brazil, see Sandra Lauredale Graham, "Slavery's Impasse," 669–94.
32. José Flores Ramos, "Eugenesia," 94, 110–14.
33. AGPR, FMSJ, Actas Cabildo, June 21, 1836, 63v–64f.
34. Marrero, *Cuba*, vol. 14, 151–56.
35. See De Hostos, *Historia de San Juan*, 477–79.
36. AGPR, FMSJ, Actas del Cabildo, July 28, 1842, 138v.
37. De Hostos, *Historia de San Juan*, 479.
38. AGPR, FMSJ, Actas Cabildo, May 6, 1840, 109f.
39. For an interesting account of the social conditions experienced by late nineteenth-century laundresses in Rio de Janeiro, see Sandra L. Graham, *House and Street*, 40–45, 52–53.

40. The 1878 proposal for the public *lavadero* is found in AGPR, FOP, Obras Municipales, L-62LL, E-15, C-326.

41. The incident is mentioned in various documents. See AGPR, FMSJ, Actas del Cabildo, May 4, 1842, 88v, and June 30, 1842, 122f and AGPR, FOP, Edificios Públicos, San Juan, L-119, C-693.

42. AHN, Se-Ultramar, S-Gobierno de Puerto Rico, L-5087, E-10, July 4, 1862.

43. The *alcalde*'s account of the incident can be found in AGPR, FOP, Obras Municipales, L-62LL, E-13, C-236, July 14, 1857. For another reading of the incident, see Martínez Vergne, *Shaping the Discourse*, chap. I, 23–28.

44. See Graham, *House and Street*, 17–18, 31–36, 40–45.

45. AGPR, FMSJ, L-73E (P.I.), E-3, December 22, 1922.

46. Carmen C. Mauleón-Benitez, *Las Turbas*, 20.

47. Juana was an eyewitness in a conciliation trial. See AGPR, FMSJ, L-73E (P. IV.), E-67, September 4, 1860.

48. Tapia y Rivera, *Mis memorias*, 78.

49. AGPR, FMSJ, L-73E (P. IV), E-68, October 2, 1860.

50. The case of María de Jesús can be followed in AGPR, FGEPR, Beneficencia, C-2, August 19, 1845, through October 6, 1845. The reference to the nurse reads "una de las mujeres que se dedican a cuidar bubas."

51. Matos Rodríguez, "¿Quién trabajará?"

52. Negrón Portillo and Mayo Santana, *La esclavitud*, 20.

53. The list also included the unemployed. See AGPR, FGEPR, Censo y Riqueza, 1858, C-16.

54. AGPR, FMSJ, Actas Cabildo, C-24, May 19, 1864, 93–93v.

55. AGPR, FMSJ, L-24G, E-941, April 3, 1876.

56. About the campaign against concubinage, see Picó, *Libertad y servidumbre*, 136–39; and Barceló Miller, "De la polilla," 74–83.

57. Matos Rodríguez, "Economy, Society," 165–69. Kinsbruner also noted the high incidence of female heads of households in *Not of Pure Blood*, 108–10.

58. For Mexico City figures, see Arrom, *Las mujeres de la ciudad de México*, 161–63. For Sao Paulo, see Elizabeth A. Kuznesof, *Household Economy*.

59. Dietz, *Economic History*, 44–49.

60. Altagracia Ortiz, *Eighteenth-Century Reforms*, 202.

61. Barceló Miller, "De la polilla," 58–63.

62. See Navarro García, *Control social*, 29–108. For a general sense of nineteenth-century campaigns against vagrancy, see Antonia Rivera Rivera, "El problema," 12–19.

63. See a copy of Pezuela's 1849 decree in the *Boletín Eclesiástico* 3, no. 18 (September 1861): 216–18.

64. Ibid.

65. "Sobre dejar de trabajar en dias festivos durante la época de la zafra," December 30, 1852, in AHD, F-Parroquias, S-Disciplinar, Se-Visita Parroquial, Parroquia de Dorado, C-P27, 32v.

66. See, for example, AGPR, FMSJ, Actas Cabildo, October 30, 1840, 346f–348v; January 23, 1850, 17v; and, July 7, 1861, 126v.

67. AGPR, FMSJ, Actas Cabildo, October 6, 1847, 329f–329v.

68. The list usually covered the cathedral parish, which roughly included the barrios of La Marina, San Juan, and Santo Domingo. The 1855 list comes from AGPR, FGEPR, San Juan, C-570, August 27, 1855. The 1861 and 1863 lists come from AHD, F-Diocesano, S-Gobierno, Se-Correspondencia, C-G60.

69. Barceló Miller, "De la polilla," 83–88.

70. AGPR, FMSJ, Actas Cabildo, October 30, 1847, 346–348v.

71. See, among others, Negrón Portilla and Mayo Santana, *La esclavitud urbana*, 75–93; Kinsbruner, *Not of Pure Blood*, 81–116; and Matos Rodríguez, "Economy, Society," 133–90.

Chapter 5

1. On the legal limitations of women playing "governing" roles, see Arrom, *Las mujeres*, 70–122.

2. Martínez Vergne, *Shaping the Discourse*, chap. 2, 32–36.

3. Rivera Rivera, "El problema." Martínez Vergne argues that the term *beneficencia* (which Spanish liberals adopted from the French) entailed a reconceptualization of previous notions of charity and welfare; see "The Liberal Concept," 167–70. To accentuate the distinction between *beneficencia* and concepts like charity and welfare, I use the term "beneficence" as my translation.

4. Adrian Shubert, "Charity Properly Understood," 36–55. Also, Martínez Vergne, "The Liberal Concept," 167–75.

5. "Para asegurar el bien estar y la conservación del hombre en el vientre de la madre, en la infancia, en la vejez, en la enfermedad, en todos los períodos de su vida miserable." The text is from a document produced by San Juan's Junta de Beneficencia as part of its struggle with the Catholic Church to obtain control of the Hospital de la Concepción. AGPR, FMSJ, L-26, E-4, 7, April 29, 1823.

6. Jacques Donzelot, *The Policing of Families*, 55–73; Martínez Vergne, "The Liberal Concept," 178–79; and William J. Callahan, *Church, Politics*, 179–94.

7. The Juntas de Beneficencia were under the town council's control. Laws passed between 1849 and 1852 gave jurisdiction to the national government over most beneficence establishments, leaving the town council with little authority in this area. See María A. García Ochoa, *La política española*, 401; Shubert, "Charity Properly Understood," 46–50; and Martínez Vergne, "The Liberal Concept," 167–68.

8. In Madrid, a very active Junta de Damas was in charge of the Montepío (since 1787) and of an orphanage (1799). It was also active in helping female inmates. See Paloma Fernández-Quintilla, *La mujer ilustrada*, 91–97. Also, Shubert, "Charity Properly Understood," 49–52.

9. See AGPR, FGEPR, C-1, Beneficencia, January 27, 1821.

10. Marrero claims that only about 20 percent of Havana's Casa de Beneficencia rent came from state taxes. The data on the budgets of the Cuban casas come from Marrero, *Cuba*, vol. 14, 180–81.

11. On the power and bourgeois spirit of the Cuban planter class, see Moreno Fraginals, *El ingenio*, vol. 1, 71–78, 126–36.

12. See Martínez Vergne, "The Liberal Concept," 174–75, for a general overview of the junta's problems with the church over the Hospital de la Concepción.

13. AGPR, FMSJ, L-26, E-4, Beneficencia, 3v–4f, April 29, 1823.

14. AGPR, FGEPR, C-1, Beneficencia, July 18, 1821.

15. De Hostos, *Historia de San Juan*, 469–70. Cuesta Mendoza argues that the Sociedad Económica had suggested the creation of a Casa de Beneficencia back in 1821; see *Historia de la educación*, 87.

16. On the plans and subsequent construction of the Casa de Beneficencia, see Castro, *Arquitectura*, 215–22; and Lidio Cruz Monclova, *Historia de Puerto Rico*, vol. 1, 275–76.

17. AGPR, FMSJ, Actas Cabildo, C-14, 1840–41.

18. The governor was describing the kind of help those intern“ed at the casa received. AHN, S-Ultramar, Se-Gobierno de Puerto Rico, L-5077, E-41, February 17, 1854.

19. In many other Latin American cities, beneficence establishments were also combined with female prisons. For the case of Buenos Aires, see Lila M. Caimari, "Whose Criminals," 194.

20. For an excellent overall account of labor conditions in the nineteenth century, see Francisco Scarano, "Labor and Society," 74–79. On the role of the casa for slave labor control, see Teresita Martínez Vergne, "The Allocation," 200–216.

21. Since there is no way of knowing what the total universe of cases might have been, my statement about the majority of cases being related to women must be taken with caution. Cuesta Mendoza (*Historia de la educación*, 87) mentions that in 1898 there were 149 boys and 143 girls in the casa. There is no way to measure the "typicality" of these data.

22. AGPR, FGEPR, C-2, Beneficencia, March 28, 1845.

23. Her insanity was caused six days after giving birth "after an annoyance produced by the woman who was assisting her." AGPR, FGEPR, C-2, Beneficencia, August 5, 1845.

24. The questionnaire included queries regarding the family's mental health history, any remedies being practiced with the patient, and the length of the patient's illness. AGPR, FGEPR, C-2, Beneficencia, November 3–5, 1845.

25. AGPR, FMSJ, Actas del Cabildo, C-22, January 12, 1859, 7f.

26. The document does not tell the length of Paula's stay in the city's jail. AGPR, FGEPR, C-1, Beneficencia, June 22, 1867.

27. The lengthy file is found in AGPR, FGEPR, C-1, Beneficencia, March 14, 1846–December 27, 1848.

28. "Habiendo vuelto a reincidir en eccesos y escandalos." AGPR, FGEPR, C-570, Beneficencia, January 24, 1852.

29. AGPR, FGEPR, C-1, Beneficencia, March 14, 1846.

30. AGPR, FMSJ, Actas del Cabildo, C-27, March 8, 1869.

31. "Por tratarse no ya de una obra caritativa sino de seguridad para el vecindario por los peligros que produciría una loca sin casa ni sugeción." AGPR, FMSJ, Actas del Cabildo, C-27, July 1, 1870, 122v–123f.

32. AGPR, FGEPR, C-2, Beneficencia, June 3–12, 1845.

33. AGPR, FGEPR, C-1, Beneficencia, September 1, 1846.

34. For the story of the *Majesty* survivors and their consignment period at the Casa de Beneficencia, see Martínez Vergne, "The Allocation."

35. AGPR, FGEPR, C-570, San Juan, November 22, 1856.

36. AGPR, FGEPR, C-300, March 9, 1864.

37. The adultery trial took place in San Germán on September 23, 1861. The conciliation trial regarding Del Toro and Deija's divorce can be found in AGPR, FMSJ, L-49 (P-IV), E-78, June 6, 1862.

38. AGPR, FMSJ, Actas del Cabildo, C-23, May 25, 1861, 88f.

39. AGPR, FMSJ, Actas del Cabildo, C-23, July 23, 1861, 121v.

40. "Acojer a los desvalidos y huérfanos sin parientes ni recurso alguno; y que si la suplicante no dio a tiempo oportuno la educación que debiera a su hijo, no es justo que los estrabios de este, began a pagar los fondos públicos, con perjucio de algún pobre que se encuentre en la verdadera necesidad." AGPR, FMSJ, Actas del Cabildo, C-23, July 3, 1861, 112f–v.

41. AGPR, FMSJ, Actas del Cabildo, C-23, September 3, 1861, 139v.

42. AGPR, FMSJ, Actas del Cabildo, C-23, September 3, 1861, 113f.

43. AGPR, FMSJ, Actas del Cabildo, C-23, August 6 and September 3, 1861, 128f and 138v.

44. AGPR, FGEPR, C-2, Beneficencia, May 30–October 16, 1845. The response was that "no se puede decir que no al pedido de una madre."

45. The mother probably did not consider that an education was such an important priority for her daughters. AGPR, FGEPR, C-1, Beneficencia, August 25, 1847.

46. AGPR, FMSJ, Actas del Cabildo, C-23, April 9, 1862, 54v.

47. AGPR, FMSJ, Actas del Cabildo, C-23, March 11, 1862, 39f.

48. Martínez Vergne, "The Liberal Concept," 171–72. The governor, in a letter to the bishop informing him of the resignation of the casa's director, praises the latter's work, particularly in the area of raising revenues to keep the establishment running. See AHD, F-Diocesano, S-Gobierno, S-Correspondencia, C-G60, December 8, 1847.

49. Havana's Casa de Beneficencia was inaugurated in 1794. See Marrero, *Cuba*, vol. 14, 178–81.

50. García's only condition for accepting women from the city jail was that they could not have any contagious diseases. AGPR, FGEPR, C-1, Beneficencia, December 16–23, 1847.

51. AGPR, FMSJ, Actas del Cabildo, C-24, August 12, 1864, 147f–v.

52. AGPR, FMSJ, Actas del Cabildo, C-24, December 23, 1864, 216v.

53. AGPR, FMSJ, Actas del Cabildo, C-24, May 19, 1864, 93f–v.

54. Caimari, "Whose Criminals," 191.

55. AGPR, FGEPR, C-1, Beneficencia, July 18, 1821. I also discussed the political, social, and economic importance of the domestic labor market in San Juan in the mid–nineteenth century in Matos Rodríguez, "¿Quién trabajará?"

56. De Hostos, *Historia de San Juan*, 470–71; Castro, *Arquitectura*, 276; and Martínez Vergne, "The Liberal Concept," 181.

57. Sepúlveda Rivera, *San Juan*, 259; and Castro, *Arquitectura*, 276.

58. Castro, *Arquitectura*, 281.

59. Cuesta Mendoza, *Historia de la educación*, 43–44.

60. Ibid.

61. Delfín Vecilla de las Herras, *Fray Pablo Benigno Carrión*, vol. 2, 83. On Dean Usera's

transfer to Cuba and the work of the Religiosas, see Cuesta Mendoza, *Historia de la educación*, 40–41.

62. On Bénitez de Gautier's poem, see Josefina Rivera de Alvarez, *Diccionario*, 194.

63. On the promotion of Marianist ideology in the second half of the nineteenth century, particularly of Bishop Carrión's efforts, consult Vecilla de la Heras, *El Obispo Carrión*, vol. I, 83, 116. See also Barceló Miller, "De la polilla," 74–88.

64. On the relationship between the growth of female organizations and the ideas of individualism and liberalism, in general, see Cott, *The Grounding*, 16–21; for the Puerto Rican case, see Colón et al., *Participación de la mujer*, 5–6. Lynn Stoner argues, from the Cuban perspective, for a link between modernization and feminism; see her introduction in *From the House*, 9–11.

65. For the history of the approval of the Asilo, with a considerable bias in favor of Bishop Carrión's arguments, consult Vecilla de las Heras, *El Obispo Carrión*, 125–28.

66. The bylaws of the Colegio/Asilo can be found in Cayetano Coll y Toste, ed., *Boletín*, vol. 5, 21. Article 6 of the bylaws stated that two of the eight *vocales* (representatives) had to be members of the Cathedral Chapter.

67. Cuesta Mendoza, *Historia de la educación*, 40–42.

68. F. M. Zeno, *La capital de Puerto Rico*, 278.

69. Of the thirty nuns working in San Juan in 1870, three were assigned to the Colegio/Asilo, fifteen to the military hospital, eight to the Casa de Beneficencia, and four to the Casa de Párvulos. See *Boletín Eclesiástico* 12, no. 2 (January 1870): 13–14.

70. The list is found in an unpublished manuscript at the AHD. See Delfin Vecilla de las Heras, *Obispo Carrión*, vol. 3, 299.

71. For the details about the president and the secretary of the Junta de Damas, see Zeno, *Historia de la capital*, 278. (Zeno spells Astarloa's name as "Atarboa.") Although of Basque origins, the Aranzamendi family migrated from Venezuela into San Juan. See Sonesson, "Puerto Rico's Commerce," 54.

72. Astarloa said she was thirty-one years of age when she drafted her will in 1844. She and Aranzamendi had five children. Her testament is found in AGPR, FPN, SJ, Juan B. Nuñez, C-502, April 24, 1844, 116v–117f.

73. AGPR, FPN, SJ, Juan B. Nuñez, C-502, April 23, 1844, 116f–v.

74. "Relación de los S. S. Hermanos Mayores," found in AHD, F-Catedral, S-Disciplinar, C-113, July 30, 1845. Astarloa is among the fifty-four women (out of a total of 182 contributors) who donated money to the Archicofradía.

75. Her transactions with Doña María Sánchez de Montijano (a widow in San Juan) are found in AGPR, FPN, Manuel Camuñas, C-29, January 10, 1861, 23v–24f, and May 17, 1861, 277v–278f.

76. AGPR, FPN, SJ, Manuel Camuñas, C-29, November 20, 1861, 547v–548f. Fernández had taken the loan on June 9, 1860. Fernández is listed in Scarano's profile of Ponce's *hacendados* as having 37,800 pesos in capital in 1845. See his *Sugar and Slavery*, 179.

77. AGPR, FPN, SJ, Agustín Rosario, C-550, June 10, 1856, 303f–v.

78. See Tapia y Rivera, *Mis memorias*, 51; and De Hostos, *Historia de San Juan*, 376.

79. Zeno, *Historia de la Capital*, 175–76.

80. I have found evidence of Vizcarrondo owning (in full in or part) at least two haci-

endas in the area: Hacienda Mercedes and Hacienda Carmen. On Mercedes, see AGPR, FPN, SJ, Agustín Rosario, C-550, 1856, 157v–159; and on Carmen, see AGPR, FPN, SJ, Manuel Camuñas, C-29, 1861, 311f–313f.

81. They were all related to the Elzaburu family from Venuzuela. Aranzamendi served as the Vizcarrondo's *apoderado* in a verbal trial trying to evict Don Francisco Armas. AGPR, FMSJ, L-49 (P. IV.), E-67, March 15, 1860.

82. AGPR, FPN, SJ, Juan B. Nuñez, C-502, June 7, 1844, 163f. On Capetillo's slave trade activities, see Sonesson, "Puerto Rico's Commerce," 48.

83. AGPR, Censos San Juan, Bo. San Francisco, 1846. González is listed as being forty years old in the census. She lived in house no. 13, Calle de los Cuarteles (Tetuán).

84. The house property data on this section come from "Reparto Municipal," AGPR, FMSJ, L-123A (P. I.), E-10, C-282, 19v (Vizcarrondo), 20v (Sevilla de López Pinto), and 24f (González de Capetillo).

85. Like an *estancia* in Bayamón. See AGPR, FPN, SJ, Manuel Camuñas, C-29, May 13, 1861, 268v–269v. The couple lived at no. 53, Fortaleza Street.

86. On Don Justo Skerret of Skerret & Hermanos, see Martínez Ortíz, "Las sociedades mercantiles," 84–86.

87. AGPR, Censos San Juan, Bo. Santo Domingo, 1846. At the time of the census Vidal was listed as twenty-five years old, and she had seven slaves in her house.

88. AGPR, Censos San Juan, Bo. Santo Domingo, 1846. Charbonier had seven slaves in her house. Saleses was married to Elsa Elzaburu, who in turn was related to the Vizcarrondo, Arranzamendi, and Artaloa families.

89. AGPR, FPN, SJ, Gervasio Puente, C-231, February 6, 1852, 31v–35v.

90. AHN, Se-Ultramar, S-Gobierno de Puerto Rico, L-5082, E-23, November 14, 1867.

91. Zeno, *Historia de la capital*, 278.

92. Cuesta Mendoza, *Historia de la educación*, 41. In 1887 the wife of Governor Contreras was the president of the Junta de Damas, and it seems that she was a very active president. See Mauleón-Benítez, *Las turbas*, 43.

93. Marrero, *Cuba*, vol. 14, 182.

94. AHN, Se-Ultramar, S-Gobierno de Puerto Rico, L-5087, E-1, October 29, 1863, and E-3, July 2, 1863.

95. Subcomité de la Historia de Mayaguez, *Historia de Mayaguez*, 90–91.

96. García Ochoa, *La política*, 408–9.

97. On this "organized solidarity," see García and Quintero Rivera, *Desafío y solidaridad*, 18–23.

98. Martínez Vergne has stressed the role that beneficence institutions such as the Casa de Beneficencia have had in reinforcing racial hierarchies in Puerto Rico; see "The Allocation," 204–5, 208–10.

99. Muriel Nazzari, "Sex/Gender Arrangements," 143.

100. On the connections among education, philanthropy, and feminism in the second half of the nineteenth century, see Cynthia J. Little, "Educación, filantropía," 271–92. Consult also Miller, *Latin American Women*, 35–38; and Hahner, *Emancipating the Female*, 20–26.

101. Hahner, *Emancipating the Female*, 24.

102. Miller, *Latin American Women*, 43.

103. On the broad Latin American trends, see Miller, *Latin American Women*, 35–109; and Asunción Lavrin, "Introducción," 18–25.

104. For an overview of U.S. women's voluntary associations, see Anne Firor Scott, *Natural Allies*, 11–55. For a more specific look at beneficence work, see Ginzberg, *Women and the Work of Benevolence*.

105. For an analysis of how privileged women can use their influence to exploit other women, see Nancy A. Hewitt, "Beyond the Search," 1–14.

106. Martínez Vergne, *Shaping the Discourse*, chap. 4, 8–9.

Conclusion

1. Cruz Monclova, *Historia de Puerto Rico*, vol. 2, 171–72.

2. The quote from the *Boletín Mercantil* comes from Cruz Monclova, *Historia de Puerto Rico*, vol. 2, 163.

3. Findlay, "Domination, Decency, and Desire," 25–27, 168–287, 508–11.

4. Alvarez Curbelo, "El afán de modernidad."

5. See, among others, Picó, *Historia general*, 203–12.

6. For a brief literary biography of both poets, see Rivera de Alvarez, *Diccionario de Literatura*, 190–96; and José L. González, *Literatura y sociedad*, 88, 101. Short, but very suggestive, is the essay by María Arrillaga on the ironic quality of María Bibiana Bénitez's poetry; see *Los silencios*.

7. Azize, *La mujer en la lucha*, 18–20.

8. García Ochoa, *La política española*, 408–9; and Osuna, *A History of Education*, 110.

9. On the foundation of the Colegio del Sagrado Corazón, see Barceló Miller, *La lucha por el sufragio*, 22–23. The state did play a role in financing the buildings for the school through the lottery. Still, the school was administered by nuns and supported by other conservative, elite members.

10. See Aixa Merino Falú, "El Gremio," 74–75. The author, unfortunately, does not provide much information regarding the composition and the objectives of the guild.

11. Although much remains to be studied about the spatial consequences of the abolition of slavery in the island's urban labor market, the pioneering study by Luis Figueroa suggests that many *libertas* left the rural areas for the cities; see "Facing Freedom," 357–66.

Bibliography

Archival Sources

Archivo General de Puerto Rico (AGPR)

1. Fondo Protocolos Notariales (PN) San Juan:
 Manuel Camuñas—1861—C-29
 José Ma. León Urbina—1827—C-442
 Juan B. Nuñez—1800—C-457
 Juan B. Nuñez—1801—C-457
 Juan B. Nuñez—1807—C-462
 Juan B. Nuñez—1808—C-462
 Juan B. Nuñez—1809—C-462
 Juan B. Nuñez—1810—C-462
 Juan B. Nuñez—1823—C-473
 Juan B. Nuñez—1829—C-478
 Juan B. Nuñez—1833—C-482
 Juan B. Nuñez—1844—C-502
 Gervasio Puente—1852—C-531
 Agustín Rosario—1856—C-550
 Agustín Rosario—1856—C-551
2. Fondo Documentos Municipales San Juan (FMSJ):
 L-1—Ayuntamiento
 L-2—Ayuntamiento
 L-25—Bancos
 L-26 (P.A.)—Beneficencia
 L-31 (P.I.)—Capitales a Censo
 L-31 (P.II.)—Capitales a Censo
 L-32—Capitales a Censo
 L-32A—Capitales a Censo
 L-33—Carceles
 L-34—Calamidades
 L-47—Estado
 L-49 (P.I–II)—Estadística/Censos Población
 L-53—Fianzas
 L-55—Fincas
 L-57—Fomento
 L-61 (P.I.)—Hacienda
 L-67—Instrucción Pública
 L-70 (P.I.)—Inventario

L-73E (P.I–IV)—Juicios Verbales y de Conciliación
L-76—Mercado y Mataderos
L-97—Ordenanzas
L-105—Policía
L-110 (P.I.)—Policía
L-123A (P.I.)—Censos Propiedad/Riqueza Urbana
L-136 (P.I.)—Teatro

Sub-Serie Actas Cabildo:
C-11—1823–25, 1825–28, 1828–30
C-12—1830–31, 1832–33, 1834–35
C-13—1836–37, 1837
C-14—1840, 1841
C-15—1842, 1843
C-17—1846, 1847
C-18—1848, 1849
C-19—1850, 1851, 1852
C-20—1853, 1854, 1855
C-21—1856, 1857
C-22—1858, 1859
C-23—1860, 1861, 1862
C-24—1863, 1864, 1865
C-25—1866, 1867
C-26—1867, 1868
C-27—1869, 1870

3. Fondo Gobernadores Españoles (FGEPR):
Asuntos Políticos y Civiles:
C-1–2—Beneficencia
C-11–16—Censo y Riqueza
C-18–22—Circulares
C-23—Comercio
C-48—Donativos
C-59–60—Esclavos
C-116—Farmacia
C-118—Hospital
C-143–45—Matrimonios
C-150—Cartas Particulares
C-163—Pasaportes
C-174—Quejas
C-182–83—Sanidad
C-184—Servicio Público
C-186—Tiendas

Asuntos Fiscales:
C-192—Bienes Difuntos
C-193—Circulares
C-194—Comercio y Comerciantes
C-196—Conventos
C-199—Deudas
C-201–2—Hacienda

 C-222—Negros
Asuntos Eclesiásticos:
 C-283—Dispensas Matrimonios y Educación
 C-290—Visitas Pastorales
Agencias del Gobierno:
 C-300—Beneficencia
 C-322–23—Fomento y Comercio
 C-326–28—Instrucción
 C-333—Justicia
Municipios:
 C-558–76—San Juan
Censos San Juan:
 Santa Bárbara, 1833
 Santa Bárbara, 1840
 Santa Bárbara, 1846
 San Francisco, 1833
 San Francisco, 1846
 San Juan, 1828
 Santo Domingo, 1833
 Santo Domingo, 1846
 Puerta de Tierra, 1845
 Puerta de Tierra, 1846
4. Fondo Obras Públicas (FOP)
5. Fondo Audiencia Territorial:
 S-Regencia, C-5, 9, 11
6. Colecciones Particulares:
 Colección Francisco Scarano (Censos 1775–1800)
 Colección Junghans, C-8, 27.

Archivo Histórico Diocesano (AHD)

1. Fondo Diocesano:
 S-Gobierno, C-G60
2. Fondo Catedral:
 S-Disciplinar, C-113
3. Fondo Cabildo:
 S-Correspondencia, C-4
4. Boletín Ecclesiástico
Archivo Histórico Nacional (AHN):
 Se-Ultramar
 S-Gobierno de Puerto Rico
 L-5063–5113, 5457

Secondary Sources

Abbad y Lasierra, Fray Agustín Iñigo. *Historia geográfica, civil y natural de la isla de San Juan Bautista de Puerto Rico*. 3d ed. Río Piedras: Editorial Universitaria, 1979.
Acosta-Belén, Edna, ed. *The Puerto Rican Woman: Perspectives on Culture, History and Society*. 2d ed. New York: Praeger, 1986.
Actas del Cabildo de San Juan de Puerto Rico, 1730–1821. 18 vols. San Juan: Municipio de San Juan, 1949–78.

Allsop, Richard. *Dictionary of Caribbean English Usage*. Oxford: Oxford University Press, 1996.
Alonso, Ana María. *Thread of Blood: Colonialism, Revolution, and Gender on Mexico's Northern Frontier*. Tucson: University of Arizona Press, 1995.
Alonso, Carlos J. *Modernity and Autochthony: The Spanish American Regional Novel*. Cambridge: Cambridge University Press, 1989.
———. "The Burden of Modernity." *Modern Language Quarterly* 57, no. 2 (1996): 227–36.
Alvarez Curbelo, Silvia. "El motín de los faroles y otras luminosas protestas: disturbios populares en Puerto Rico, 1894." *Historia y Sociedad* 2 (1989): 120–47.
Andrews, Kenneth R. *The Spanish Caribbean: Trade and Plunder, 1530–1630*. New Haven: Yale University Press, 1978.
Aponte, Gilberto. *San Mateo de Cangrejos (Comunidad cimarrona en Puerto Rico): Notas para su historia*. San Juan: Comité de Historia de los Pueblos, 1985.
Arregui, Mariví. "Trayectoria del feminismo en la République Dominicana." *Ciencia y Sociedad* (Santo Domingo, INTEC) 13, no. 1 (1988): 9–18.
Arrillaga, María. *Los silencios de María Bibiana Benítez*. San Juan: Instituto de Cultura Puertorriqueña, 1985.
Arrom, Silvia M. *La mujer mexicana ante el divorcio eclesiástico (1800–1857)*. México DF: Sepsetentas, 1976.
———. *Las mujeres de la ciudad de México, 1790–1857*. México DF: Siglo XXI Editores, 1988.
Arroyo, Celestino A. "La acción ilegal de los holandeses en el Caribe y su impacto en las Antillas y Puerto Rico durante la primera mitad del siglo XVIII." *Revista de Indias* 14, nos. 1–4 (1984): 67–79.
Artola, Miguel. *La burguesía revolucionaria*. Madrid: Alianza Editorial, 1974.
Asenjo, Federico. *Las fiestas de San Juan*. 1868. Reprint, San Juan: Editorial El Coquí, 1973.
Azize, Yamila. *La mujer en la lucha*. Río Piedras: Editorial Cultural, 1985.
Azize Vargas, Yamila. "The Roots of Puerto Rican Feminism: The Struggle for Universal Suffrage." *Radical America* 23, no. 1 (1989): 71–80.
Azize Vargas, Yamila, ed. *La mujer en Puerto Rico: Ensayos de Investigación*. Río Piedras: Ediciones Huracán, 1987.
Baralt, Guillermo. *Esclavos rebeldes: Conspiraciones y sublevaciones de esclavos en Puerto Rico (1795–1873)*. Río Piedras: Ediciones Huracán, 1982.
———. *La Buena Vista: 1833–1904 (Estancia de frutos menores, fábrica de harinas y hacienda cafetalera)*. San Juan: Fideicomiso de Conservación, 1988.
Barceló Miller, María T. "De la polilla a la virtud: Visión sobre la mujer de la Iglesia jerárquica de Puerto Rico." In *La mujer en Puerto Rico: Ensayos de investigación*, edited by Yamila Azize Vargas, 49–88. Río Piedras: Ediciones Huracán, 1987.
———. *La lucha por el sufragio femenino en Puerto Rico, 1896–1935*. Río Piedras: Ediciones Huracán & Centro de Investigaciones Sociales, 1997.
Beckles, Hilary. "Sex and Gender in the Historiography of Caribbean Slavery." In *Engendering History: Caribbean Women in Historical Perspective*, edited by Verene Shepherd, et al, 125–40. Kingston, Jamaica: Ian Randle Publishers, 1995.
Berg, Barbara J. *The Remembered Gate: Origins of American Feminism*. New York: Oxford University Press, 1978.
Bergad, Laird W. "Agrarian History of Puerto Rico, 1870–1930." *Latin American Research Review* 13, no. 3 (1978): 63–94.
———. "Towards Puerto Rico's Grito de Lares: Coffee, Social Stratification, and Class Conflicts, 1828–1868." *Hispanic American Historical Review* 60, no. 4 (1981): 617–42.

———. *Coffee and the Growth of Agrarian Capitalism in Nineteenth-Century Puerto Rico.* Princeton: Princeton University Press, 1983.
Besse, Susan E. *The Modernization of Gender Inequality in Brazil, 1914–1940.* Chapel Hill: University of North Carolina Press, 1996.
Boa, Sheena. "Urban Free Black and Coloured Women: Jamaica, 1760–1834." *Jamaican Historical Review* 18 (1993): 1–6.
Brading, David A. *Miners and Merchants in Bourbon Mexico, 1763–1810.* Cambridge: Cambridge University Press, 1971.
Brereton, Bridget. "General Problems and Issues in Studying the History of Women." In *Gender in Caribbean Development*, edited by Patricia Mohammed and Catherine Shepherd, 125–43. Kingston: University of the West Indies, Women and Development Studies Project, 1988.
Buitrago Ortiz, Carlos. *Haciendas cafetaleras y clases terratenientes en el Puerto Rico decimonónico.* Río Piedras: Editorial Universitaria, 1982.
Bunker, Oscar L. *Historia de Caguas.* Caguas: n.p., 1975.
Bush, Barbara. *Slave Women in Caribbean Society, 1650–1838.* Bloomington: Indiana University Press, 1990.
Cabrera, Olga. "Cuba y la primera experiencia de incorporación fabril de la mujer: La obrera tabaquera." *Revista de Indias* 49, no. 185 (1989): 227–33.
Caimari, Lila M. "Whose Criminals Are These? Church, State, and Patronatos and the Rehabilitation of Female Convicts (Buenos Aires, 1890–1940)." *The Americas* 54, no. 2 (1997): 185–208.
Callahan, William J. *Church, Politics and Society in Spain, 1750–1874.* Cambridge: Harvard University Press, 1984.
Carr, Raymond. *Spain 1808–1939.* Oxford: Clarendon Press, 1966.
Castro, María de los Angeles. *Arquitectura en San Juan de Puerto Rico (siglo XIX).* Río Piedras: Editorial Universitaria, 1980.
———. "Los moldes imperiales: Ordenamiento urbano en los Bandos de Policía y Buen Gobierno." *Cuadernos de la Facultad de Humanidades* 12 (1984): 11–36.
Caulfield, Sueann. "Women of Vice, Virtue, and Rebellion: New Studies of Representation of the Female in Latin America." *Latin American Research Review* 28, no. 2 (1993): 165–73.
Cepero Bonilla, Raúl. *Azucar y abolición.* 1948. Reprint, Barcelona: Editorial Grijalbo, 1976.
Childs, Matt. "Sewing Civilization: Cuban Female Education in the Context of Afri-canization, 1800–1860." *The Americas* 54, no. 1 (1997): 83–108.
Chinea, Jorge L. "Race, Colonial Exploitation and West Indian Immigration in Nineteenth-Century Puerto Rico, 1800–1850." *The Americas* 52, no. 4 (1996): 495–520.
Cifre de Loubriel, Estela. *La inmigración a Puerto Rico durante el siglo XIX.* San Juan: Instituto de Cultura Puertorriqueña, 1964.
———. *La formación del pueblo puertorriqueño: La contribución de los catalanes, balearicos y valencianos.* San Juan: Instituto de Cultura Puertorriqueña, 1975.
Clement, Jean-Pierre. "El nacimiento de la higiene urbana en la América española del siglo XVIII." *Revista de Indias* 43, no. 171 (1983): 77–95.
Coll y Toste, Cayetano, ed. *Boletín Histórico de Puerto Rico.* 14 vols. San Juan: Tipografía Cantero Fernández y Cia., 1914–27.
Colón, Alice, Margarita Mergal, and Nilsa Torres. *Participación de la mujer en la historia de Puerto Rico.* Río Piedras: Centro de Investigaciones Sociales & Centro Coordinador de Estudios, Recursos y Servicios a la Mujer (CERES), 1986.

Córdova, Pedro Tomás de. *Memorias geográficas, históricas, económicas y estadísticas de la isla de Puerto Rico.* 1831. 2d facsimilar ed., San Juan: Editorial Coquí, 1968.
Cott, Nancy F. *The Bonds of Womanhood: "Women's Sphere" in New England, 1780–1835.* New Haven: Yale University Press, 1977.
———. *The Grounding of Modern Feminism.* New Haven: Yale University Press, 1987.
Cottias, Myriam, and Annie Fitte-Duval. "Femme, Famille et Politique Dans Les Antilles Françaises de 1828 a nos Jours." *Caribbean Studies* 28, no. 1 (1995): 76–100.
Couturier, Edith. "Women and the Family in Eighteenth Century Mexico: Law and Practice." *Journal of Family History* 10, no. 3 (1985): 294–304.
Cruz Monclova, Lidio. *Historia de Puerto Rico (siglo XIX).* 6 vols. Río Piedras: Editorial Universitaria, 1979.
Cubano Iguina, Astrid. *El hilo en el laberinto: Claves de la lucha política en Puerto Rico (siglo XIX).* Río Piedras: Ediciones Huracán, 1990.
Cuesta Mendoza, Antonio. *Historia de la educación en el Puerto Rico colonial (1821–1899).* Santo Domingo: Imprenta Arte & Cine, 1948.
Curet, José. *De la esclavitud a la abolición: Transiciones económicas en las haciendas de Ponce, 1845–1873.* San Juan: CEREP, 1974.
———. "About Slavery and the Order of Things: Puerto Rico, 1845–1873." In *Between Slavery and Free Labor: The Spanish-Speaking Caribbean in the Nineteenth Century,* edited by Manuel Moreno Fraginals et al., 117–40. Baltimore: Johns Hopkins University Press, 1985.
Curtin, Philip D. *The Atlantic Slave Trade: A Census.* Madison: University of Wisconsin Press, 1969.
Daitsman, Andy. "Unpacking the First Person Singular: Marriage, Power, and Negotiation in Nineteenth-Century Chile." *Radical History Review* 70 (Winter 1998): 26–47.
Dávila, Arturo. "Aspectos de una pastoral de esclavitud en Puerto Rico durante el siglo XIX: 1803–1873." *La Torre* 21, nos. 81–82 (1973): 39–102.
Dávila Santiago, Rubén. *El derribo de las murallas: Orígenes intelectuales del socialismo en Puerto Rico.* Río Piedras: Editorial Cultural, 1988.
De Hostos, Adolfo. *Historia de San Juan, ciudad murada.* San Juan: Instituto de Cultura Puertorriqueña, 1983.
De la Rosa Martínez, Luis. *La periferia del Grito de Lares: Antología de documentos históricos, 1861–1869.* 2d ed. Santo Domingo: Editora Corripio, 1985.
———. *Lexicón Histórico Documental de Puerto Rico, 1812–1899.* San Juan: Centro de Estudios Avanzados de Puerto Rico y el Caribe, 1986.
Delgado Cintrón, Carmelo. *Derecho y colonialismo: La trayectoria histórica del Derecho puertorriqueño.* Río Piedras: Editorial Edil, 1988.
Delgado Pasapera, Germán. *Puerto Rico: Sus luchas emancipadoras, 1850–1989.* Río Piedras: Editorial Cultural, 1984.
Deutsch, Sandra McGee. "Gender and Sociopolitical Change in Twentieth-Century Latin America." *Hispanic American Historical Review* 71, no. 2 (1991): 259–306.
———. "The Catholic Church, Work, and Womanhood in Argentina, 1890–1930." In *Confronting Change, Challenging Tradition: Women in Latin America History,* edited by Gertrude M. Yeager, 127–51. Wilmington: Scholarly Resources, 1994.
"Diario del Gobernador Norzagaray." *Anales de Investigación Históricos* 6, no. 1 (1979): 70–132.
Diaz, Jorge David. "Estudio sobre el clero en Caguas, siglo XIX." *Cuadernos de la Facultad de Humanidades* 1 (1978): 67–138.

Diaz Caballero, Arlene J. "Las trabajadoras asalariadas en Santurce, 1910." *Anales de Investigación Históricos*, n.s., 1 (1988): 1–119.
Diaz-Quiñones, Arcadio. *La memoria rota*. Río Piedras: Ediciones Huracán, 1993.
Diaz Soler, Luis M. *Historia de la esclavitud en Puerto Rico*. 3d ed. Río Piedras: Editorial Universitaria, 1981.
Dietz, James L. "Puerto Rico's New History." *Latin American Research Review* 19, no. 1 (1984): 210–22.
———. *Economic History of Puerto Rico*. Princeton: Princeton University Press, 1986.
Dillard, Heath. *Daughters of the Reconquest: Women in Castilian Town Society, 1100–1300*. Cambridge: Cambridge University Press, 1984.
Donzelot, Jacques. *The Policing of Families*. New York: Pantheon Books, 1979.
Dore, Elizabeth, ed. *Gender Politics in Latin America: Debates in Theory and Practice*. New York: Monthly Review Press, 1997.
Ellis, Pat, ed. *Women of the Caribbean*. London: Zed Books Ltd., 1986.
Fernández Méndez, Eugenio, ed. *Crónicas de Puerto Rico desde la conquista hasta nuestros días (1493–1955)*. Río Piedras: Editorial Universitaria, 1981.
Fernández-Quintilla, Paloma. *La mujer ilustrada en la España del siglo XVIII*. Madrid: Ministerio de Cultura, 1981.
Firor Scott, Anne. *Natural Allies: Women's Associations in American History*. Chicago: University of Illinois Press, 1991.
Flandrin, Jean-Louis. *Families in Former Times: Kinship, Household, and Sexuality in Early Modern France*. Cambridge: Cambridge University Press, 1979.
Flinter, George. *An Account of the Present State of the Island of Porto Rico*. London: n.p., 1834.
Fontana, Josep. *La crisis del Antiguo régimen, 1808–1833*. 2d ed. Barcelona: Editorial Grijalbo, 1983.
Franco, Jean. *Plotting Women: Gender and Representation in Mexico*. New York: Columbia University Press, 1988.
García, Gervasio, and Angel G. Quintero Rivera. *Desafío y solidaridad: Breve historia del movimiento obrero puertorriqueño*. Río Piedras: Ediciones Huracán, 1982.
García Ochoa, María A. *La política española en Puerto Rico durante el siglo XIX*. Río Piedras: Editorial Universitaria, 1982.
Gatell, Frank O. "Puerto Rico in the 1830s: The Journal of Edward Bliss Emerson." *The Americas* 16, no. 1 (1959): 63–75.
Geertz, Clifford. *Local Knowledge: Further Essays in Interpretative Anthropology*. New York: Basic Books, 1983.
Gil-Bermejo García, Juana. *Panorama histórico de la agricultura en Puerto Rico*. Seville: Escuela de Estudios Hispano-Americanos, 1970.
Ginzberg, Lori D. *Women and the Work of Benevolence: Morality, Politics and Class in the Nineteenth-Century United States*. New Haven: Yale University Press, 1990.
Gómez Acevedo, Labor. *Organización y reglamentos del trabajo en el Puerto Rico del siglo XIX: Propietarios y jornaleros*. San Juan: Instituto de Cultura Puertorriqueña, 1970.
Gonzalbo Aizpuru, Pilar. *Las mujeres en la Nueva España: Educación y vida cotidiana*. Mexico City: El Colegio de México, 1987.
González, José L. *Literatura y sociedad en Puerto Rico*. Mexico City: Fondo de Cultura Económica, 1976.
———. *El país de cuatro pisos y otros ensayos*. Río Piedras: Ediciones Huracán, 1980.
González Vales, Luis. "Towards a Plantation Society (1860–1866)." In *Puerto Rico: A Political*

and Cultural History, edited by Arturo Morales Carrión, 92–98. New York: W. W. Norton, 1983.
Gordon, Linda. *Heroes of Their Own Lives: The Politics and History of Family Violence.* New York: Penguin Books, 1988.
Graham, Sandra L. *House and Street: The Domestic World of Servants and Masters in Nineteenth-Century Rio de Janeiro.* Cambridge: Cambridge University Press, 1988.
———. "Slavery's Impasse: Slave Prostitutes, Small-Time Mistresses, and the Brazilian Law of 1871." *Comparative Studies in Society and History* 33, no. 4 (1991): 669–94.
Gramsci, Antonio. *Selections from the Prison Notebooks.* New York: International Publishers, 1971.
Guerra y Sánchez, Ramiro. *Historia de la guerra de los diez años, 1868–78.* 2 vols. 1944. Reprint, Havana: Editorial de las Ciencias Sociales, 1972.
Gutiérrez, Ramón A. *When Jesus Came, the Corn Mothers Went Away: Marriage, Sexuality and Power in New Mexico, 1500–1846.* Stanford: Stanford University Press, 1991.
Gutiérrez del Arroyo, Isabel. *El reformismo ilustrado en Puerto Rico.* Mexico City: El Colegio de México, 1953.
———. "Juan Alejo de Arizmendi, primer obispo puertorriqueño (1803–1814)." *Revista del Instituto de Cultura Puertorriqueña,* no. 9 (1960): 38–52.
Gutman, Herbert. *The Black Family in Slavery and Freedom, 1750–1925.* New York: Vintage Books, 1977.
Hahner, June E. *Emancipating the Female Sex: The Struggle for Women's Rights in Brazil, 1850–1940.* Durham, N.C.: Duke University Press, 1990.
Henry, Louis. *Manual de demografía histórica: Técnicas de análisis.* Barcelona: Editorial Crítica, 1983.
Hernández Ruigómez, Almudena. *La desamortización en Puerto Rico.* Madrid: Instituto de Cooperación Iberoamericana, 1987.
Hewitt, Nancy A. "Beyond the Search for Sisterhood: American Women's History in the 1980s." In *Unequal Sisters: A Multi-Cultural Reader in U.S. Women's History,* edited by Ellen Carol DuBois and Vicky Ruiz, 1–14. New York: Routledge, 1990.
Higman, B. W. *Slave Populations of the British Caribbean, 1807–1834.* Baltimore: Johns Hopkins University Press, 1984.
Hünefeldt, Christine. *Paying the Price of Freedom: Family and Labor among Lima's Slaves, 1800–1854.* Berkeley: University of California Press, 1994.
Iglesias, Fé. "La periodización de la historia de Cuba: Un estudio historiográfico." *Santiago* 68 (1988): 85–137.
Jelin, Elizabeth. "Family and Household: Outside World and Private Practice." In *Family, Household, and Gender Relations in Latin America,* edited by Elizabeth Jelin, 12–39. London: Kegan Paul International, 1991.
Jiménez de Wagenheim, Olga. "Puerto Rican Women in the Nineteenth Century: An Agenda for Research." *Revista/Review Interamericana* 11, no. 2 (1981): 196–203.
———. *El Grito de Lares: Sus causas y sus hombres.* Río Piedras: Ediciones Huracán, 1984.
Johnson, Ann H. "The Impact of Market Agriculture on Family and Household Structure in Nineteenth-Century Chile." *Hispanic American Historical Review* 58, no. 4 (1978): 625–48.
Johnson, Lyman. "Artisans." In *Cities and Society in Colonial Latin America,* edited by Louisa S. Hoberman and Susan M. Socolow, 227–50. Albuquerque: University of New Mexico Press, 1986.
Johnson, Sherry. "La Guerra Contra los Habitantes de los Arrabales: Changing Patterns of Land Use and Land Tenancy in and around Havana, 1763–1800." *Hispanic American Historical Review* 77, no. 2 (1997): 181–210.

Kanter, Deborah E. "Native Female Land Tenure and Its Decline in Mexico, 1750–1900." *Ethnohistory* 42, no. 4 (1995): 607–16.
Karasch, Mary. "Suppliers, Sellers, Servants and Slaves." In *Cities and Society in Colonial Latin America*, edited by Louisa S. Hoberman and Susan M. Socolow, 251–84. Albuquerque: University of New Mexico Press, 1986.
Keen, Benjamin. "Main Currents in United States Writing on Colonial Spanish America." *Hispanic American Historical Review* 65, no. 4 (1985): 657–82.
Kerber, Linda K. "Separate Spheres, Female Worlds, Woman's Place: The Rhetoric of Women's History." *Journal of American History* 75, no. 1 (1988): 9–39.
Kerr, Paulette. "Jamaican Female Lodging House Keepers in the Nineteenth Century." *Jamaican Historical Review* 18 (1993): 7–17.
Kinsbruner, Jay. "The Pulperos of Caracas and San Juan during the First Half of the Nineteenth Century." *Latin American Research Review* 13, no. 1 (1978): 65–85.
———. "Caste and Capitalism in the Caribbean: Residential Patterns and House Ownership among the Free People of Color of San Juan, Puerto Rico, 1823–46." *Hispanic American Historical Review* 70, no. 3 (1990): 433–62.
———. *Not of Pure Blood: The Free People of Color and Racial Prejudice in Nineteenth-Century Puerto Rico*. Durham, N.C.: Duke University Press, 1996.
Kiple, Kenneth F. *The Caribbean Slave: A Biological History*. New York: Cambridge University Press, 1984.
———. "Cholera and Race in the Caribbean." *Journal of Latin American Studies* 17, no. 2 (1985): 157–77.
Klein, Herbert S. *The Middle Passage: Comparative Studies in the Atlantic Slave Trade*. Princeton: Princeton University Press, 1978.
———. *African Slavery in Latin America and the Caribbean*. New York: Oxford University Press, 1986.
Knaster, Meri. *Women in Spanish America: An Annotated Bibliography from Pre-Conquest to Contemporary Times*. Boston: G. K. Hall, 1977.
Knight, Franklin. *Slave Society in Cuba during the XIXth Century*. Madison: University of Wisconsin Press, 1970.
———. *The Caribbean: The Genesis of a Fragmented Nationalism*. 2d ed. New York: Oxford University Press, 1990.
Kuethe, Allan J. *Cuba, 1753–1815: Crown, Military and Society*. Knoxville: University of Tennessee Press, 1986.
Kuznesof, Elizabeth. "Household Composition and Headship as Related to Changes in Mode of Production: Sao Paulo 1765–1836." *Comparative Studies in Society and History* 22, no. 1 (1980): 78–108.
———. *Household Economy and Urban Development: Sao Paulo, 1765–1836*. Boulder, Colo.: Westview Press, 1986.
———. "A History of Domestic Service in Spanish America, 1492–1980." In *Muchachas No More: Household Workers in Latin America and the Caribbean*, edited by Elsa M. Chaney and Mary García Castro, 17–36. Philadelphia: Temple University Press, 1989.
———. "Household and Family Studies." In *Latinas of the Americas: A Source Book*, edited by K. Lynn Stoner, 305–88. New York: Garland Publishing, 1989.
Lavrin, Asunción. "Investigación sobre la mujer de la colonia en México: Siglos XVII y XVIII." In *Las mujeres latinoamericanas: Perspectivas históricas*, edited by Asunción Lavrin, 34–73. Mexico City: Fondo de Cultura Económica, 1985.
———. *Sexuality and Marriage in Colonial Latin America*. Lincoln: University of Nebraska Press, 1989.

---. "Women in Latin America: Current Research Trends." In *Integrating Latin American and Caribbean Women into the Curriculum and Research*, edited by Edna Acosta-Belén and Christine E. Bose, 5–25. Albany: CELAC (Center for Latin America and the Caribbean), State University of New York–Albany, 1991.

Lebsock, Suzanne. *The Free Women of Petersburg: Status and Culture in a Southern Town, 1784–1860.* New York: W. W. Norton, 1985.

Ledrú, André P. *Viaje a la Isla de Puerto Rico en el año 1797.* Río Piedras: Editorial Universitaria, 1957.

Le Riverend, Julio. *Historia Económica de Cuba.* Havana: Editorial de las Ciencias Sociales, 1985.

---. *La Habana, espacio y vida.* Madrid: Editorial Mapfre, 1992.

Levene, Ricardo. *Introducción a la historia del derecho indiano.* Buenos Aires: n.p., 1924.

Little, Cynthia J. "Educación, filantropía, y feminismo: Partes integrantes de la feminidad argentina, 1860–1926." In *Las mujeres latinoamericanas: Perspectivas históricas*, edited by Asunción Lavrin, 271–92. Mexico City: Fondo de Cultura Económica, 1985.

Lockhart, James. "The Social History of Colonial Spanish America." *Latin American Research Review* 7, no. 1 (1972): 6–45.

López Cantos, Angel. *Historia de Puerto Rico, 1650–1700.* Seville: Escuela de Estudios Hispano-Americanos, 1975.

---. "El comercio legal de Puerto Rico con las colonias extranjeras de América: 1700–1815." *Revista de Ciencias Sociales* 24, nos. 1–2 (1985): 201–17.

Lugar, Catherine. "Merchants." In *Cities and Society in Colonial Latin America*, edited by Louisa S. Hoberman and Susan M. Socolow, 47–76. Albuquerque: University of New Mexico Press, 1986.

Luque de Sánchez, María D. "Matrimonios y compadrazgos: La interrelación social de los corsos con la población criolla de Yauco durante la primera mitad del siglo XIX." *Historia y Sociedad* 3 (1990): 43–55.

Maluquer de Motes, Jordi. "Inmigración y comercio catalán en las Antillas Españolas durante el siglo XIX." *Siglo XIX* 2, no. 4 (1987): 161–82.

Manucy, Albert, and Ricardo Torres-Reyes. *Puerto Rico and the Forts of Old San Juan.* Riverside, Conn.: Chatham Press, 1973.

Marrero, Leví. *Cuba: Economía y sociedad.* 15 vols. Madrid: Editorial Playor, 1981–93.

Marte, Roberto. *Cuba y la República Dominicana: Transición económica en el Caribe en el siglo XIX.* Santo Domingo: Editorial CENAPEC, 1988.

Martínez Alcubillas, Marcelo. *Diccionario de la administración española.* 6th ed. 9 vols. Madrid: n.p., 1917.

Martínez Alier, Verena. *Marriage, Class and Colour in Nineteenth-Century Cuba: A Study of Racial Attitudes and Sexual Values in a Slave Society.* 2d ed. Ann Arbor: University of Michigan Press, 1989.

Martínez-Fernández, Luis. *Torn between Empires: Economy, Society and Patterns of Political Thought in the Hispanic Caribbean, 1840–1878.* Athens: University of Georgia Press, 1994.

Martínez Ortiz, Nilda. "Las sociedades mercantiles en San Juan: 1870–80." *Anales de Investigación Históricas* 1, no. 2 (1974): 74–104.

Martínez-San Miguel, Yolanda. "Deconstructing Puerto Ricanness through Sexuality: Female Counternarratives on Puerto Rican Identity (1894–1934)." In *Puerto Rican Jam: Essays on Culture and Politics*, edited by Francés Negrón-Muntaner and Ramón Grosfogel, 127–39. Minneapolis: University of Minnesota Press, 1997.

Martínez Vergne, Teresita. "The Liberal Concept of Charity: Beneficencia Applied to Puerto Rico, 1821–1868." In *The Middle Period in Latin America: Values and Attitudes in the 17th–*

19th Centuries, edited by Mark D. Szuchman, 167–84. Boulder, Colo.: Lynne Rienner, 1989.

———. "The Allocation of Liberated African Labour through the Casa de Beneficencia—San Juan, Puerto Rico, 1859–1864." *Slavery and Abolition* 12, no. 3 (1991): 200–216.

———. *Capitalism in Colonial Puerto Rico: Central San Vicente in the Late Nineteenth Century.* Gainesville: University Press of Florida, 1992.

———. *Shaping the Discourse on Space: Charity and Its Wards in Nineteenth-Century San Juan, Puerto Rico.* Austin: University of Texas Press, forthcoming.

Matos Rodríguez, Félix V. "La mujer y el derecho en el siglo XIX en San Juan, Puerto Rico (1820–1862)." In *Género, familia y mentalidades en América Latina,* edited by Pilar Gonzalbo, 227–64. Río Piedras: Centro de Investigaciones Históricas, 1987.

———. "Diario de Edward Bliss Emerson (San Juan, 1831–32)." *Historia y Sociedad* 4 (1991): 167–87.

———. "Women's History in Puerto Rican Historiography: The Last Thirty Years." In *Puerto Rican Women's History: New Perspectives,* edited by Félix V. Matos Rodríguez and Linda Delgado, 9–37. Armonk, N.Y.: M. E. Sharpe, 1998.

———. "¿Quién trabajará?: Domestic Workers, Urban Slaves, and the Abolition of Slavery in Puerto Rico." In *Puerto Rican Women's History: New Perspectives,* edited by Félix V. Matos Rodríguez and Linda Delgado, 62–82. Armonk, N.Y.: M. E. Sharpe, 1998.

Mauleón-Benítez, Carmen C. *Las turbas: Mauleón, políticos y patriotas.* Río Piedras: Editorial Cultural, 1990.

Mayo Santana, Raúl, and Mariano Negrón Portillo. "La familia esclava urbana en San Juan en el siglo XIX." *Revista de Ciencias Sociales* 30, nos. 1–2 (1993): 163–97.

Mayo Santana, Raúl, Mariano Negrón Portillo, and Manuel Mayo López. "Esclavos y libertos: Trabajo en San Juan pre y post-abolición." *Revista de Ciencias Sociales* 30, nos. 3–4 (1995): 1–48.

———. *Cadenas de la esclavitud . . . y de solidaridad: Esclavos y libertos en San Juan, siglo XIX.* Río Piedras: Centro de Investigaciones Sociales, 1997.

Mead, Karen. "Gendering the Obstacles to Progress in Positivist Argentina, 1880–1920." *Hispanic American Historical Review* 77, no. 4 (1997): 645–76.

Merino Falú, Aixa. "El Gremio de lavanderas de Puerta de Tierra." In *Historias vivas: Historiografía puertorriqueña contemporánea,* edited by Antonio Gaztambide Géigel and Silvia Alvarez Curbelo, 74–79. San Juan: Asociación Puertorriqueña de Historiadores and Editorial Postdata, 1997.

Metcalf, Alida. "Women and Means: Women and Family Property in Colonial Brazil." *Journal of Social History* 24, no. 2 (1990): 277–98.

Miller, Francesca. *Latin American Women and the Search for Social Justice.* Hanover, N.H.: University Press of New England, 1991.

Mintz, Sidney W. "Men, Women, and Trade." *Comparative Studies in Society and History* 13, no. 3 (1971): 247–69.

Mohammed, Patricia, and Catherine Shepherd, eds. *Gender in Caribbean Development.* Kingston: University of the West Indies, Women and Development Studies Project, 1988.

Morales Carrión, Arturo. *Auge y decadencia de la trata negrera en Puerto Rico (1820–1860).* San Juan: Centro de Estudios Avanzados de Puerto Rico y el Caribe and Instituto de Cultura Puertorriqueña, 1978.

Moreno Fraginals, Manuel. *El ingenio: Complejo económico social cubano del ázucar.* 3 vols. Havana: Editorial de Ciencias Sociales, 1978.

Moreno Fraginals, Manuel, Frank Moya Pons, and Stanley L. Engerman, eds. *Between Slavery*

and Free Labor: The Spanish-Speaking Caribbean in the Nineteenth Century. Baltimore: Johns Hopkins University Press, 1985.
Morrissey, Marietta. Slave Women in the New World: Gender Stratification in the Caribbean. Lawrence: University of Kansas Press, 1989.
Nadal, Jordi. El fracaso de la Revolución Industrial en España, 1814–1913. Barcelona: Editorial Ariel, 1975.
Navarro, Marysa. "Women in Pre-Columbian and Colonial Latin America." In Restoring Women to History: Teaching Packets for Integrating Women's History into Courses on Africa, Asia, Latin America, the Caribbean, and the Middle East, 3–40. Bloomington: Organization of American Historians, 1988.
Navarro García, Jesús R. "Fuentes documentales españolas para el estudio del Gobierno de Miguel de la Torre (Conde de Torrepando) en Puerto Rico: de la desintegración colonial a la revolución liberal (1822–1837)." Revista de Historia, nos. 5–6 (1987): 44–62.
———. Control social y actitudes políticas en Puerto Rico (1823–1837). Seville: Diputación Provincial de Sevilla, 1991.
Nazzari, Muriel. "Sex/Gender Arrangements and the Reproduction of Class in the Latin American Past." In Gender Politics in Latin America: Debates in Theory and Practice, edited by Elizabeth Dore, 134–48. New York: Monthly Review Press, 1997.
Needell, Jeffrey D. "Rio de Janeiro and Buenos Aires: Public Space and Public Consciousness in Fin-de-Siècle Latin America." Comparative Studies of Society and History 37, no. 3 (1995): 519–40.
Negrón Portillo, Mariano, and Raúl Mayo Santana. La esclavitud urbana en San Juan: Estudio del Registro de Jornaleros de Esclavos de 1872. Río Piedras: Ediciones Huracán, 1992.
———. "Trabajo, producción y conflictos en el siglo XIX: Una revisión crítica de las nuevas investigaciones históricas en Puerto Rico." Revista de Ciencias Sociales 24, nos. 3–4 (1985): 469–96.
Negroni, Héctor A. Historia militar de Puerto Rico. San Juan: Sociedad Estatal Quinto Centenario, 1992.
Newell, Colin. Methods and Models in Demography. London: Belhaven Press, 1988.
Nicholson, Linda J. Gender and History: The Limits of Social Theory in the Age of the Family. New York: Columbia University Press, 1986.
Nistal-Moret, Benjamín. "Problems in the Social Structure of Slavery in Puerto Rico during the Process of Abolition, 1872." In Between Slavery and Free Labor: The Spanish-Speaking Caribbean in the Nineteenth Century, edited by Manuel Moreno Fraginals, et al., 141–57. Baltimore: Johns Hopkins University Press, 1985.
Nuñez Jiménez, Antonio, and Carlos Venegas Fournias. La Habana. 2d ed. Madrid: Agencia Española de Cooperación Internacional and Instituto de Cooperación Iberoamericana, 1989.
Ormaechea, Dario de. "Memoria acerca de la agricultura, el comercio y las rentas internas, 1847." In Crónicas de Puerto Rico desde la conquista hasta nuestros días (1493–1955), edited by Eugenio Férnandez Méndez, 389–442. Río Piedras: Editorial Universitaria, 1981.
Ortiz, Altagracia. Eighteenth-Century Reforms in the Caribbean. Rutherford: Fairleigh Dickinson University Press, 1983.
Ortiz Medina, Félix M. "Análisis de los registros de matrimonios (1813–1850) de la parroquia de Yabucoa." Anales de Investigación Históricos 1, no. 1 (1974): 73–92.
Osuna, Juan J. A History of Education in Puerto Rico. 2d ed. Río Piedras: Editorial Universitaria, 1949.
Ots Capdequi, José M. "El sexo como circunstancia modificativa de la capacidad jurídica en nuestra legislación de Indias." Anuario de historia del Derecho Español 7 (1930): 312–80.

Pagán, Bolivar. *Historia de los partidos políticos puertorriqueños (1898–1956).* 2d ed. 2 vols. Barcelona: n.p., 1972.
Patterson, Orlando. *Slavery and Social Death: A Comparative Study.* Cambridge: Harvard University Press, 1982.
Pérez, Louis A. *Cuba: Between Reform and Revolution.* New York: Oxford University Press, 1988.
Pérez de la Riva, Juan. *El barracón: Esclavitud y capitalismo en Cuba.* Havana: Editorial de las Ciencias Sociales, 1978.
Pérez González, Lydia. *Enfermería en Puerto Rico desde los Precolombinos hasta el siglo XX.* Mayaguez: Universidad de Puerto Rico—Recinto de Mayaguez, 1997.
Pérez Moreda, Vicente. "La modernización demográfica, 1800–1930: Sus limitaciones y cronología." In *La modernización económica de España, 1830–1930,* edited by Nicolás Sánchez-Albornoz, 25–62. Madrid: Alianza Editorial, 1987.
Pérez Moris, José. *Historia de la Insurrección en Lares.* 1872. Reprint, Río Piedras: Edil, 1975.
Pérez Vega, Ivette. "Las sociedades mercantiles en Ponce, 1817–1825." *Anales de Investigación Histórica* 6, no. 2 (1979): 52–112.
———. *El cielo y la tierra en sus manos: Los grandes propietarios de Ponce, 1816–1830.* Río Piedras: Ediciones Huracán, 1985.
———. "Juana María Escobales, Liberta Liberada." *Homines* 11, nos. 1–2 (1987–88): 397–402.
Pescador, Juan Javier. "Vanishing Woman: Female Migration and Ethnic Identity in Late-Colonial Mexico City." *Ethnohistory* 42, no. 4 (1997): 617–26.
Picó, Fernando. *Amargo café: Los pequeños y medianos caficultores de Utuado en la segunda mitad del siglo XIX.* Río Piedras: Ediciones Huracán, 1981.
———. *Libertad y servidumbre en el Puerto Rico del siglo XIX: Los jornaleros utuadeños en vísperas del auge del café.* 2d ed. Río Piedras: Ediciones Huracán, 1982.
———. "Reseña del libro de Luis de la Rosa, *La periferia del Grito de Lares.*" *Anales de Investigación Históricos* 19, nos. 1–2 (1982): 74–78.
———. *Educación y sociedad en el Puerto Rico del siglo XIX.* Río Piedras: CEREP, Cuadernos—Herramientas y Documentos no. 2, 1983.
———. "Nociones de orden y desórden en la periferia de San Juan, 1765–1830." *Revista de Historia* 1, no. 2 (1985): 48–54.
———. "Fuentes para la historia de las comunidades rurales en Puerto Rico durante los siglos 19 y 20." *Op Cit: Revista del Centro de Investigaciones Históricas* 1 (1985–86): 1–16.
———. "Esclavos, cimarrones, libertos y negros libres en Río Piedras, 1774–1873." *Anuario de Estudios Americanos* 43 (1986): 25–33.
———. *Historia general de Puerto Rico.* 3d ed. Río Piedras: Ediciones Huracán, 1986.
———. *Vivir en Caimito.* Río Piedras: Ediciones Huracán, 1989.
Picó, Isabel. "The History of Women's Struggle for Equality in Puerto Rico." In *The Puerto Rican Woman: Perspectives on Culture, History and Society,* 2d ed., edited by Edna Acosta-Belén, 46–58. New York: Praeger, 1986.
Pike, Ruth. "Penal Servitude in the Spanish Empire: Presidio Labor in the XVIIIth Century." *Hispanic American Historiacal Review* 58, no. 1 (1978): 21–40.
Pollard, A. H., Farhat Yusuf, and G. N. Pollard. *Demographic Techniques.* Sydney: Pergamon Press, 1974.
Quintero Rivera, Angel G. *Conflictos de clase y política en Puerto Rico.* 3d ed. Río Piedras: Ediciones Huracán, 1981.
———. *Patricios y plebeyos: Burgueses, hacendados, artesanos y obreros (Las relaciones de clase en el Puerto Rico de cambio de siglo).* Río Piedras: Ediciones Huracán, 1988.

Ramos, Donald. "City and Country: The Family in Minas Gerais, 1804–1838." *Journal of Family History* 3, no. 4 (1978): 361–75.
Ramos, Héctor F. "El comercio de contrabando en la costa sur de Puerto Rico, 1750–1778." *Revista de Indias* 14, nos. 1–4 (1984): 80–99.
Ramos, Julio. *Desencuentros de la modernidad en América Latina: Literatura y política en el siglo XIX*. Mexico City: Fondo de Cultura Económica, 1989.
Ramos Mattei, Andrés. *La hacienda azucarera: Su crecimiento y crisis en Puerto Rico (siglo XIX)*. San Juan: CEREP, 1981.
———. "La importación de trabajadores contratados para la industria azucarera puertorriqueña: 1860–1880." In *Inmigración y clases sociales en el Puerto Rico del siglo XIX*, edited by Francisco Scarano, 125–42. Río Piedras: Ediciones Huracán, 1981.
———. "El liberto en el régimen de trabajo azucarero de Puerto Rico, 1870–1880." In *Azúcar y esclavitud*, edited by Andrés Ramos Mattei, 99–124. Río Piedras: Editorial Universitaria, 1982.
———. "Technical Innovations and Social Change in the Sugar Industry of Puerto Rico, 1870–1880." In *Between Slavery and Free Labor: The Spanish-Speaking Caribbean in the Nineteenth Century*, edited by Manuel Moreno Fraginals et al., 158–80. Baltimore: Johns Hopkins University Press, 1985.
Ramos Mattei, Andrés, ed. *Azúcar y esclavitud*. Río Piedras: Editorial Universitaria, 1982.
Ribes Tovar, Federico. *La mujer puertorriqueña: Su vida y evolución a través de la historia*. New York: Plus Ultra, 1972.
Richardson, Bonham C. *The Caribbean in the Wider World, 1492–1992*. Cambridge: Cambridge University Press, 1992.
Rigau, Jorge. *Puerto Rico 1900: Turn-of-the-Century Architecture in the Hispanic Caribbean, 1890–1930*. New York: Rizzoli, 1992.
Rigau-Pérez, José G. "The Introduction of Smallpox Vaccine in 1803 and the Adoption of Immunization as a Government Function in Puerto Rico." *Hispanic American Historical Review* 69, no. 3 (1989): 393–424.
Rivera de Alvarez, Josefina. *Diccionario de Literatura Puertorriqueña*. 2 vols. San Juan: Instituto de Cultura Puertorriqueña, 1974.
Rivera Rivera, Antonia. "El problema de la vagancia en el Puerto Rico del siglo XIX." *Exegesis* 5, no. 14 (1992): 12–19.
Rodríguez, E. *La mujer española y americana*. Madrid: n.p., 1898.
Rodríguez Castro, María Elena. "Tradición y modernidad: El intelectual puertorriqueño ante la década del treinta." *Op. Cit.: Revista del Centro de Investigaciones Históricas* 3 (1987–88): 45–56.
Rodríguez Juliá, Edgardo. *Campeche o los diablejos de la melancolía*. San Juan: Instituto de Cultura Puertorriqueña, 1986.
Rodríguez Morales, Herminio R. "Canal de transporte entre el Río Grande de Loíza y la Bahía de San Juan." *Cupey* 7 (1990): 130–39.
Rodríguez Villanueva, Carlos. "Guaynabo en 1860." *Anales de Investigación Históricos* 8, nos. 1–2 (1981): 127–62.
Roqué, Ana. *Luz y sombra*. 2d ed. Río Piedras: Editorial Universitaria and Instituto de Cultura Puertorriqueña, 1991.
Rosario Rivera, Raquel. *Los emigrantes llegados a Puerto Rico procedentes de Venezuela entre 1810–1848*. San Juan: Comisión Celebración del Quinto Centenario de América y Puerto Rico, 1992.

———. *María de las Mercedes Barbudo: Primera mujer independentista de Puerto Rico, 1773–1849.* San Juan: n.p., 1997.
Sánchez-Albornoz, Nicolás. *The Population of Latin America: A History.* Berkeley: University of California Press, 1974.
Sánchez-Albornoz, Nicolás, ed. *La modernización económica de España, 1830–1930.* Madrid: Alianza Editorial, 1987.
Sánchez Korrol, Virginia. "Women in Nineteenth-and Twentieth-Century Latin America and the Caribbean." In *Restoring Women to History: Teaching Packets for Integrating Women's History into Courses on Africa, Asia, Latin America, the Caribbean, and the Middle East,* 41–87. Bloomington: Organization of American Historians, 1988.
Sanjurjo, Carmela Eulate. *La muñeca.* 2d ed. Río Piedras: Editorial Universitaria and Instituto de Cultura Puertorriqueña, 1987.
San Miguel, Pedro. *El mundo que creo el azucar: Las haciendas en Vega Baja, 1800–1873.* Río Piedras: Ediciones Huracán, 1989.
Santiago Marazzi, Rosa. "El impacto de la inmigración a Puerto Rico, 1800 a 1830: Analísis Estadístico." *Revista de Ciencias Sociales* 18, nos. 1–2 (1974): 1–44.
———. "La inmigración de mujeres españolas a Puerto Rico en el periodo colonial español." *Homines* 10, no. 2 (1986–87): 154–65.
Scarano, Francisco. "Slavery and Free Labor in the Puerto Rican Sugar Economy, 1815–1873." In *Comparative Perspectives on Slavery in New World Plantation Societies,* edited by Vera Rubin and Arthur Tuden, 553–63. New York: Annals of the Academy of Sciences, 1977.
———. *Sugar and Slavery in Puerto Rico: The Plantation Economy of Ponce, 1800–1850.* Madison: University of Wisconsin Press, 1984.
———. "Población esclava y fuerza de trabajo: Problemas del analísis demográfico de la esclavitud en Puerto Rico, 1820–1873." *Anuario de Estudios Americanos* 43 (1986): 3–25.
———. "Labor and Society in the Nineteenth Century." In *The Modern Caribbean,* edited by Franklin Knight and Colin Palmer, 51–84. Chapel Hill: University of North Carolina Press, 1989.
Scott, Rebecca. *Slave Emancipation in Cuba: The Transition to Free Labor, 1860–1899.* Princeton: Princeton University Press, 1985.
Seed, Patricia. *To Love, Honor and Obey in Colonial Mexico: Conflicts over Marriage Choice, 1574–1821.* Stanford: Stanford University Press, 1988.
Senior, Olive. *Working Miracles: Women's Lives in the English Speaking Caribbean.* Bloomington: University of Indiana Press, 1991.
Sepúlveda Rivera, Aníbal. *San Juan: Historia ilustrada de su desarollo urbano, 1508–1898.* San Juan: Carimar, 1989.
Shepherd, Verene, Bridget Brereton, and Barbara Bailey, eds. *Engendering History: Caribbean Women in Historical Perspective.* Kingston: Ian Randle, 1995.
Shubert, Adrian. "Charity Properly Understood: Changing Ideas about Poor Relief in Liberal Spain." *Comparative Studies of Society and History* 33, no. 1 (1991): 36–55.
Silva Dias, María Odila. *Power and Everyday Life: The Lives of Working Women in Nineteenth-Century Brazil.* New Brunswick, N.J.: Rutgers University Press, 1995.
Silvestrini, Blanca. *Women and Resistance: Herstory in Contemporary Caribbean History.* Kingston: University of the West Indies (Mona), Department of History, 1989.
Socolow, Susan M. *The Merchants of Buenos Aires, 1778–1810.* Cambridge: Cambridge University Press, 1978.

———. "Women and Crime: Buenos Aires, 1757–97." *Journal of Latin American Studies* 12, no. 1 (1980): 39–54.

———. "Introduction." In *Cities and Society in Colonial Latin America*, edited by Louisa S. Hoberman and Susan M. Socolow, 3–18. Albuquerque: University of New Mexico Press, 1986.

———. "Acceptable Partners: Marriage Choice in Colonial Argentina, 1778–1810." In *Sexuality and Marriage in Colonial Latin America*, edited by Asunción Lavrin, 209–51. Lincoln: University of Nebraska Press, 1989.

Sommer, Doris. *Foundational Fictions: The National Romances of Latin America*. Berkeley: University of California Press, 1991.

Sonesson, Birgit. *La Real Hacienda en Puerto Rico: Administración, política y grupos de presión (1815–1868)*. Madrid: Instituto de Estudios Fiscales & Instituto de Cooperación Iberoamericana, 1990.

Staples, Anne. "*Policía y Buen Gobierno*: Municipal Efforts to Regulate Public Behaviour, 1821–1857." In *Rituals of Rule, Rituals of Resistance: Public Celebrations and Popular Culture in Mexico*, edited by William H. Beezley, Cheryl English Martin, and William E. French, 115–26. Wilmington, Del.: Scholarly Resources Books, 1994.

Stephen, Lynn. *Women and Social Movements in Latin America: Power from Below*. Austin: University of Texas Press, 1997.

Stern, Steve. *The Secret History of Gender: Women, Men, and Power in Late Colonial Mexico*. Chapel Hill: University of North Carolina Press, 1995.

Stoler, Ann L. "Making Empire Respectable: The Politics of Race and Sexual Morality in 20th-Century Colonial Cultures." *American Ethnologist* 16 (1989): 634–60.

Stoner, K. Lynn. *Latinas of the Americas*. New York: Garland, 1989.

———. *From the House to the Streets: The Cuban Woman's Movement for Legal Reform, 1898–1940*. Durham, N.C.: Duke University Press, 1991.

Subcomité de la Historia de Mayaguez. *Historia de Mayaguez, 1760–1960*. Mayaguez: Comité del Bicentenario de la Fundación de Mayaguez, 1960.

Sued Badillo, Jalil. *La mujer indígena y su sociedad*. 2d ed. Río Piedras: Editorial Cultural, 1979.

Sued Badillo, Jalil, and Angel López Cantos. *Puerto Rico negro*. Río Piedras: Editorial Cultural, 1986.

Szászdi, Adam. "Credit without Banking in Early Nineteenth Century Puerto Rico." *The Americas* 19, no. 2 (1962): 149–71.

———. "Apuntes sobre la esclavitud en San Juan de Puerto Rico, 1800–1811." *Anuario de Estudios Americanos* 13 (1962): 1433–77.

Szuchman, Mark D. "The City as Vision—The Development of Urban Culture in Latin America." In *I Saw a City Invincible: Urban Portraits of Latin America*, edited by Gilbert M. Joseph and Mark D. Szuchman, 1–32. Wilmington, Del.: Scholarly Resources, 1996.

Tapia y Rivera, Alejandro. *Mis memorias o Puerto Rico como lo encontré y como lo dejo*. 3d ed. Río Piedras: Editorial Edil, 1979.

Taylor, William B. "Between Global Process and Local Knowledge: An Inquiry into Early Latin American Social History, 1500–1900." In *Reliving the Past: The Worlds of Social History*, edited by Olivier Zuns, 115–90. Chapel Hill: University of North Carolina Press, 1985.

Témime, Emile, Albert Broder, and Gérard Chastagnaret. *Historia de la España contemporánea: Desde 1808 hasta nuestros días*. 3d ed. Barcelona: Editorial Ariel, 1989.

Thompson, Donald. "Notes on the Inauguration of the San Juan (Puerto Rico) Municipal Theater." *Latin American Music Review* 11, no. 1 (1990): 84–91.

Tornero, Pablo. "Immigración, población y esclavitud en Cuba (1765–1817)." *Anales de Estudios Americanos* 44 (1987): 266–71.
Trías Monje, José. *Historia Constitucional de Puerto Rico*. 4 vols. Río Piedras: Editorial Universitaria, 1980–83.
Twinam, Ann. *Miners, Merchants and Farmers in Colonial Colombia*. Austin: University of Texas Press, 1983.
Valle Ferrer, Norma. "Primeros fermentos de la lucha femenina en Puerto Rico." *Revista del Instituto de Cultura Puertorriqueña* 22, no. 84 (1979): 15–19.
———. "Feminism and Its Influence on Women's Organizations in Puerto Rico." In *The Puerto Rican Woman: Perspectives on Culture, History and Society*, 2d ed., edited by Edna Acosta-Belén, 75–87. New York: Praeger, 1986.
———. *Luisa Capetillo: Historia de una mujer proscrita*. Río Piedras: Editorial Cultural, 1990.
Vance, James E. *The Continuing City: Urban Morphology in Western Civilization*. Rev. ed. Baltimore: Johns Hopkins University Press, 1990.
Vázquez Arce, María C. "Las compra-ventas de esclavos y las cartas de libertad en Naguabo durante el siglo XIX." *Anales de Investigación Históricos* 3, no. 1 (1976): 42–79.
Vecilla de las Heras, Delfín. *El Obispo Carrión: Educador, benefactor, apóstol de Puerto Rico*. Vol. 1. Río Piedras: Editorial Plus Ultra, n.d.
———. *Fray Pablo Benigno Carrión de Málaga: Obispo de Puerto Rico*. Vol. 2. Río Piedras: Editorial Plus Ultra, 1960.
Vicens Vives, Jaime. *Historia económica y social de España y América*. Barcelona: Editorial Vicens Vives, 1962.
Vilar, Pierre. *Historia de España*. 23d ed. Barcelona: Editorial Crítica, 1986.
Villegas, Gregorio. "Fluctuaciones de la población de Guaynabo en el período 1780–1830." *Anales de Investigación Histórica* 8, nos. 1–2 (1981): 90–126.
Waldron, Kathy. "The Sinners and the Bishop in Colonial Venezuela: The Visita of Bishop Mariano Martí, 1771–1784." In *Sexuality and Marriage in Colonial Latin America*, edited by Asunción Lavrin, 156–77. Lincoln: University of Nebraska Press, 1989.
Watts, David. *The West Indies: Patterns of Development, Culture and Environmental Change since 1492*. Cambridge: Cambridge University Press, 1990.
Zapatero, Juan Manuel. *La fortificación abaluartada en América*. San Juan: Instituto de Cultura Puertorriqueña, 1978.
Zeno, F. M. *La capital de Puerto Rico, 1508–1947*. San Juan: Editorial Casa Baldrich, 1948.

Unpublished Materials

Alvarez Curbelo, Silvia. "El afán de modernidad: La constitucion de la discursividad moderna en Puerto Rico (siglo XIX)." Ph.D. diss., University of Puerto Rico–Río Piedras, 1998.
Aponte-Parés, Luis. "Casas y Bohios: Territorial Development and Urban Growth in XIXth Century Puerto Rico." Ph.D. diss., Columbia University, 1990.
Baralt, Guillermo. "Los estadounidenses se acercan a la Isla en busca de ázucar." Paper presented at the Latin American Studies Association Conference, Miami, October 1989.
Campos Esteve, Carmen. "La política del comercio: Los comerciantes de San Juan: 1837–1844." Master's thesis, University of Puerto Rico–Río Piedras, 1987.
Carbonell Fernández, Rubén. "Las compra-ventas de esclavos en San Juan, 1817–1873." Master's thesis, University of Puerto Rico–Río Piedras, 1976.
Colberg, Elisa. "Esquema histórico-biográfico de la literatura antillana femenina en el siglo XIX." Ph.D. diss., University of North Carolina, 1989.
Eizaguirre, José M. "Los sistemas en el régimen de abasto de carnes de San Juan durante la primera mitad del siglo XIX." Master's thesis, University of Puerto Rico–Río Piedras, 1974.

Figueroa, Luis A. "Facing Freedom: The Transition from Slavery to Free Labor in Guayama, Puerto Rico, 1860–1989." Ph.D. diss., University of Wisconsin, 1991.

Findlay, Eileen J. "Domination, Decency, and Desire: The Politics of Sexuality in Ponce, Puerto Rico, 1870–1920." Ph.D. diss., University of Wisconsin, 1995.

Flores Ramos, José E. "Eugenesia, higiene pública y alcanfor para las pasiones: La prostitución en San Juan de Puerto Rico, 1876–1919." Master's thesis, University of Puerto Rico–Río Piedras, 1995.

García Leduc, José M. "La Iglesia y el clero católico de Puerto Rico (1800–1873): Su proyección social, económica y política." Ph.D. diss., Catholic University of America, 1990.

González-Mendoza, Juan R. "The Parish of San German de Auxerre in Puerto Rico, 1765–1850: Patterns of Settlement and Development." Ph.D. diss., State University of New York, 1989.

Hunter, Tera. "Household Workers in the Making: Afro-American Women in Atlanta and the New South, 1861 to 1921." Ph.D. diss., Yale University, 1990.

Jimenez-Muñoz, Gladys M. "A Storm Dressed in Skirts: Ambivalence in the Debate on Women's Suffrage in Puerto Rico, 1927–1929." Ph.D. diss., State University of New York, 1994.

Kinsbruner, Jay. "Real Property Ownership in San Juan, Puerto Rico during the Early Nineteenth Century: An Analysis of the Census of 1820. " Unpublished manuscript. Archivo General de Puerto Rico.

Matos Rodríguez, Félix V. "Economy, Society, and Urban Life: Women in Nineteenth-Century San Juan, Puerto Rico (1820–1870)." Ph.D. diss., Columbia University, 1994.

Padilla, Carlos. "Political Economy in Nineteenth-Century Puerto Rico." Ph.D. diss., University of Connecticut, 1989.

Sonesson, Birgit. "Puerto Rico's Commerce, 1835–1865: From Regional to World Wide Market Relations." Ph.D. diss., New York University, 1985.

Stetson, George Edward. "San Juan, Puerto Rico: A Case Study of the Evolution and Functional Role of a Primate City." Ph.D. diss., University of North Carolina, 1976.

Vecilla de las Heras, Delfín. *Obispo Carrión: Educador, benefactor, reformador (1798–1871)*. Vol. 3. Unfinished manuscript. Archivo Histórico Diocesano, San Juan, n.d.

Vega Lugo, Ramonita. "Epidemia y sociedad: El cólera en San Germán y Mayaguez, 1856." Master's thesis, University of Puerto Rico–Río Piedras, 1989.

Welch, Pedro L. "The Urban Context of the Slave Plantation System: Bridgetown, Barbados, 1680–1834." Ph.D. diss., University of the West Indies, 1994.

Index

Abbad y Lasierra, Fray Iñigo, 13, 19, 38
Acosta, José Julián, 93
Africa, 40, 49–51, 54, 56–58, 88, 109
Agregados, 43, 88
Aguadilla, 52
Alonso, Carlos, 7
Alonso de Andrade, Nicolás, 16, 137n.33
Alvarez Curbelo, Silvia, 7
Arecibo, 22, 46, 60
Argentina, 6, 123
Arranzamendi, José Lucas, 61–62, 119–20
Arrom, Silvia Marina, 5, 8
Artisans, 77, 81, 87, 89, 103, 105–6, 110–11, 114, 122, 127–28
Asabud, Juana, 85–86
Asilo de Pobres, 121
Asilo Municipal de Caridad, 128
Asilo San Ildefonso, 4–5, 115–19, 122, 124, 128
Asociación de Beneficencia Domiciliaria de la Habana, 121
Asociación de Damas para la Instrucción de la Mujer, 128
Asociación para la Protección de la Niñez, 128
Astarloa de Arranzamendi, Escolástica, 62, 118–20

Baez, Bernarda, 1, 84
Baldrich, Gabriel, 125
Ballajá barrio, 12–14, 25, 42, 58, 92, 126, 136n.16, 143n.42
Bando de Jornaleros, 33
Bando de Policía y Buen Gobierno, 89
Baracoa, 50
Barbudo, María de las Mercedes, 7
Barcelona, 119

Basques, 53, 60–63, 119
Bayamón 16, 19, 65, 91
Bazán, Saturnina, 110–111
Beneficence, 3–5, 9, 26, 96, 101–8, 110–18, 121–24, 128, 153n.3
Benitez, María Bibiana, 127
Benitez de Gautier, Alejandrina, 116, 127
Boletín Eclesiástico, 25, 28–30, 35, 116
Boletín Mercantil, 125
Bourbon Reforms, 8, 103
Brazil, 123
Brewster de Vizcarrondo, Harriet, 118–19
Bridgetown, 12, 44, 66
British Siege of 1797, 11, 137n.33
Buenos Aires, 18, 123

Cabildo. See Town council
Cadiz, 60, 64
Caguas, 15, 64, 69
Cambien, María, 73, 85
Cami, Pedro, 73, 85
Campos, Florentina, 104–5
Canary Islanders, 41, 49–51, 53–54, 72, 111
Cangrejos, 15–16, 19, 21, 41, 45, 75, 87, 89, 92
Cantero de Romero, Nicolasa, 118, 120
Caparra, 11, 15
Capetillo, Casimiro, 86, 120
Caracas, 52, 63
Carbonera, La, 19
Caribbean, 4–5, 8–9, 12, 36–37, 42, 49–51, 55, 66, 72, 88, 96, 109
Carmelite convent, 11–12, 15, 91
Carolina, 120
Carretera Central, 15, 87
Carrión, Fray Pablo Benigno, 29–30, 115, 117

178 Index

Casa de Beneficencia, 4, 13, 26, 42, 76, 94, 101–2, 104–15, 124
Casa de Párvulos, 115, 122
Castillo, José Mauleón, 93
Catalans, 41, 49, 53, 60–63, 72
Cataño, 15–16, 19, 91
Cathedral Chapter, 1, 115, 117, 133n.1
Catholic Church, 1, 3–6, 8–9, 11, 23–24, 27–32, 35, 59, 73–74, 82, 84, 90, 96–104, 114–15, 128
Cédula de Gracias, 41
Charbonier de Fuertes, Demetria, 118, 120
Children, 28–29, 31–32, 48, 77, 91, 93, 96, 103, 106, 110–12, 114–15, 117
Chile, 123
Chupani, Antonia, 85–86
Cienfuegos, 50
Cifre de Loubriel, Estela, 49
Código Negro, 42
Colegio del Sagrado Corazón, 128
Colonialism, 3–4, 6–7, 24, 32, 34, 100, 102–3, 116–17; 122
Compañía de Aguirre-Aristegui, 60
Compañía de Barcelona, 60
Concubinage, 5, 19, 28–29, 85, 96–100, 106
Condado, 90–92
Cordero, Celestina, 74–75, 149n.91
Córdova, María Asunción de, 64, 65
Coro, 52
Costa Firme, 22, 49, 52–53, 56–57, 64, 67, 72, 86, 104, 144n.50
Creole. *See Criollos*
Criollos, 13, 22, 43, 50, 53, 55–56, 60, 63, 72, 102, 120, 138n.60
Cuba, 6–7, 17, 34, 40, 50, 52–53, 55, 62, 72, 81, 90, 104, 114, 116, 121, 123
Cumaná, 52, 64
Curaçao, 42, 51, 88

Damas del Asilo, 121
Dávila Ramírez, Bárbara, 64, 68
Deija, Matias, 109–10
Depósito Mercantil, 63, 64
Deutsch, Sandra McGee, 6
Dorado, Carmen, 85, 88
Domestic workers, 3, 18, 23, 27, 37, 40–41, 44–45, 48, 51, 55, 65–66, 75, 78–80, 82, 84, 87–96, 99, 105, 112–14, 119, 122, 124–26, 150n.118

Dominican convent, 11–13
Dominican Republic, 44, 49; War of Restoration, 115. *See also* Hispaniola; Santo Domingo (city)

Education, 5–6, 26–27, 32–33, 35, 73–75, 81–83, 101–3, 105–6, 110–12, 116–17, 123, 127, 128
Elzaburu y Compañía, 61
Emerson, Edward Bliss, 15, 20, 72, 86
Emerson, Ralph Waldo, 86
Epidemics, 40, 77, 113
Estancias, 19, 20, 65

Female heads of household, 70, 88, 96, 99–100
Feminism, 5, 124, 127, 134n.12
Fernando VII, 103
Findlay, Eileen, 6
Fortaleza (barrio), 12, 14, 43–45, 47–48, 136n.11, 143n.30
Fortaleza Palace. *See* Palacio de Santa Catalina
Fragoso, Tiburcia, 65, 72
France, 22, 38, 50, 77
Franciscan convent, 11–12, 91
Franco, Jean, 5

Galicia, 72
García, Dominga, 112–13
Geigel, José, 62, 69
Goenaga, Pesquera y Compañía, 72
González de Capetillo, Socorro, 118, 120
González de Geigel, María Asunción, 62, 69
Guadeloupe, 51
Guarch, Antonio, 62, 64–65
Guarch, Pedro, 62, 64
Guayama, 17, 20, 46, 48
Guaynabo, 16, 19, 44, 61, 68, 89, 91
Guyana, 52
Guzmán, Ana María, 85, 88

Hacendados, 16–17, 20, 22, 25, 41, 49, 54, 60, 63–65, 69, 94–95, 97, 104–5, 109, 119–21
Hahner, June, 123
Haiti, 3, 50. *See also* Hispaniola
Hato Rey, 19
Havana, 12, 38, 44, 46, 53, 57–58, 90, 104, 112

Higman, Barry, 66
Hijas de la Caridad, 115–16, 118
Hijas de María, 29–30
Hispaniola, 49–50. *See also* Dominican Republic; Haiti; Santo Domingo
Hospital de la Caridad, 92
Hospital de la Concepción, 104, 107
Hospital Militar, 12, 52, 67, 92, 94, 104, 112
Hygiene, 25–26, 34, 89, 92, 114, 126–27

Inmates, 103–7, 113–14
Isla Grande, 15

Junta de Beneficencia, 81, 103–5, 153n.7
Junta de Damas, 65, 101–2, 116, 118–19, 121–24
Junta de Instrucción, 75

Kingston, 12, 72, 88
Kinsbruner, Jay, 71–72

La Azucena, 127
Las Brisas de Borinquén, 127
La Guaira, 52, 119
La Guirnalda Puertorriqueña, 127
Lares, 34
Landladies, 3, 68–69, 126
Latimer, George, 63
Latin America, 4–5, 8, 22, 36, 60, 62, 73, 88, 96, 113, 122–23
Laundresses, 3, 78–79, 90–94, 99, 112–13, 125–26, 128
Ledrú, André Pierre, 38
Le Riverend, Julio, 52
Libertos. See People of color (free)
Linares de Lázaro, Emilia, 118, 121
Literature, 34–35, 115, 127
Loíza, 15, 19, 121

Majesty, 109
Manatí, 48
Maracaibo, 52
Marina, La (barrio), 15, 19, 26, 37, 42
Marriage, 24, 28–31, 52–53, 62–64, 66, 72, 76–77, 79, 81, 87, 97–100, 106, 109, 127
Martin Peña Bridge, 19
Martínez Vergne, Teresita, 4, 23
Mascaró, Ignacio, 16, 137n.33
Mason, Sidney, 20, 61, 63, 86

Matanzas, 104
Mayaguez, 17, 20, 37, 48, 121, 126
Méndez Vigo, Santiago, 54
Mentally ill, 103, 106–8, 110, 115–16
Merchants, 17, 20, 22–23, 25, 34, 46, 53–54, 59–65, 70, 82, 88–89, 101, 119–20, 129
Mexico, 5, 8, 81, 123
Mexico City, 18
Midwives, 76, 94
Military, 16–18, 21, 27, 33, 45–46, 63, 67, 76–77, 90, 92, 105, 111–12, 129, 141n.11
Mintz, Sidney, 88
Miraflores, 15, 91
Modernization, 3–5, 7–9, 23–26, 28, 35, 59, 82, 85, 92, 100–102, 104, 116, 122–24, 126–27, 129, 133n.3
Mondogueras, 14, 23, 78–80, 87, 89, 99
Montilla de Arroyo, Julia, 118, 121
Morales, Angustia, 73, 85
Moret Law, 33
Morro Castle, 11–12, 14
Munero, Catalina, 85–86
Municipal Theater, 13, 112

Norzagaray, Fernando de, 10, 42

Palacio de Santa Catalina, 11–13
Palo Seco, 15, 19, 89, 91
People of color (free), 48, 73, 78, 85, 87, 91, 109, 127, 129
Peralta de Riego Pica, Consuelo, 65, 118–19
Pezuela, Juan de la, 97
Plantation owners. *See* Hacendados
Ponce, 6, 17, 20, 22, 22, 37, 44, 46, 48–49, 52, 60, 65, 119, 121, 126–27
Port au Prince, 12
Prim y Prats, Juan, 42
Professionals, 23–24, 35, 73, 81, 122–23, 126–27
Prostitution, 89, 94, 103, 106–7, 113, 126
Public Safety, 42, 86–88, 91–92, 95, 99–100, 103–6, 108, 110, 113, 126, 127
Puerta de San Juan (gate), 14–15
Puerta de San Justo (gate), 14–15, 91
Puerta de Tierra (barrio), 15, 19, 21, 37, 42, 45, 67, 98
Puerta de Tierra (gate), 14–15
Puerto Cabello, 52
Puerto Nuevo, 91

Pulperías, 70–72, 85, 87, 98, 148n.62
Puntilla, La (barrio), 67, 91

Religiosas del Amor a Dios, 116
Requena, María Toribia, 75, 77
Revendones/as, 14, 19, 23, 25–26, 85, 88–89
Rio Piedras, 16, 19, 65, 89, 91
Rodríguez, Antonia, 72, 78

Saint Croix, 52
Saint Thomas, 22, 50–51
San Antonio Bridge, 14–15, 91
San Cristobal, 14, 42
Sancti Spíritus, 104
San Francisco (barrio), 12–14, 43–44, 46–48, 78–80, 85
San Juan (barrio). *See* Fortaleza barrio
San Juan (city): economy of, 16–22, 24, 27, 37, 59–61, 63, 65, 67, 69, 71–72, 81–82, 84, 90, 95, 102, 112–14, 126, 128, 138n 56; immigration to, 40–41, 47–58, 126; population of, 10, 18, 36–58, 67, 70, 113; real estate market in, 21–22, 26–27, 42, 45, 58, 66–70, 79–80, 82, 101, 118, 126; social structure of, 22–23, 78–79, 138n.56; urbanization in, 8–9, 11–16, 27, 35, 37–38, 41–42, 57–58, 66–67, 70; water supplies in, 14–15, 21, 26, 40, 73, 90–92
Santa Bárbara, 12–14, 42–44, 46–48, 58, 72, 78–80, 85, 87, 142n.27
Santander, 61
Santiago de Cuba, 50, 104
Santiago Marazzi, Rosa, 49
Santo Domingo (barrio), 12–14, 43–44, 46–48, 58, 78–80, 85
Santo Domingo (city), 50, 86. *See also* Dominican Republic; Hispaniola
Santurce, 41
Saviñón, Ramona, 72, 78
Scarano, Francisco, 40
Seamstresses, 77–80, 99, 105, 107
Sevilla de López Pinto, Josefa, 118, 120
Sexuality, 5–6, 94, 96–99, 105
Skerret de Saldaña, Julia, 118, 120
Slaughterhouse, 14, 87, 89
Slavery, 7, 33, 40–42, 47–48, 54–55, 109, 128; abolition of, 4, 27, 32–35, 84, 92, 94–96, 99, 102, 113, 120–22, 125–29

Slaves, 3, 17, 23, 25, 34, 36, 40, 43, 46–47, 54, 56–57, 65, 73, 81, 84, 87–90, 94–95, 105–6, 112–13, 119–20, 127–28; manumission of, 51, 88, 109
Sociedad de Auxilio Mutuo y Beneficencia, 128
South America, 3, 41, 50–52, 56, 60, 63, 74, 77
Spain, 7, 17, 21–22, 27, 31–32, 34, 37–38, 49–51, 53–54, 56–57, 60–61, 63, 82, 86, 99, 102–3, 109, 116, 119, 122
Storekeepers, 22, 60, 70–72, 81–82, 85–86, 88, 99
Street vendors, 87–89, 93, 99, 127

Tapia y Rivera, Alejandro, 21, 94
Teachers, 21, 23, 26, 59, 73–75, 81, 118, 127
Toa Alta, 16, 19
Toa Baja, 16, 19
Toro, Petrona del, 109–10
Town council, 10, 13, 15, 19–21, 24–27, 35, 74–77, 86, 88–91, 95–98, 103–4, 106, 108, 110–13, 127
Trinidad, 104
Trujillo, 16, 19, 120

United States, 4, 6, 20, 22, 60–61, 86, 91, 119–21, 123, 126
Uruguay, 123

Vagrancy, 26, 96–97, 103, 106, 110–11
Vega Baja, 44–45
Vega del Toro, Micaela, 52, 67
Venezuela, 63, 119–20
Vergara de Sánchez, Estevanía, 64, 69
Vidal de Hernaiz, Concepción, 118, 120
Virgin Mary, 29–30, 33, 116
Viuda y Sobrinos de Ezquiaga, 20, 61
Vives, Salvador, 49
Vizcarrondo, Aurelia, 118, 120
Vizcarrondo, Julio, 119–20

West Indies, 50
Widows, 50, 52, 59, 61–62, 64–69, 71, 79, 81, 85, 88, 106, 111, 119, 124; pensions for, 76–77
Women's Organizations, 5–6, 34, 101–2, 117, 121, 123–24, 127, 128, 134n.12

Yrriarte, Elías, 64, 69

www.ingramcontent.com/pod-product-compliance
Lightning Source LLC
Chambersburg PA
CBHW030140170426
43199CB00008B/141